Ball.

sociation foot ball.

ny direction with one or both

in any direction with one or both

h the ball, the player must throw

ches it, allowance to be made for

unning at a good speed.

~~n or between the hands, the arms or~~

it.

pushing, tripping or striking, in

shall be allowed. The first

To PAUL —
Here's to following !
our Dreams !
1.8.2014

hoop
the american dream™

Robin Layton

robin layton

pH **powerHouse Books**

Brooklyn, NY

Dedicated to Pat Summitt and
The Boys & Girls Clubs of America.

To my parents Barrett and Shirley Crump.

Everything I do, I do to honor you. Thank you for always
believing in me, and encouraging me to follow my dreams.

Basketball is deeply ingrained in our childhood, our play, in our culture and dreams. Rich or poor, unknown or famous, rent or own, we love the game of basketball.

Hoops can be found anywhere and made of just about anything: from a hole in the bottom of a bucket or crate, to a metal ring tacked onto a tree, to a hoop inside a state-of-the-art gym.

Anyone can play. All you need is a ring, a ball... and a dream.

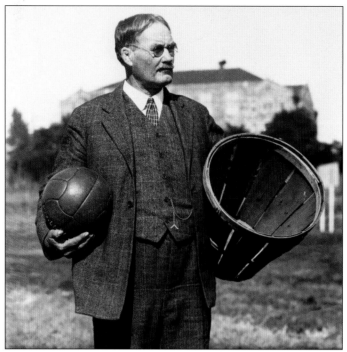

The inventor of basketball, Dr. James Naismith © Corbis

FOREWORD

In 1891, James Naismith couldn't find any wooden boxes, so he tacked up a pair of peach baskets in the YMCA Training School gym. The balcony rail he attached them to just happened to be precisely 10 feet off the floor, a spectacularly lucky accident as things turned out. Naismith typed up a short list of 13 rules and introduced a group of secretarial students to a novel new indoor activity. He only intended to give his students some exercise in the depths of a long New England winter. What he unwittingly created was a national phenomenon.

From that simple beginning in Springfield, Massachusetts, Naismith's "basket ball" has woven itself into the very fabric of American life. From a game of HORSE in the driveway, to high-school hoopla, to March Madness brackets, basketball is now deeply ingrained in our collective childhood, our play, in our culture and dreams.

Basketball is by far our most democratic game. Anyone can play — and almost everyone has — regardless of background, circumstance, or gender. Hard work is rewarded. Individual achievement is celebrated. Objectives are achieved through complicated, committed teamwork. In these regards, basketball teaches us everything required for success in life: polished skills, teamwork, planning, execution, persistence, and resiliency.

The equipment is simple and inexpensive: a round ball and an iron ring. These lowly tools have become the stuff of dreams for generations. From urban playgrounds to windswept barnyards, basketball has become a universal American experience and a worldwide cultural touchstone.

Virtually every child has at least dribbled a basketball and launched it toward a hoop. Most kids have played on at least one team. High school and college narrows the field considerably, but builds legions of new fans every year. And then there is the NBA where only a few of us have been lucky enough to play on the world's biggest stages.

Basketball builds connections, both personal and cultural. Who hasn't whiled away an hour shooting hoops with a friend? Countless pickup games are played every day among friends — and soon-to-be friends. We cheer for our favorites along with thousands of other rabid fans and we enjoy a quiet game at home with Dad on the sofa.

The photographs collected in this book capture that shared community, as well as the diversity and beauty surrounding the game. Photographer Robin Layton reminds us of the weathered dreams, fading memories, and future glories hanging from solitary backboards all around the country; they are very familiar to me. Through these images of hoops — some mundane and abandoned, others celebrated — a breathtaking portrait of America emerges.

As you turn the pages, you'll find the childhood hoops of famous players, where they honed their skills and made a first splash in the game. These pictures take us from lowly schoolyards all the way to the White House; from French Lick, Indiana, to New York City's Rucker Park.

In the end, hoop is a truly original love letter to the game of basketball. More than 120 years after the game was invented, Layton puts a whole new spin on "shooting hoops" — and, in the process, shows us an America continually fueled by simple dreams.

— *Jerry West*

RIGHT James Naismith's gravesite, Memorial Park Cemetery, Lawrence, Kansas

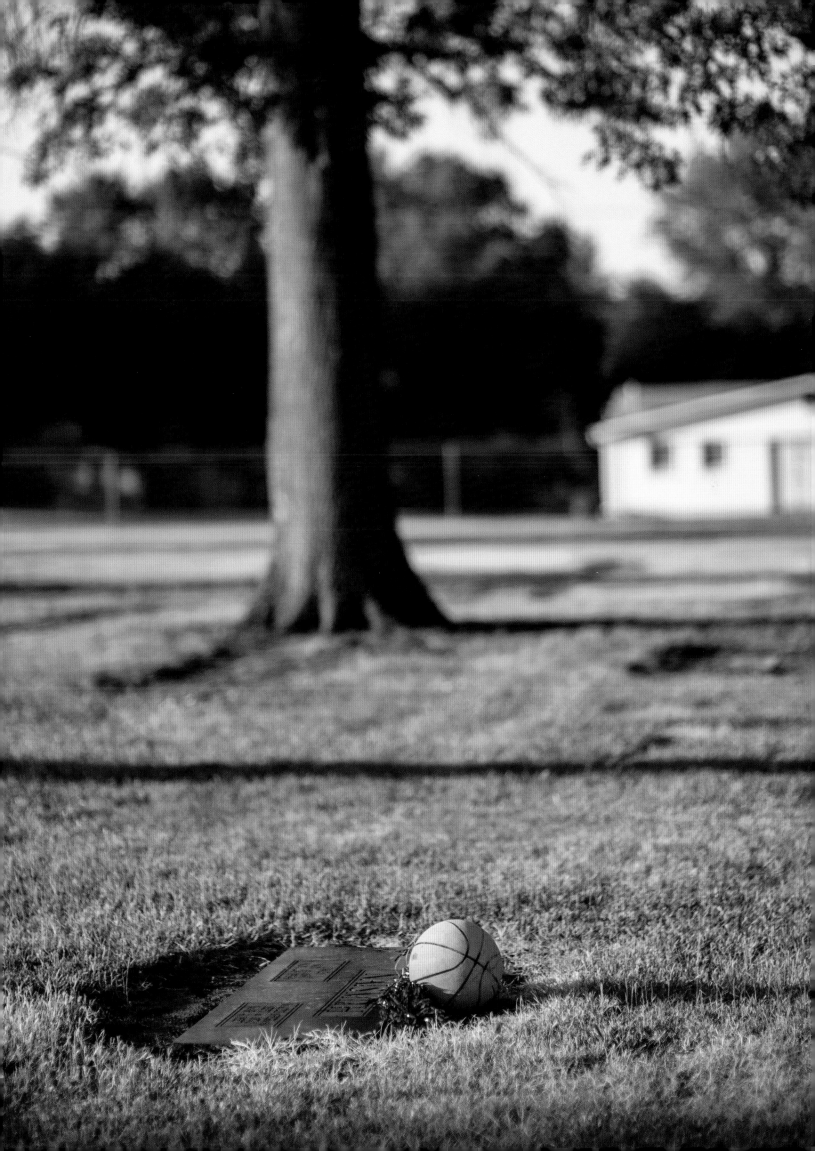

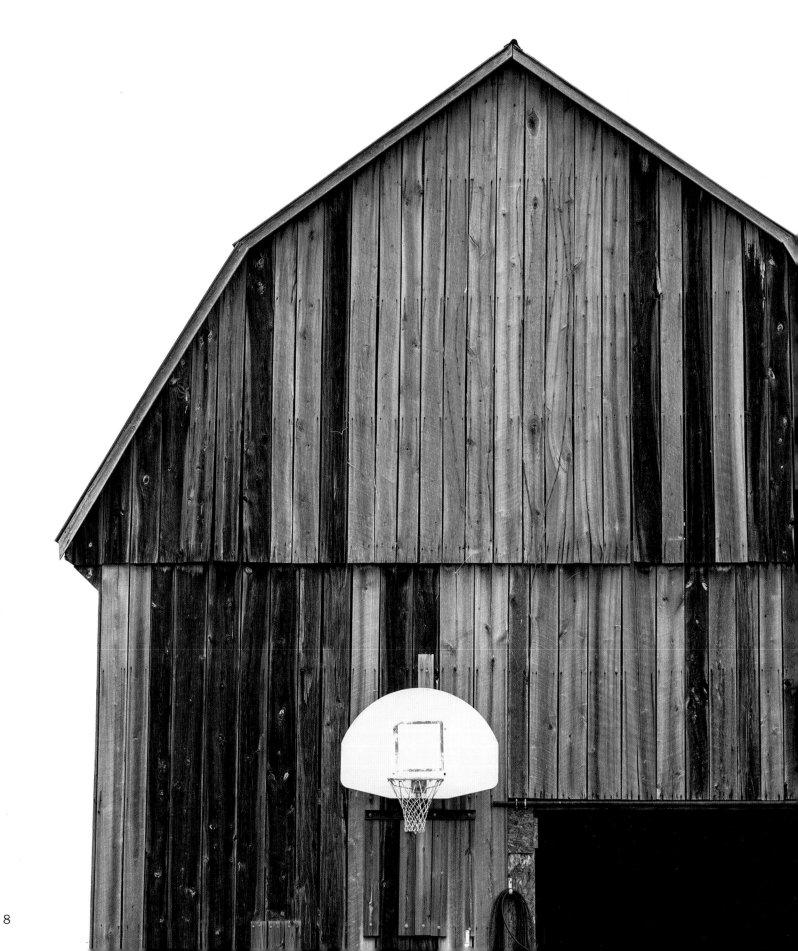

"I grew up with a basketball in my hand. I have enjoyed playing the game and I've especially loved teaching the game. It has been such a large part of my life, from the time I could pick up a ball until right now. Growing up...and after all the cows were milked and our other chores were done...my brothers and I would go up in our hay loft and play for hours. Any time I can watch a game, I do, men or women, it doesn't matter to me.

I am very proud of all the young women that have come through our program and now have gone on to have successful coaching careers themselves. We share a passion for the game, and I enjoy watching them now.

Make the most out of every opportunity you receive. Don't let anyone outwork you.

Do your best on and off the court!"

— *Pat Summitt*

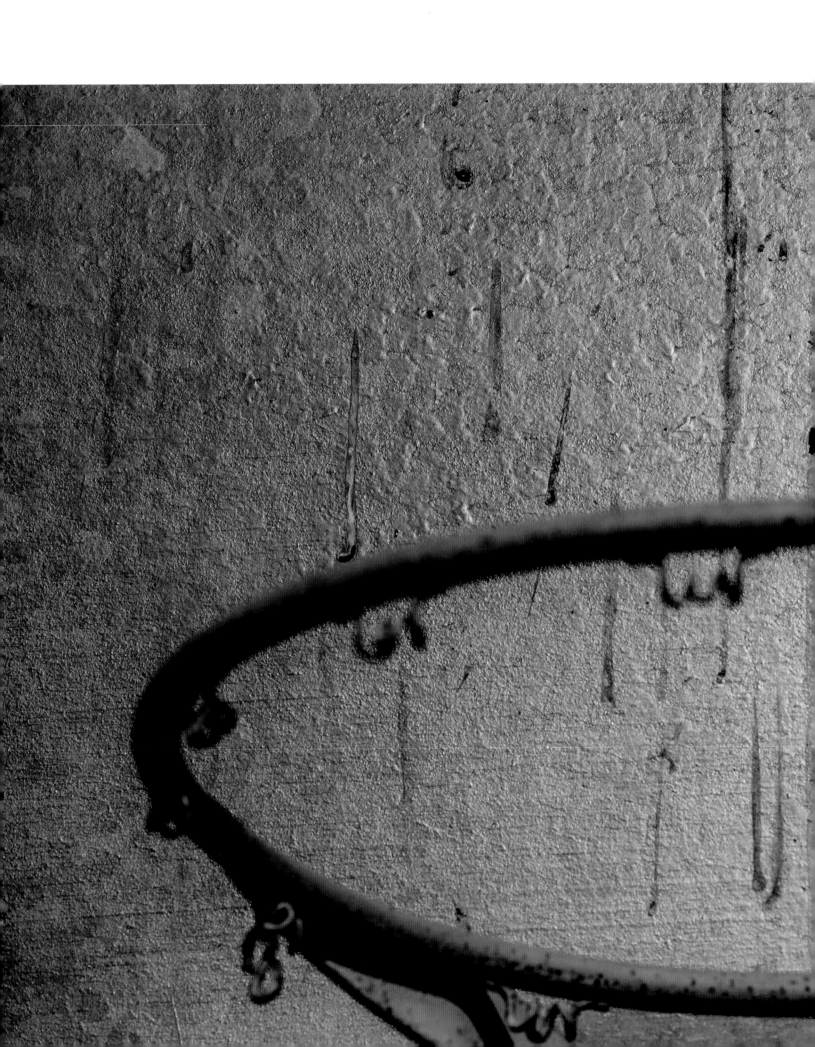

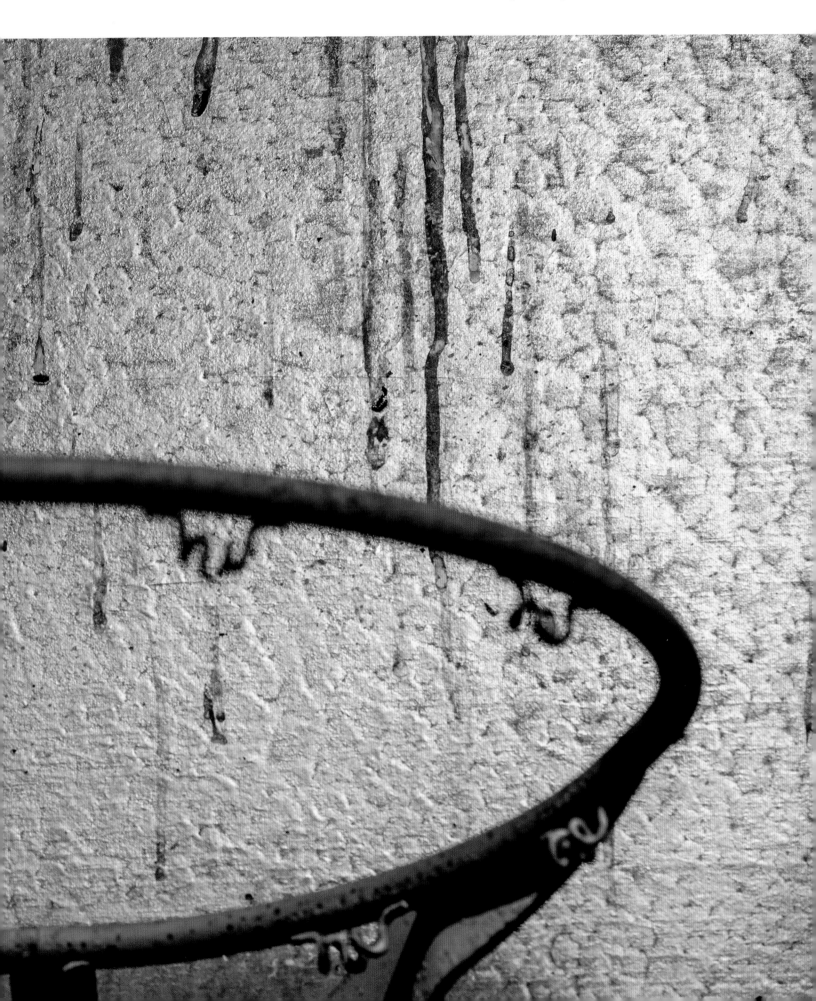

**If there was a chain on the hoop, it was a good day.
If there wasn't, it was a tougher day.**"

— *Ann Meyers Drysdale*

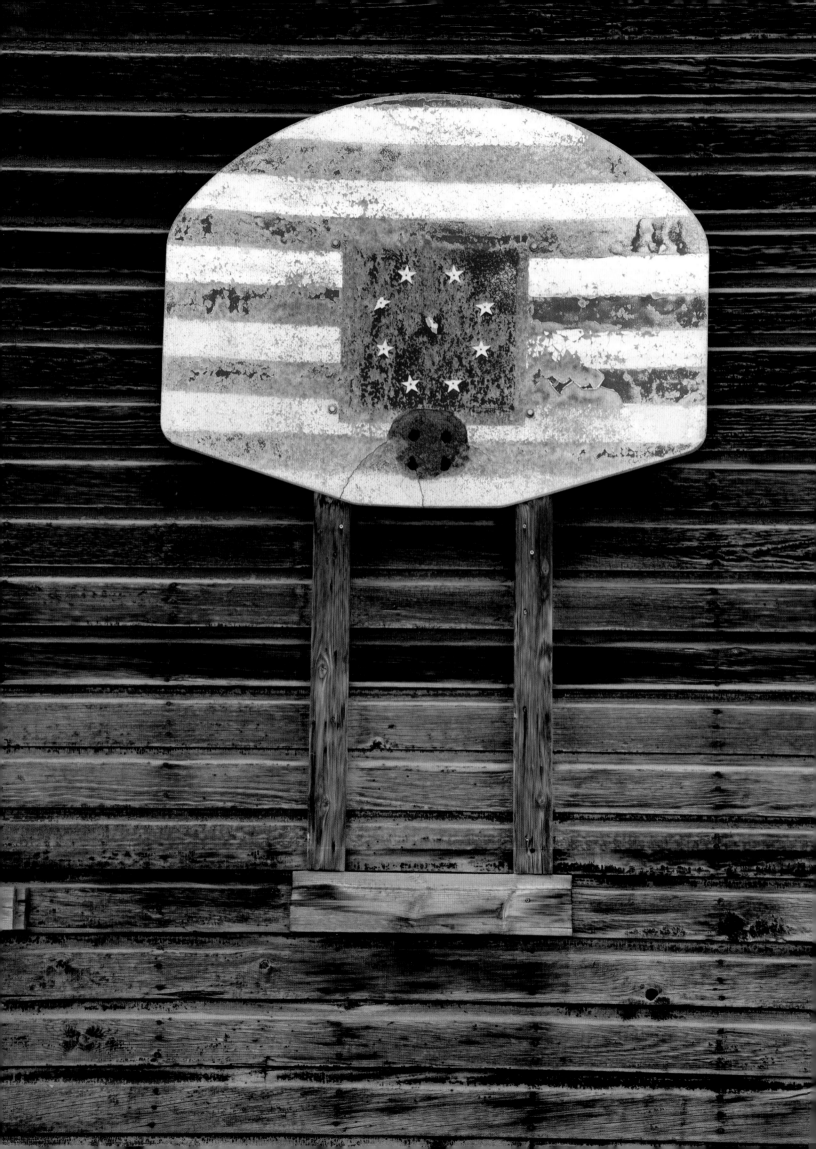

" I always imagined myself doing special things when I worked on my game in the Columbus schoolyard. It's crazy that those dreams have turned into more than I could have ever expected!

I love the game of basketball. It is hard to hear people say the game owes them something. We all owe the game a lot more than it owes us."

— *Mike Krzyzewski*

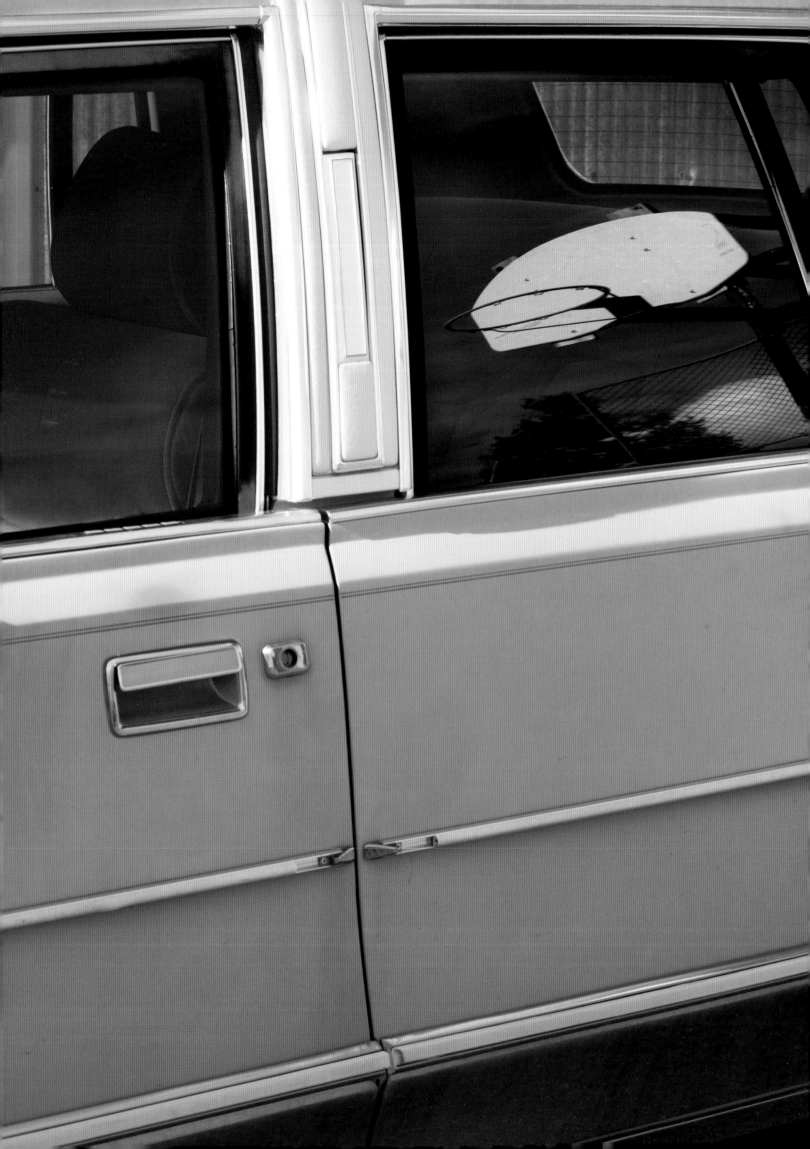

"As a little kid in Oakland, California, I wasn't really into basketball. I'd run around and pretend I was a police officer (I watched "S.W.A.T." a lot) and I'd jump off our garage playing cops and robbers. I was forced to go to my older brother's basketball games because my father was his coach.

We had this tree that was split in half in front of our house. One day, my father went outside and took an orange basketball hoop and nailed it to that tree. You couldn't hang on it because it was put on with nails and it would come out of the tree.

So I went out there and started playing, but my brother and his friends would never let me have the ball. I would go into the house and cry to my father and he would come out and help me, but then my brother and his friends would get mad.

One day, I went inside and cried and cried and finally my dad said. 'You know what? You need to man up and keep trying so you can get better and better.' Well, I did get better. I worked and worked until I could do things other kids couldn't. As I got bigger, I got a lot better, so I decided to go to the playground around the corner. I'd play with kids that were a couple years older than me and that helped me get better yet.

I started living basketball, carrying a basketball everywhere I went. I just kept playing and playing and playing. It just took off from there.

I owe everything to basketball. Basketball is the main reason I have opportunities to do things right now. If you get an opportunity to be great at basketball — or anything — grab that opportunity and take it to another level. Become a successful person and bring it back to your neighborhood to encourage kids that they can do the same.

You can do a whole lot more than hang out on the streets doing negative things. You don't have to be a basketball player. You can be a teacher, a doctor, a lawyer. You can be a lot of things.

Basketball taught me a lot about life. It showed me how to grow up, how to deal with people, how to deal with money, and how to be a man."

— *Gary Payton*

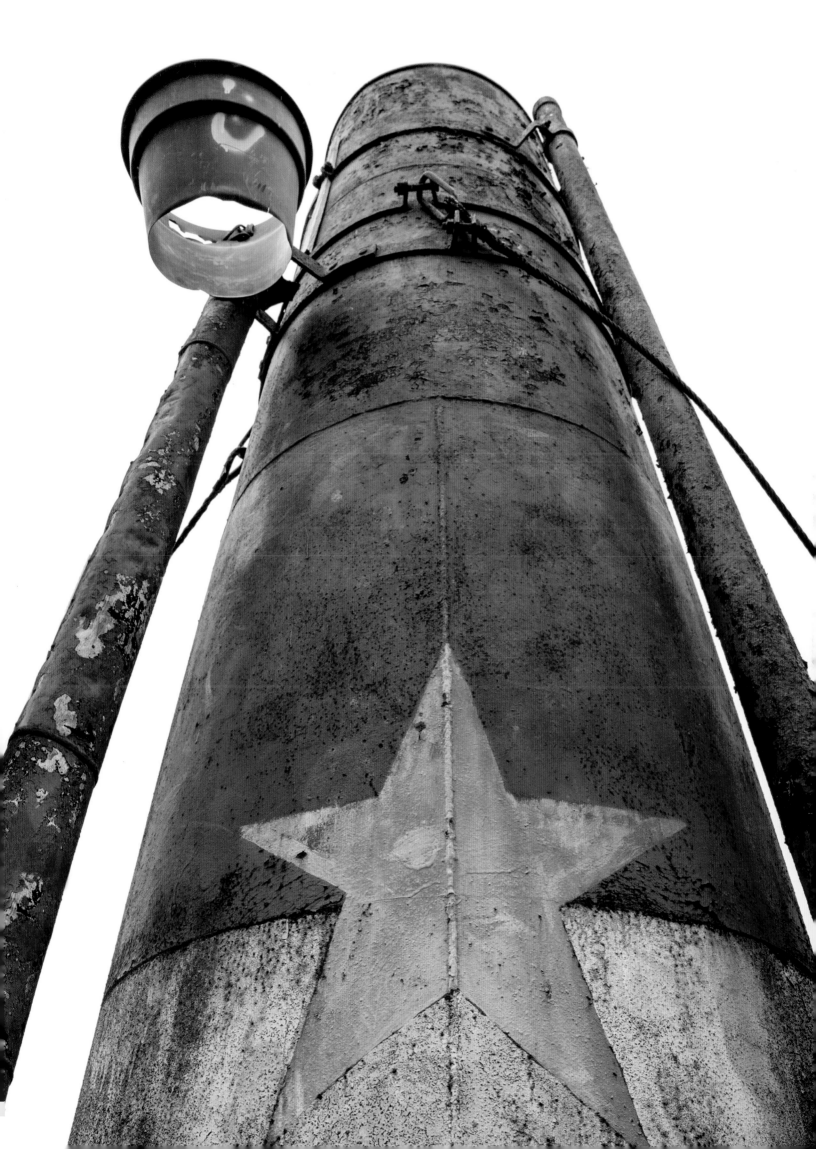

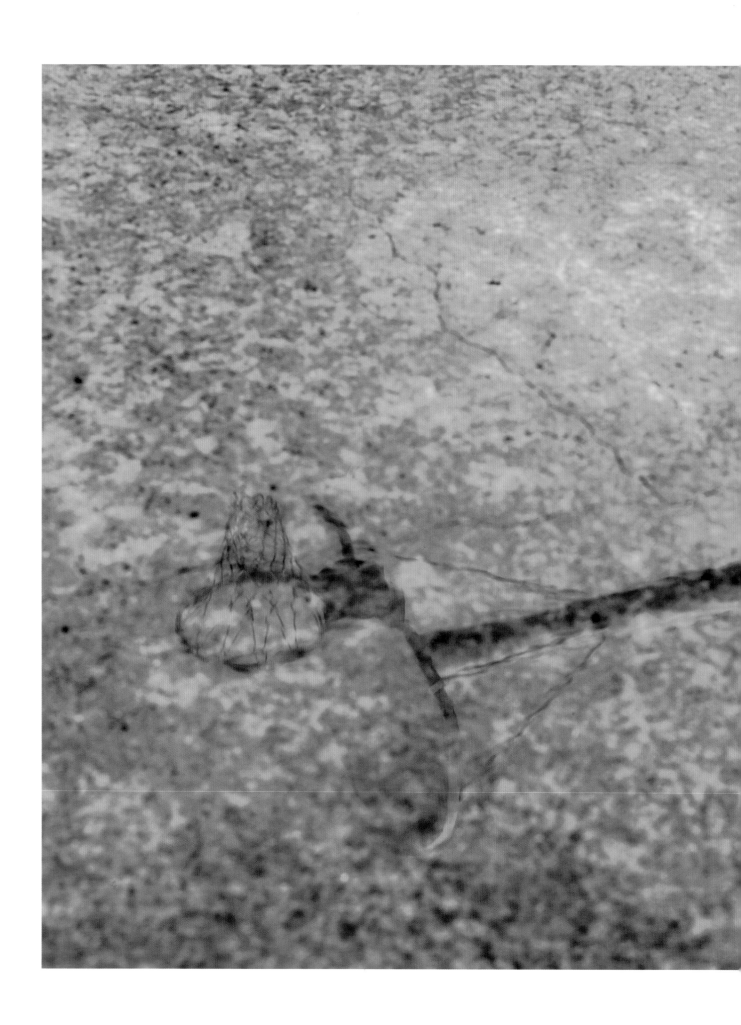

ABOVE Childhood hoop of Jackie Stiles, Claflin Swimming Pool, Claflin, Kansas
NEXT SPREAD Hardeeville, South Carolina

"When I was a little girl, my Dad was a basketball coach for varsity boys. I'd follow him to the gym and I can remember I would be running wild anytime I was there in the gym. He would throw me in and show me how to dribble and the fundamentals, and I just couldn't wait to show him that I could master it.

I remember telling my second grade teacher that I would play professional basketball one day when I grew up. At a very young age, I had the vision of the basketball game and what I wanted. I was very passionate very early on and wanted to be the best I could be. Basically, my life centered around it. I can remember being a little girl and I would beg my way in to play pickup games with the boys at the park. Basketball, basketball, basketball, 24/7.

It does not matter what size you are, if you truly believe in something, work hard at it. There will be tough times, but have a goal. There's no goal more important than following your dreams.

Don't let anyone discourage you from following your dreams. Dreams do come true."

— *Jackie Stiles*

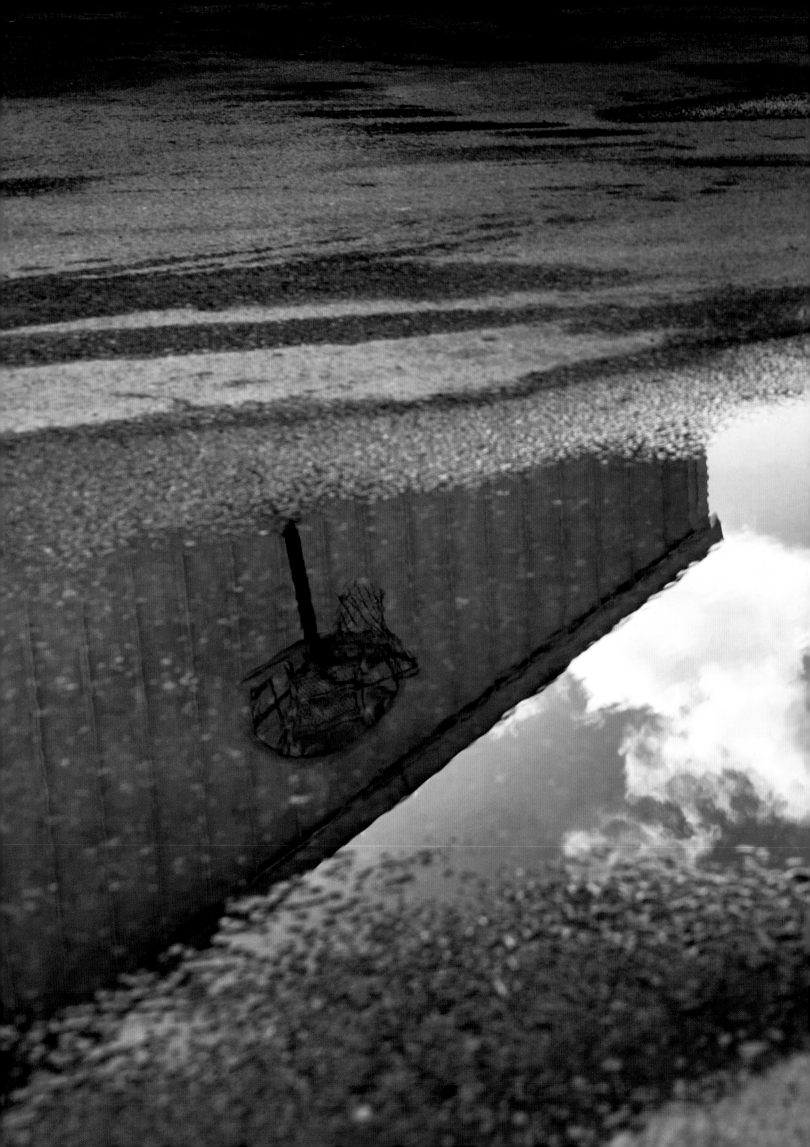

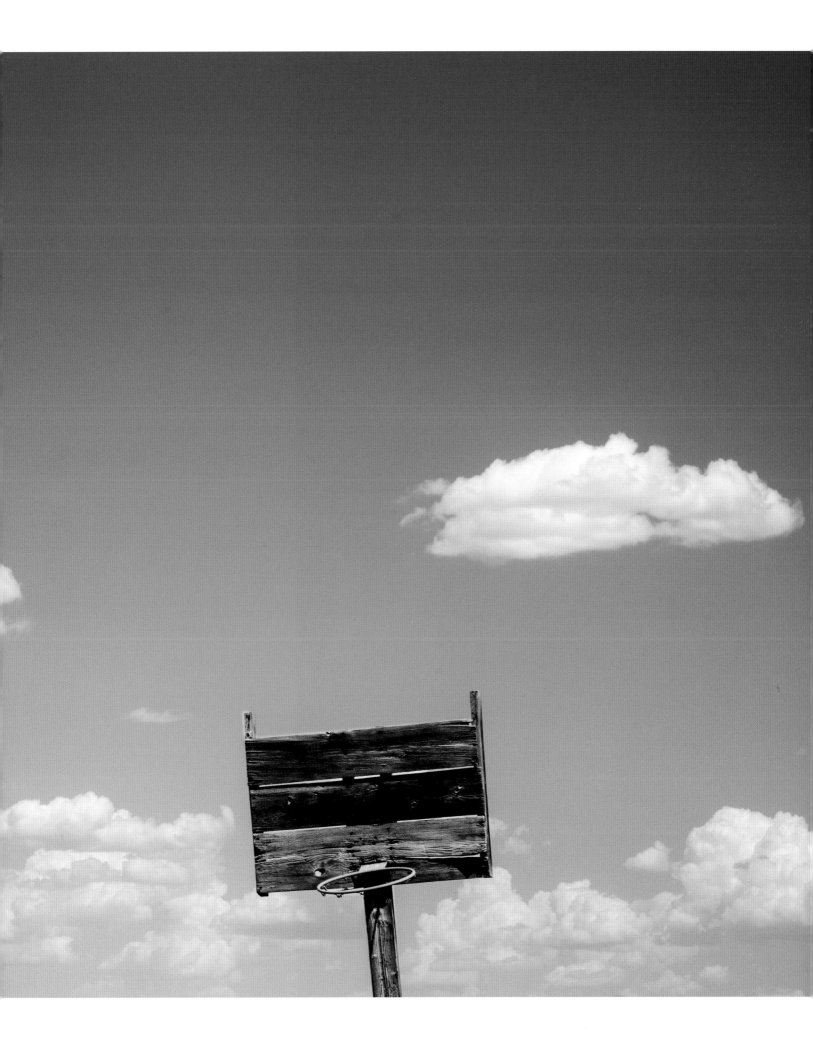

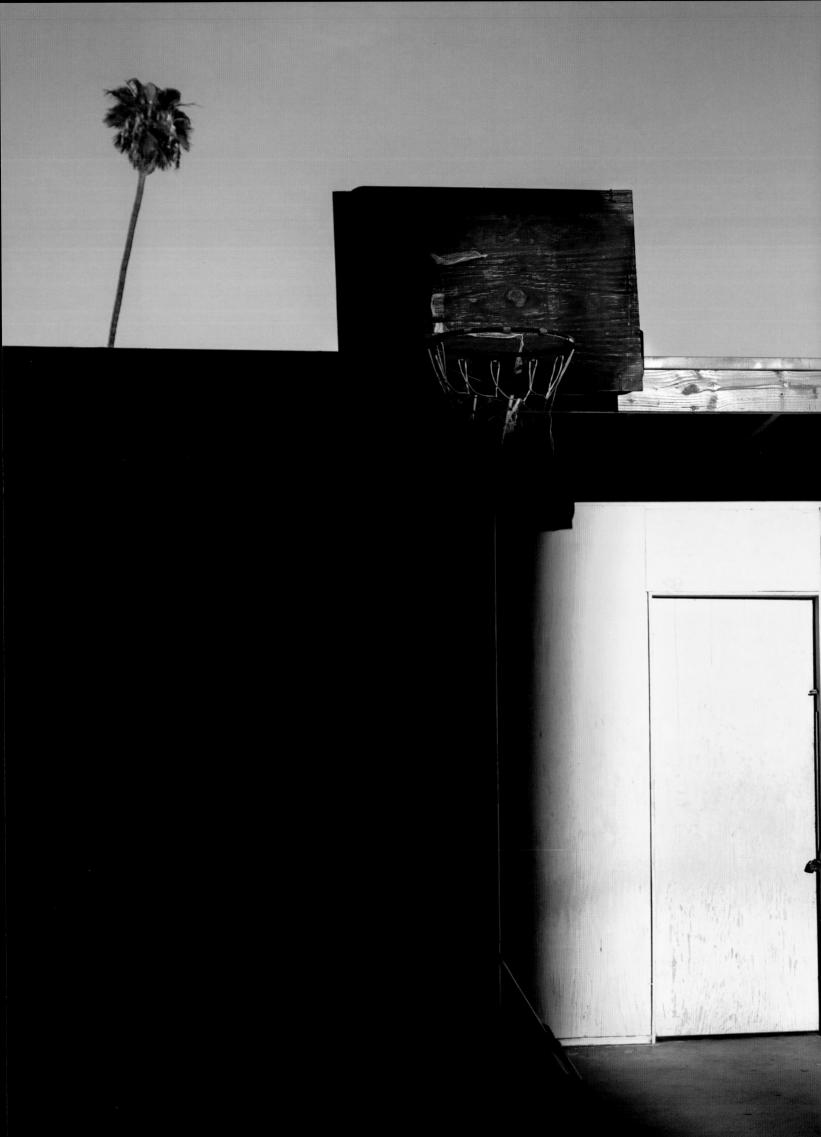

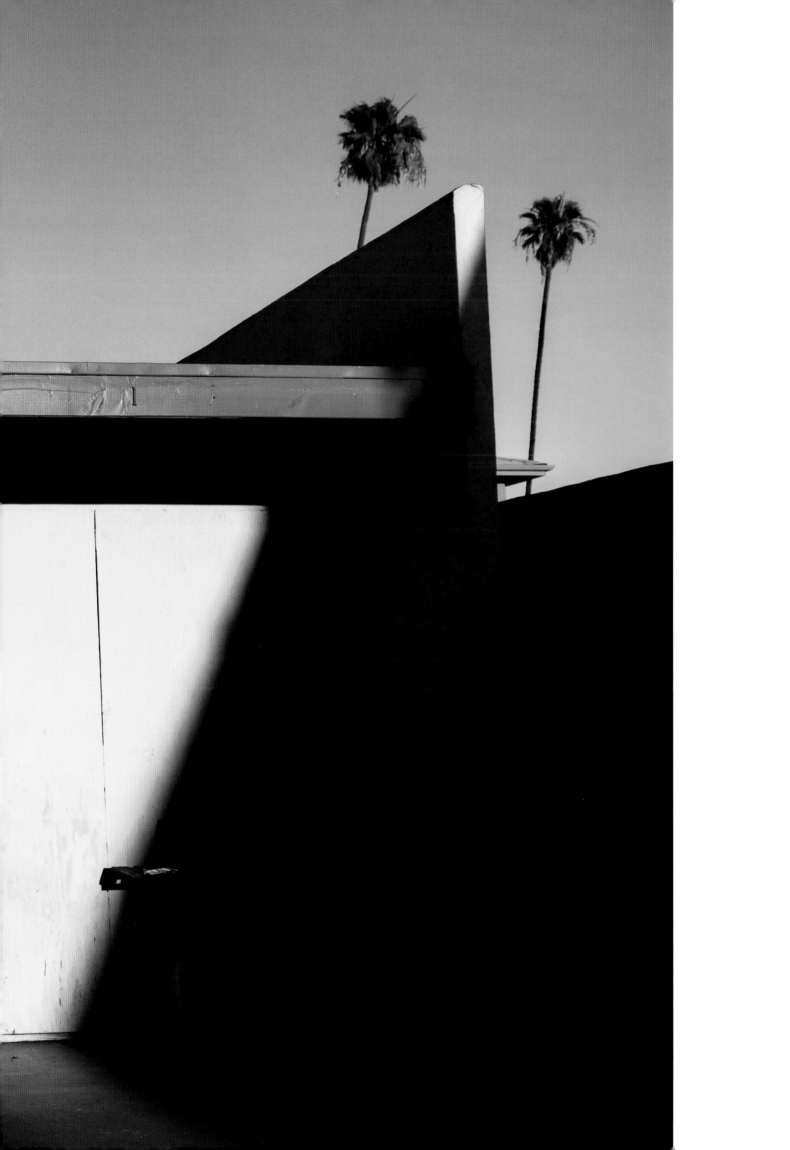

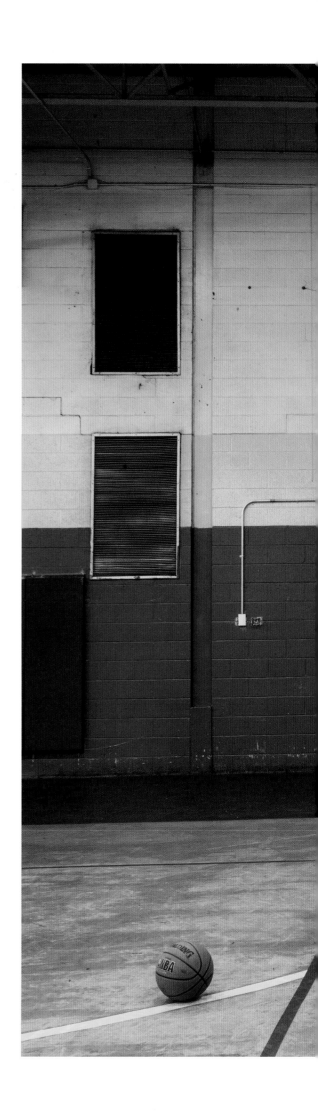

"	The Boys and Girls Club saved my life. Growing up in the projects in Newark, New Jersey, there are a lot of negative temptations: drugs, gangs, a lot of bad things. My mother and father worked very hard to support the family, so they would say, 'Fulfill your dreams, if you want to make it into this NBA thing...go in there and play with other kids, but do not leave this building until we pick you up.' That was my daily routine. In there, I learned how to become a people person, learned how to become a team player. I learned how to become a nice guy, become a protector. I learned how to become a leader and it's all because of the Boys and Girls Club."

— *Shaquille O'Neal*

RIGHT Childhood hoop of Shaquille O'Neal
Boys and Girls Club of Newark
Newark, New Jersey

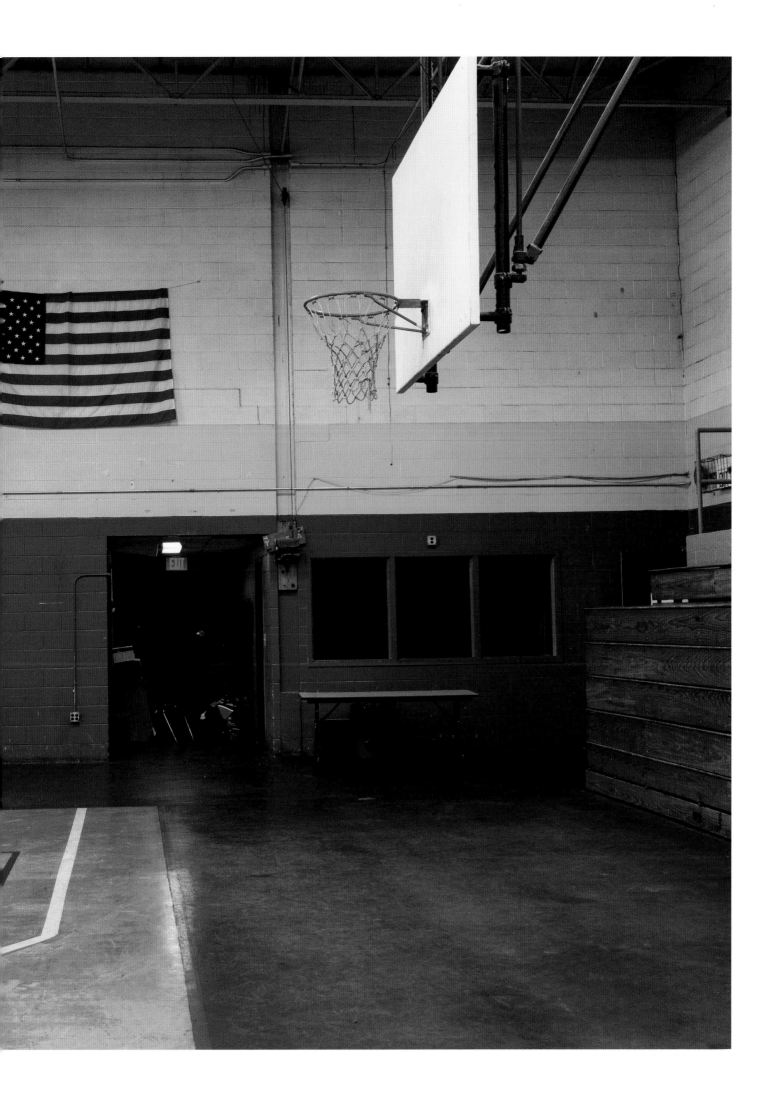

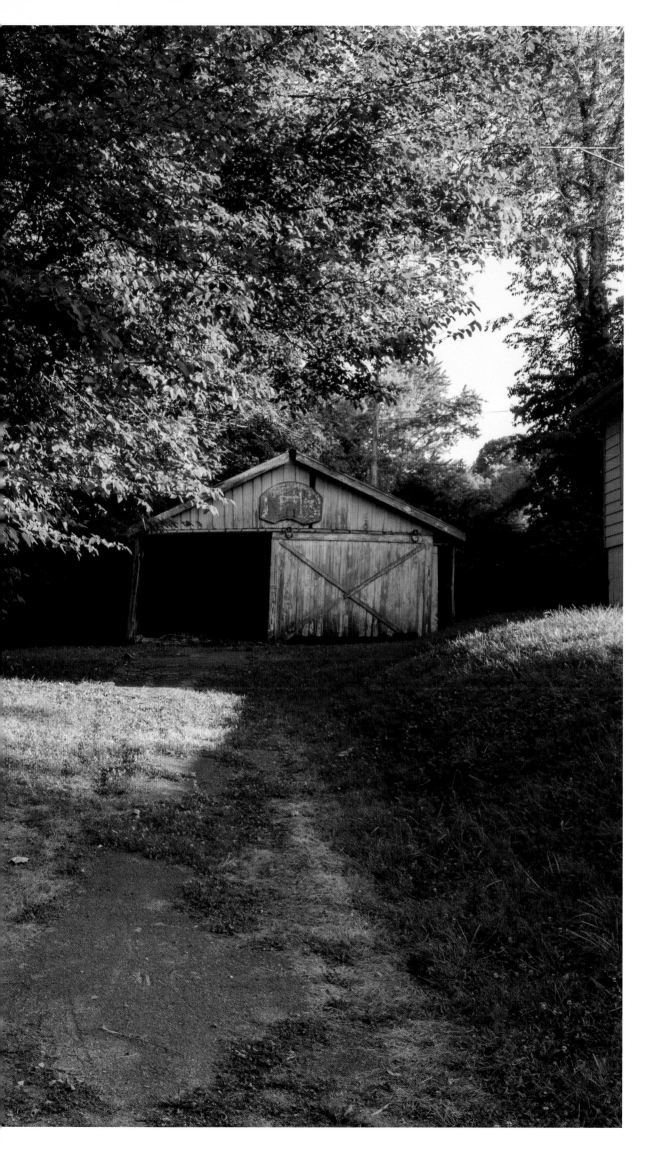

Childhood hoop of Larry Bird
French Lick, Indiana

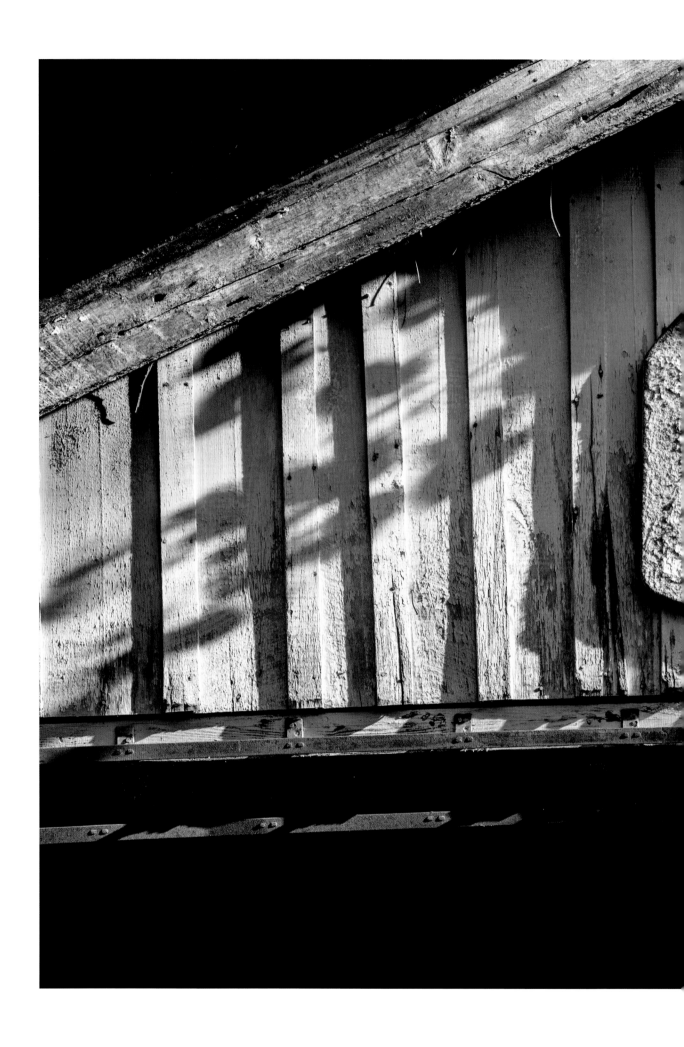

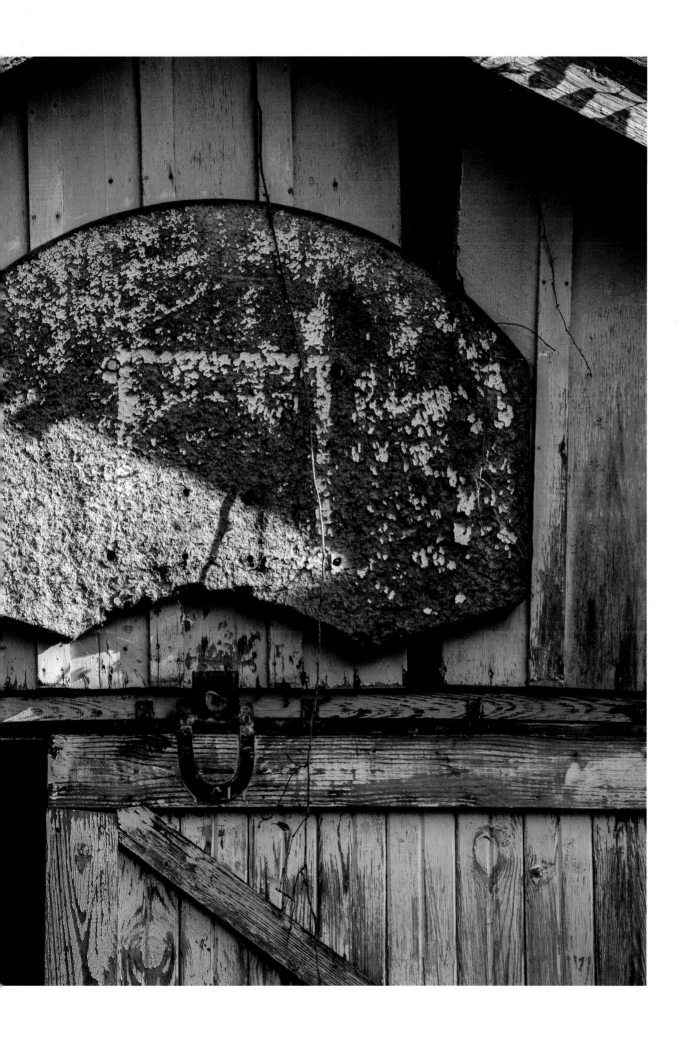

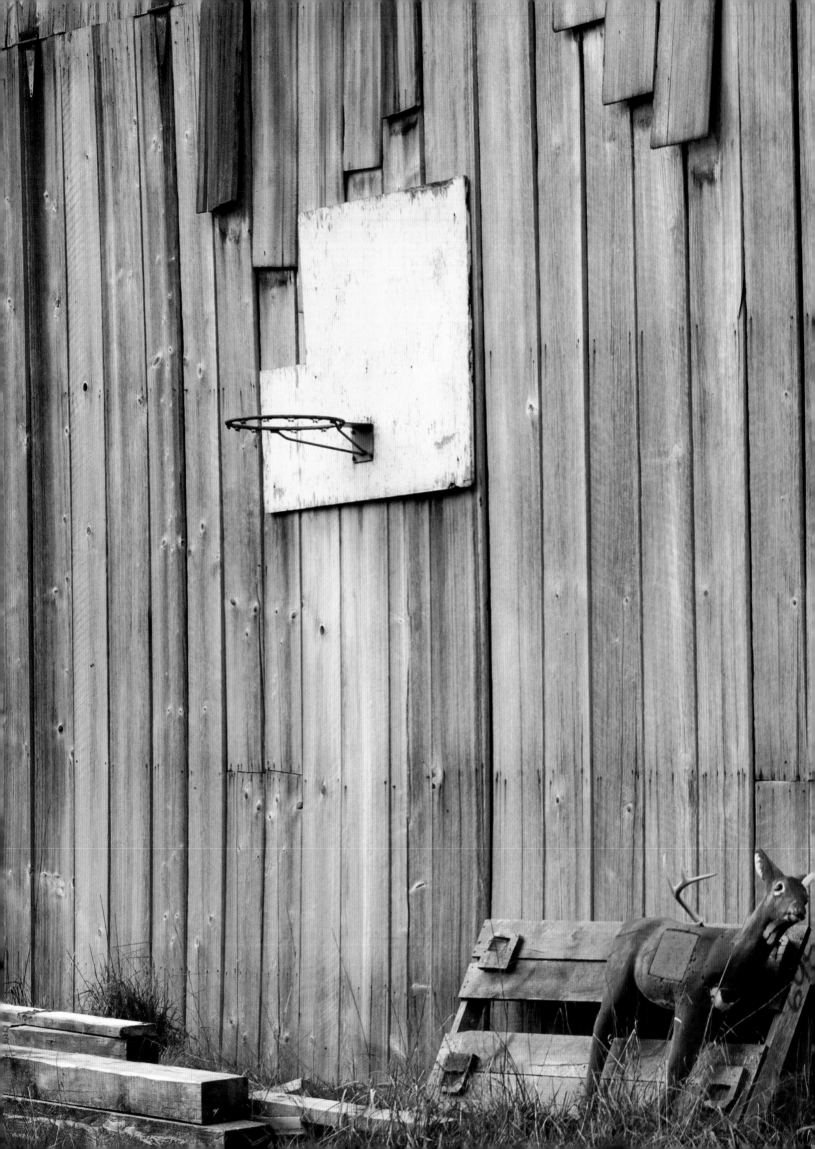

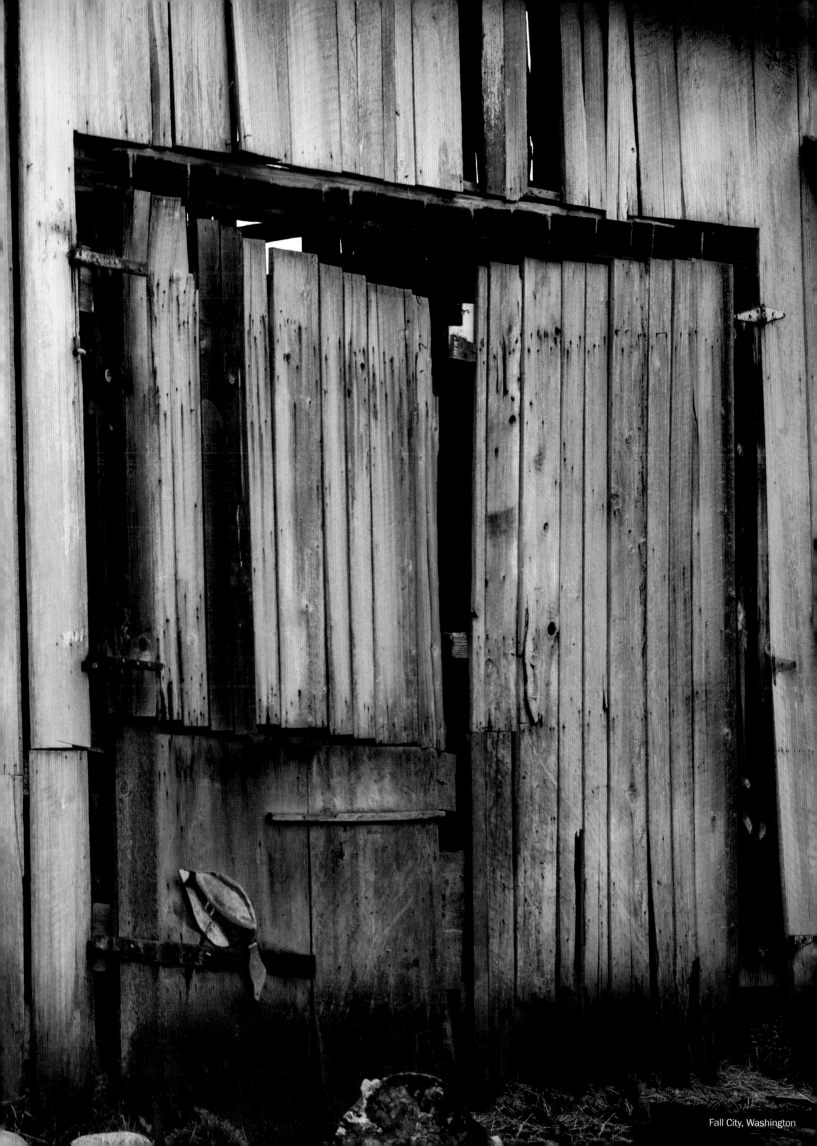

Fall City, Washington

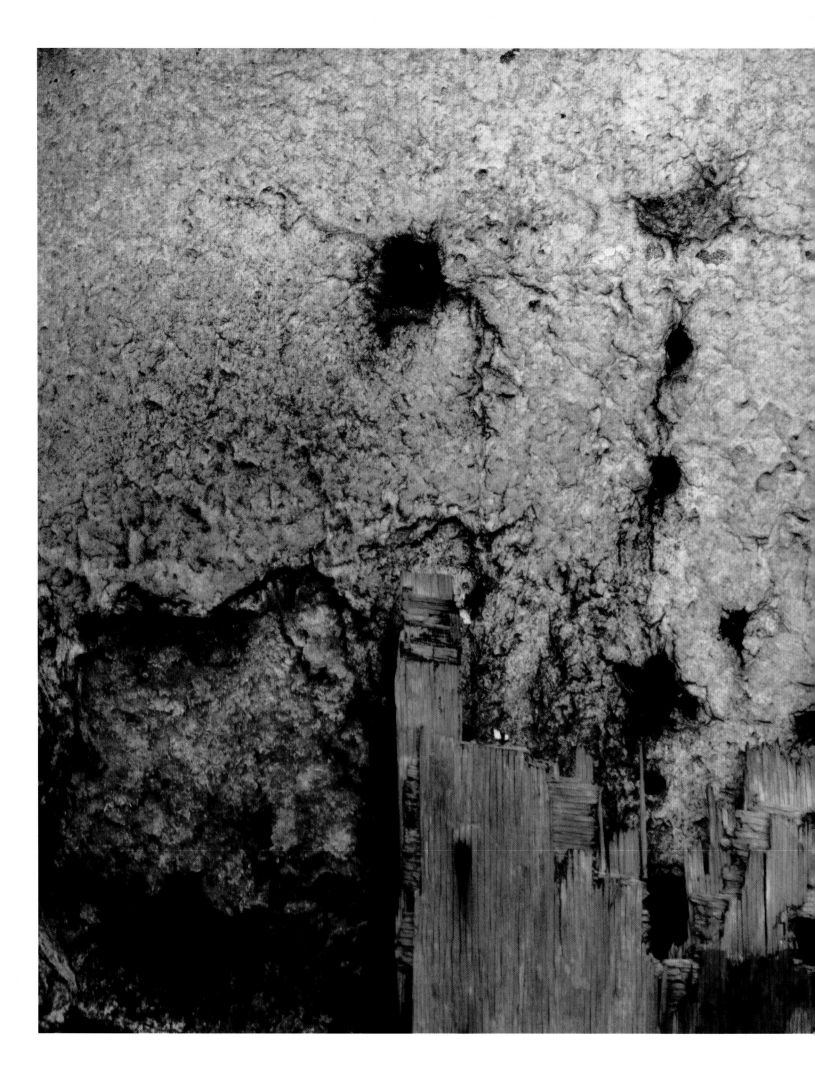

ABOVE Philadelphia, Pennsylvania

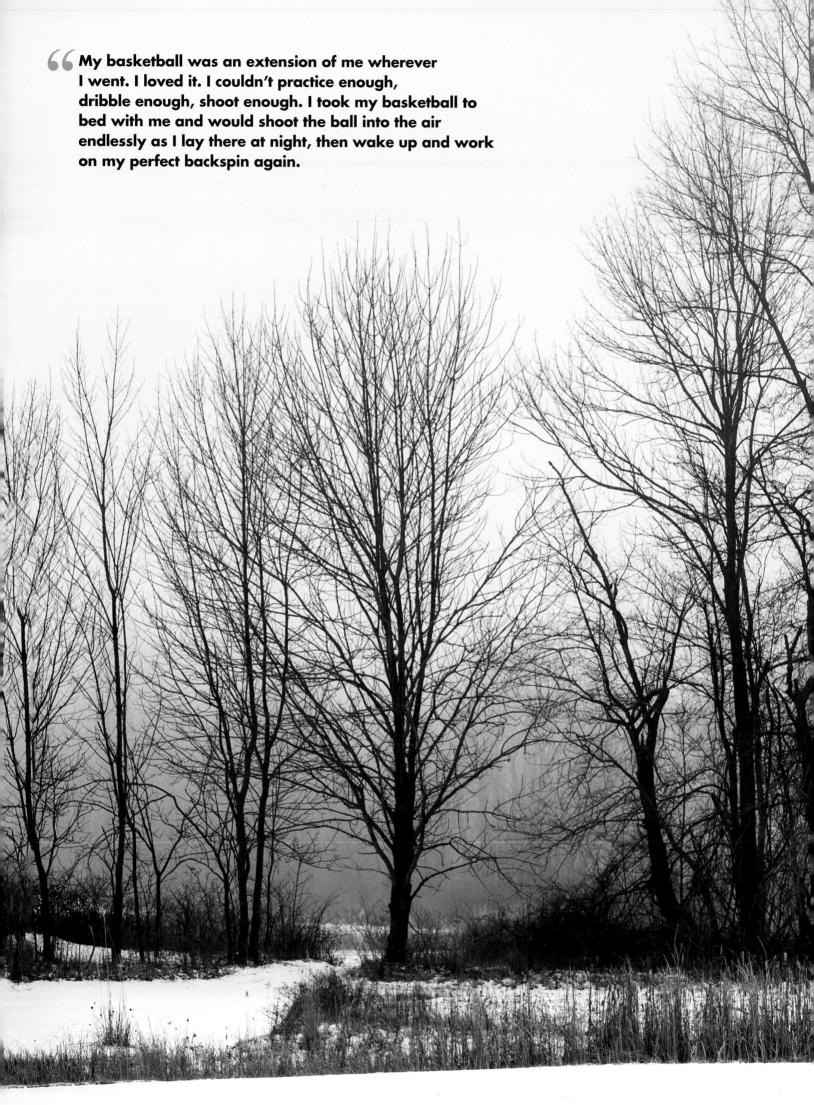

My basketball was an extension of me wherever I went. I loved it. I couldn't practice enough, dribble enough, shoot enough. I took my basketball to bed with me and would shoot the ball into the air endlessly as I lay there at night, then wake up and work on my perfect backspin again.

Granville, Ohio

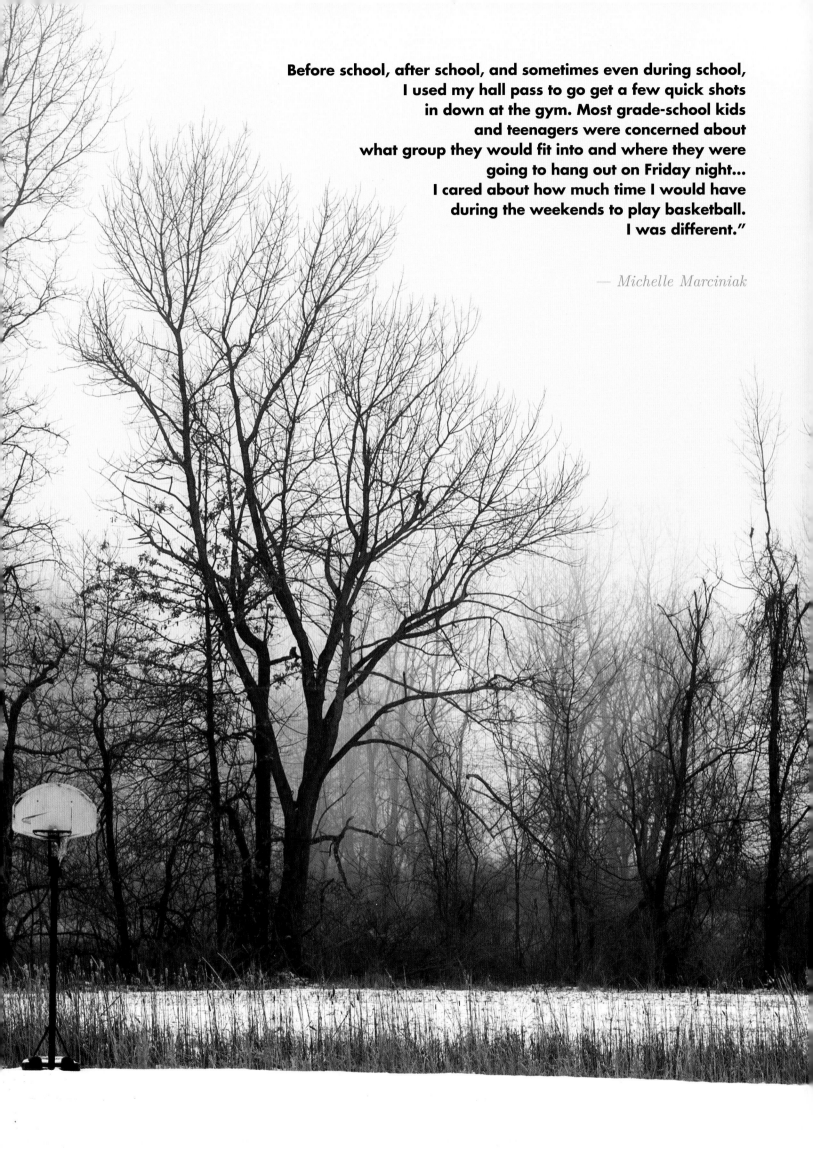

Before school, after school, and sometimes even during school,
I used my hall pass to go get a few quick shots
in down at the gym. Most grade-school kids
and teenagers were concerned about
what group they would fit into and where they were
going to hang out on Friday night...
I cared about how much time I would have
during the weekends to play basketball.
I was different."

— *Michelle Marciniak*

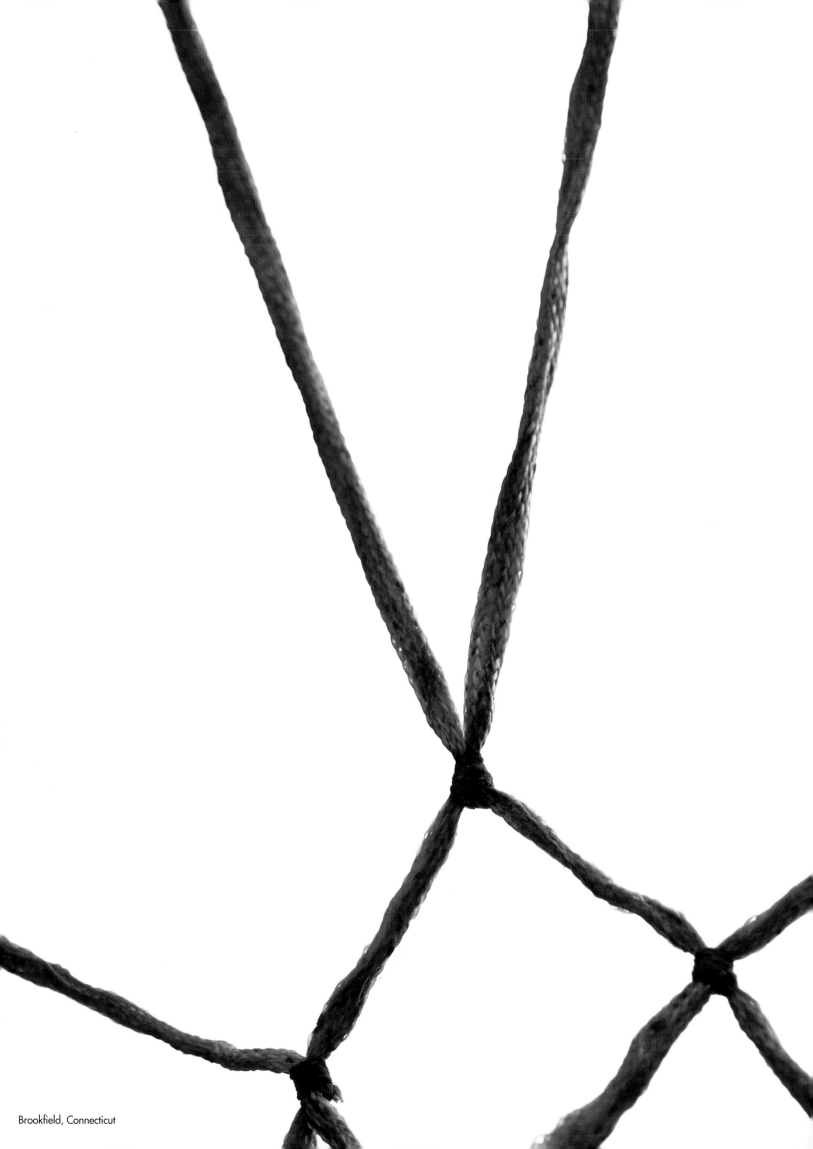

Brookfield, Connecticut

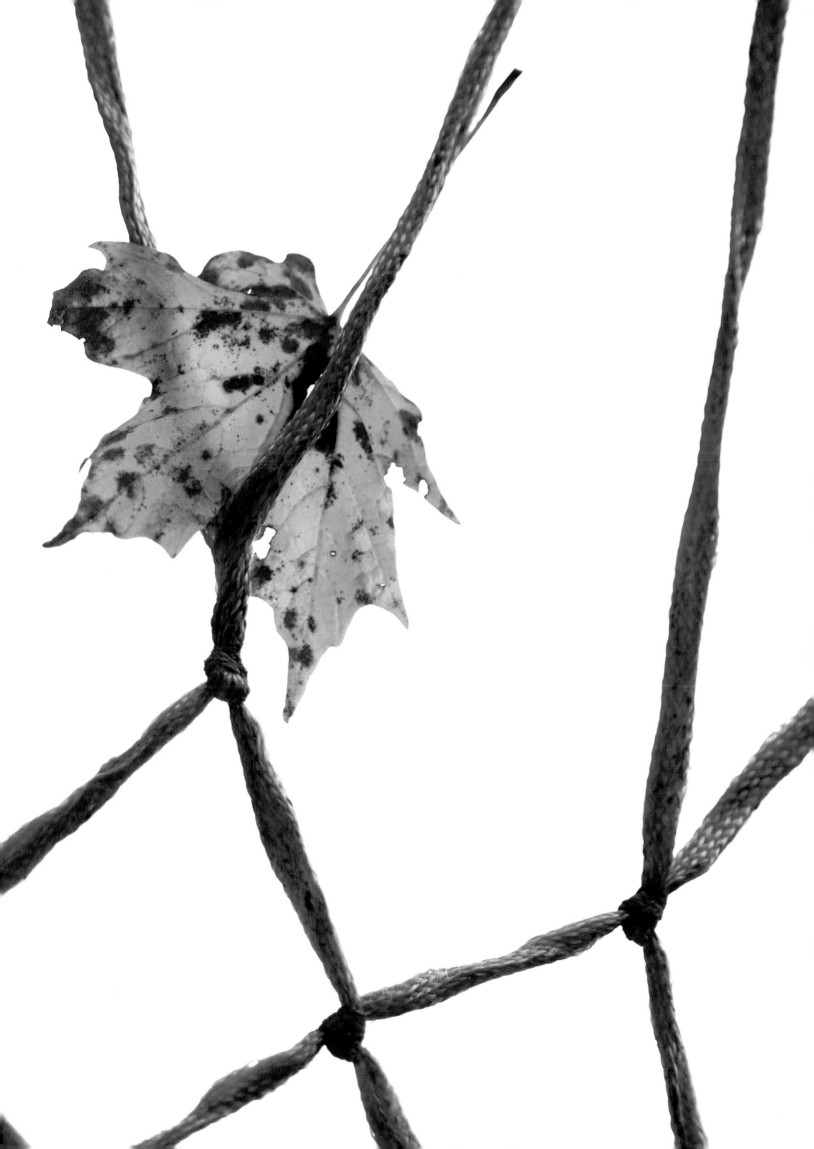

“ When I was a kid, I loved to play—all the time—day and night. I started playing basketball when I was about 13 or 14 years old, at the public park near our house. Actually, there were two parks near our house, one for whites and one for *coloreds.*

That's what they called us then. The park for us had grass and trees. I guess it was nice enough for picnics and stuff, but you couldn't do much in it. The white park across the street had a basketball court, tennis court, and other facilities.

We would steal into the white park after it closed and played, that is, until we were run off, but then we would just come right back in. We played at night by the light from the lampposts, sometimes all night long. We didn't have a basketball, so we started out with a tennis ball, then, after a while, somebody found a volleyball. So, we played with that, until finally we got an old basketball. We played and played and played at night and sometimes all night. I later joined teams at the Southeast Settlement House and the Southwest Boys Club. Whenever and wherever I could, I played. I loved it."

— *Elgin Baylor*

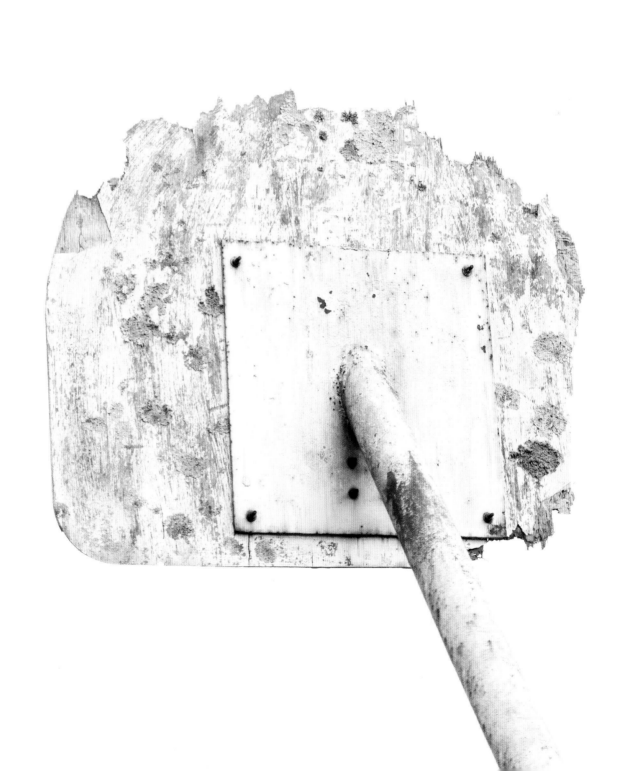

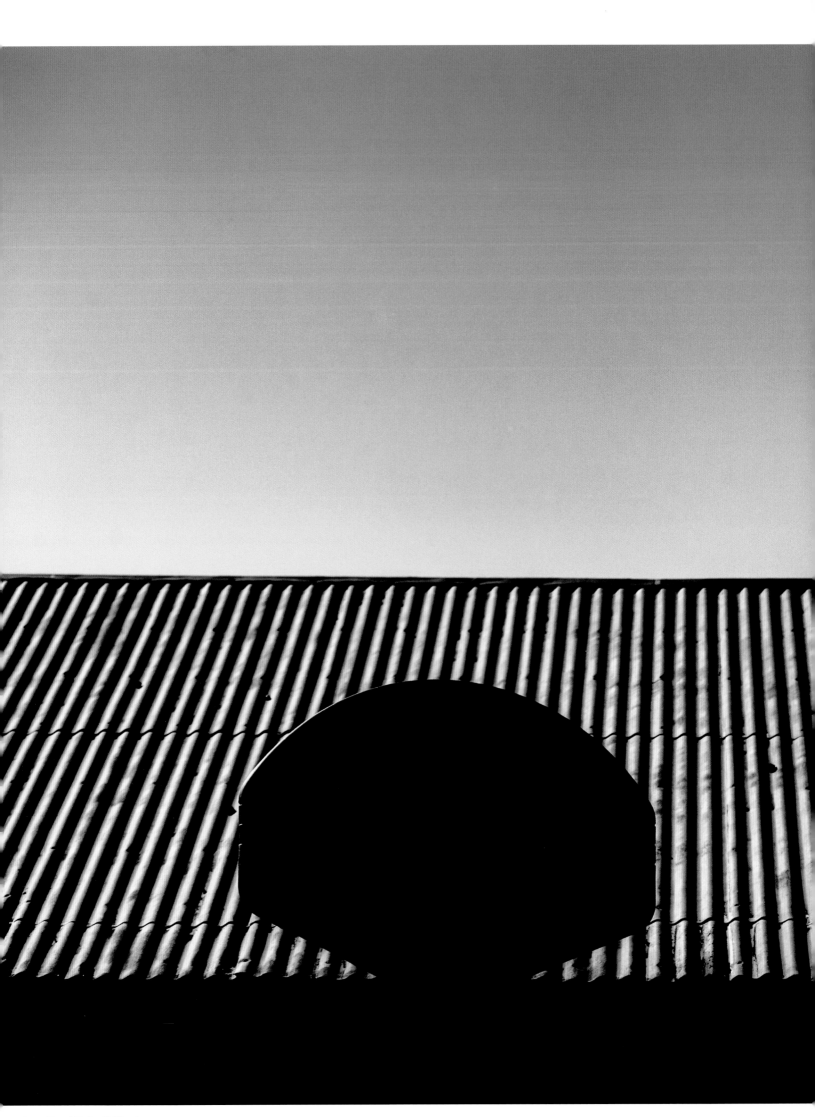

ABOVE Royal Oaks, California

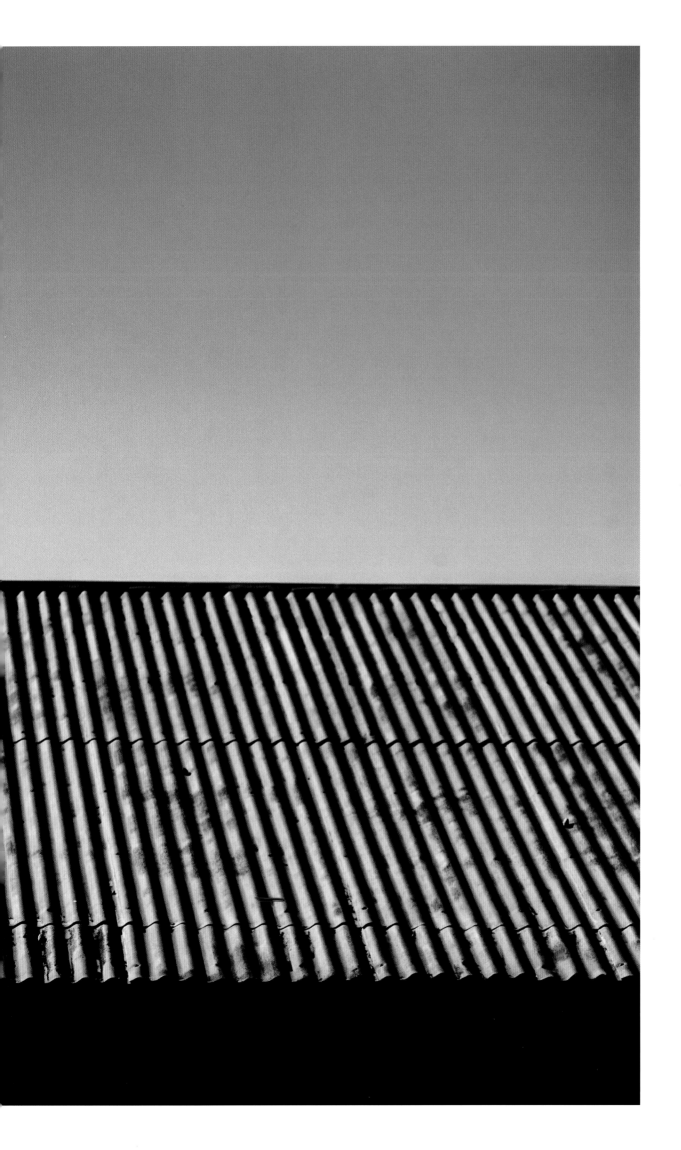

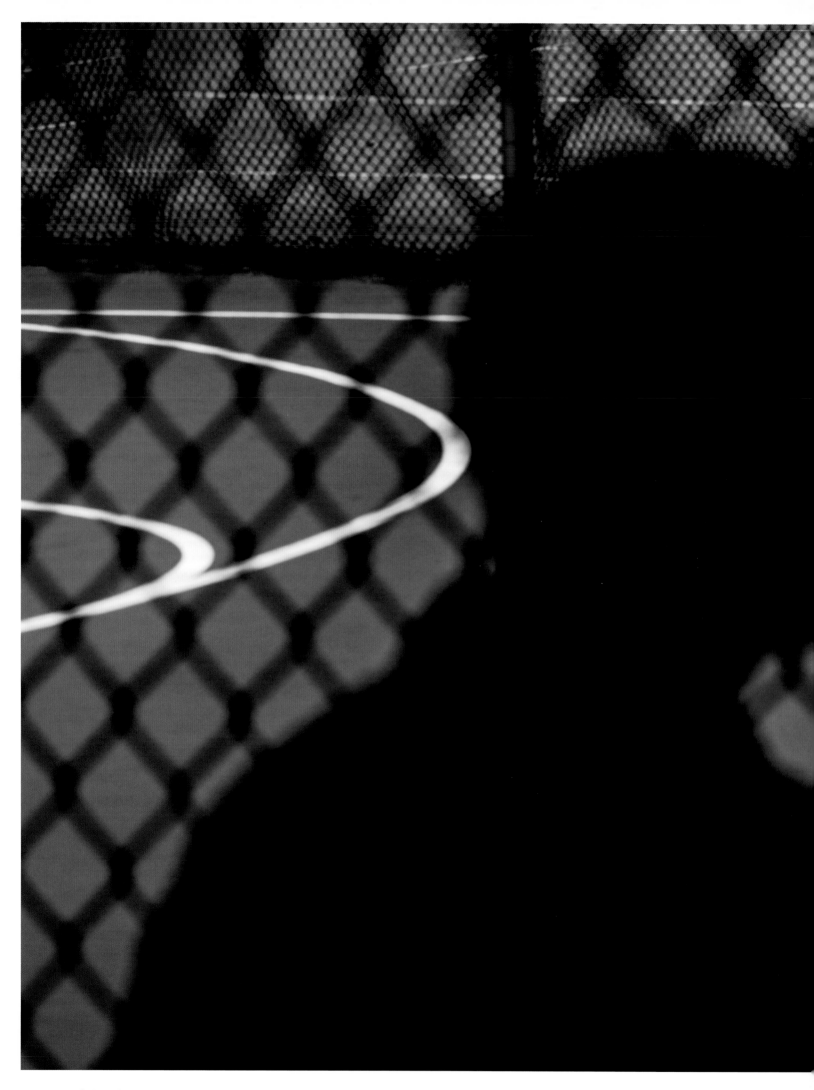

ABOVE West 4th Street Courts
"The Cage"
New York, New York

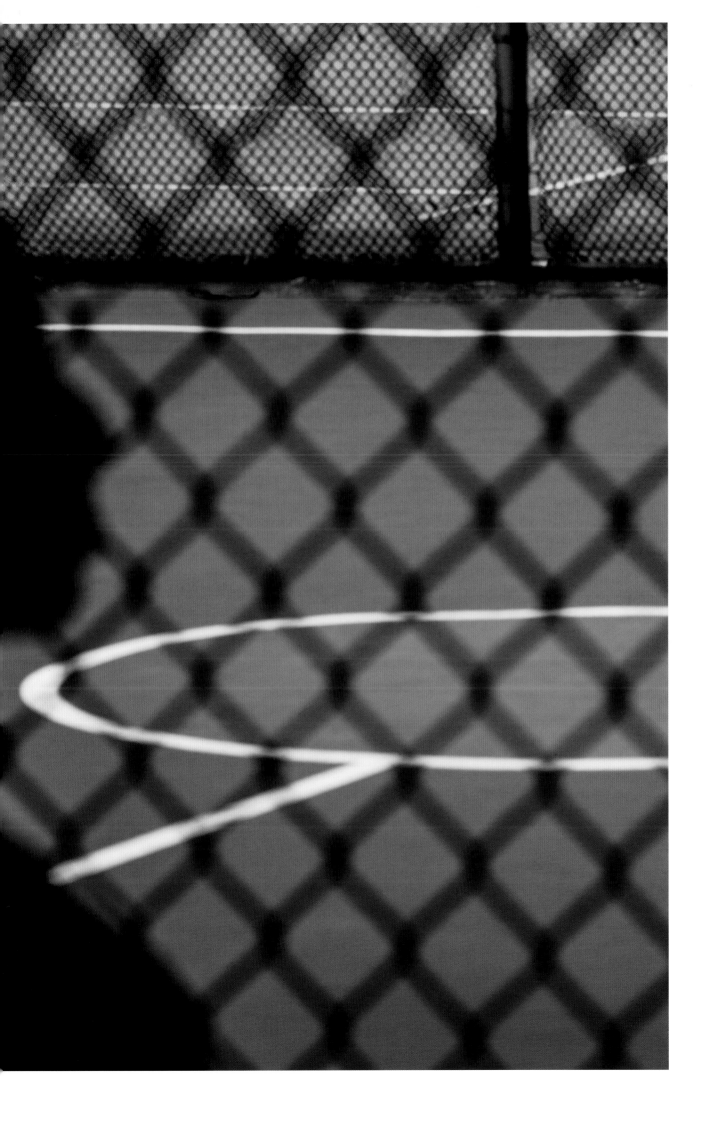

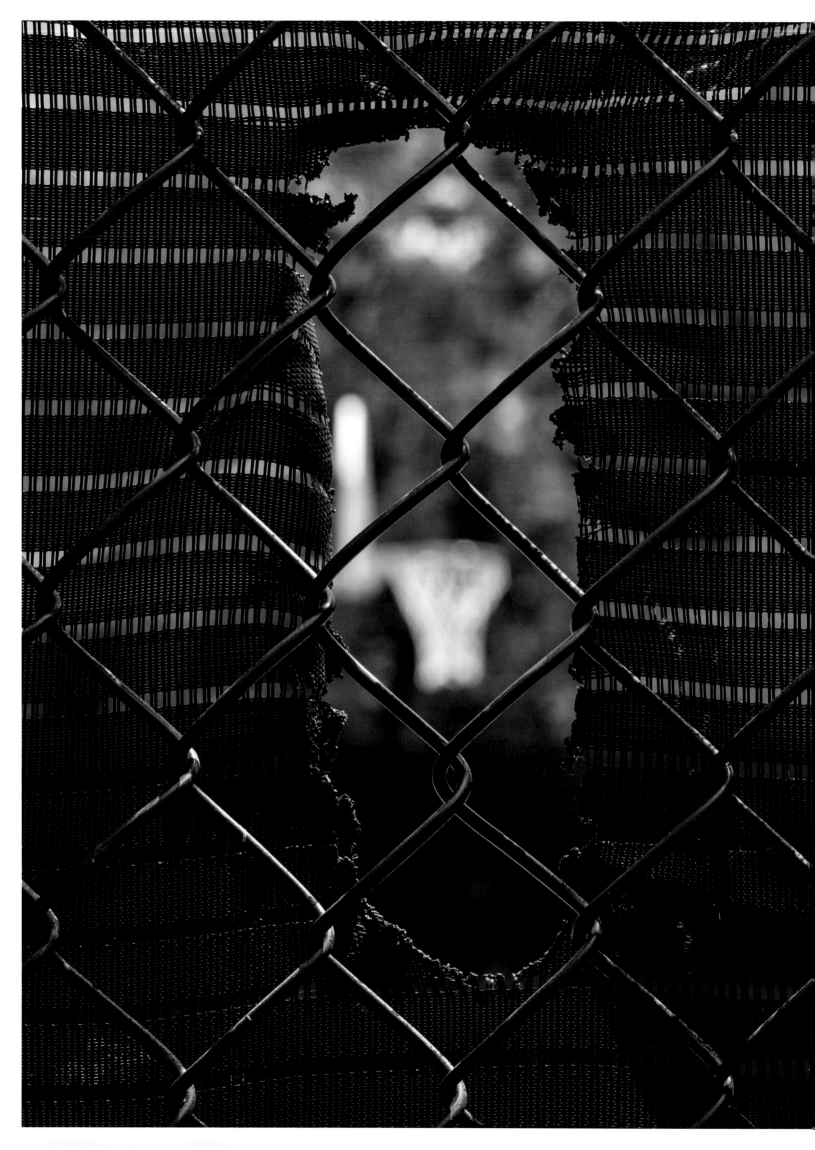

66 **Growing up with a hearing aid, a speech impediment, and glasses, the basketball was my safe haven. I may have been teased for being different, but on the court I became someone else. The game of basketball gave me confidence and respect, so I poured my heart out on the court."**

— *Tamika Catchings*

LEFT Childhood hoop of Tamika Catchings
James C. Mitchell Park, Deerfield, Illinois
NEXT SPREAD Riverside Park, New York, New York

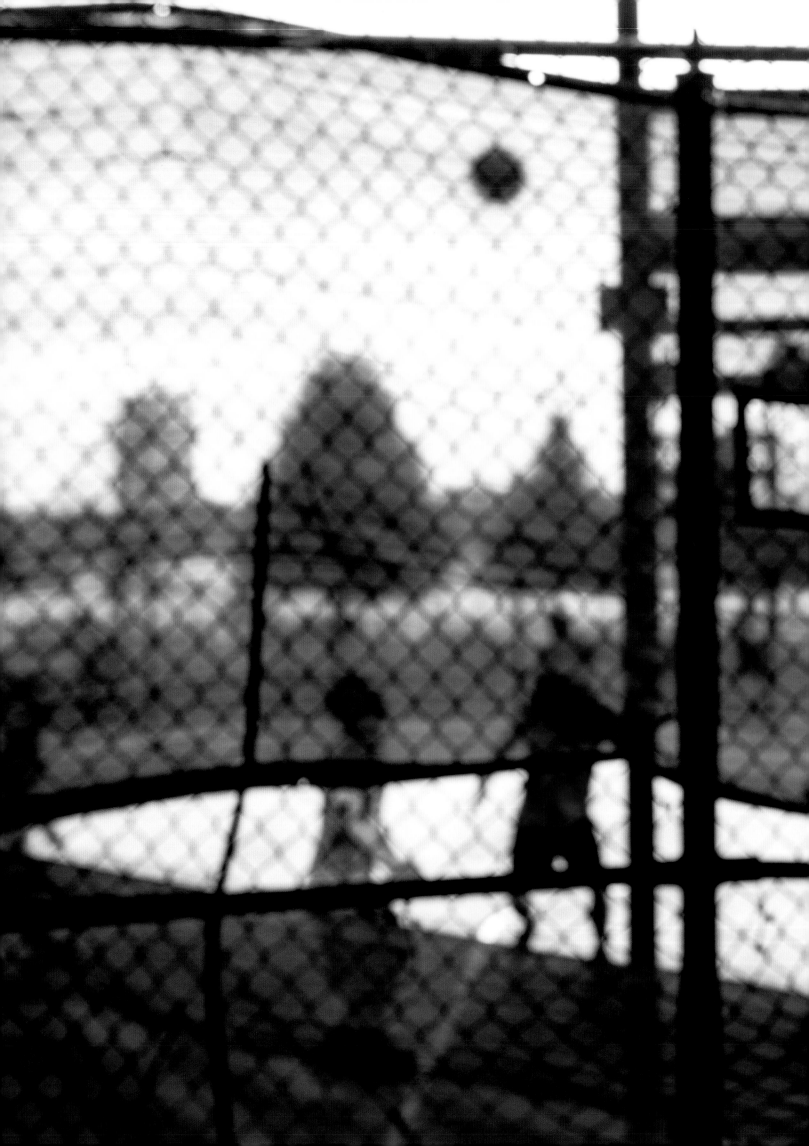

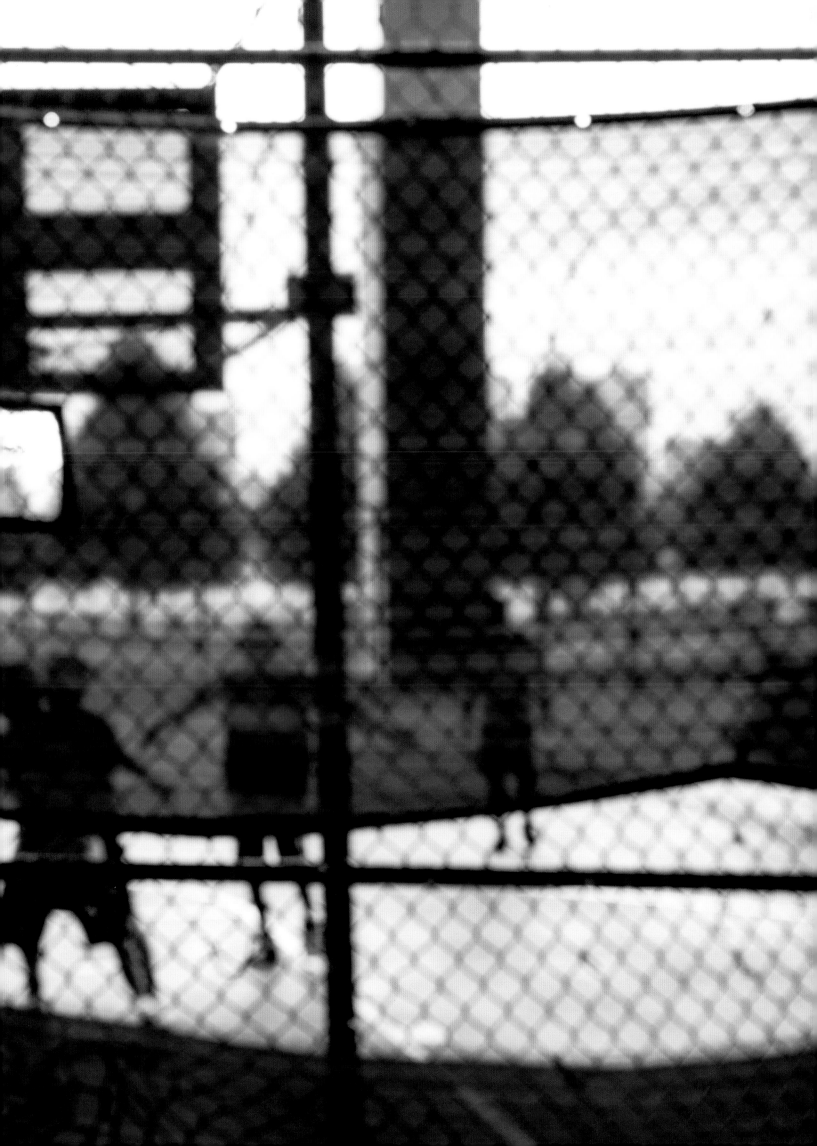

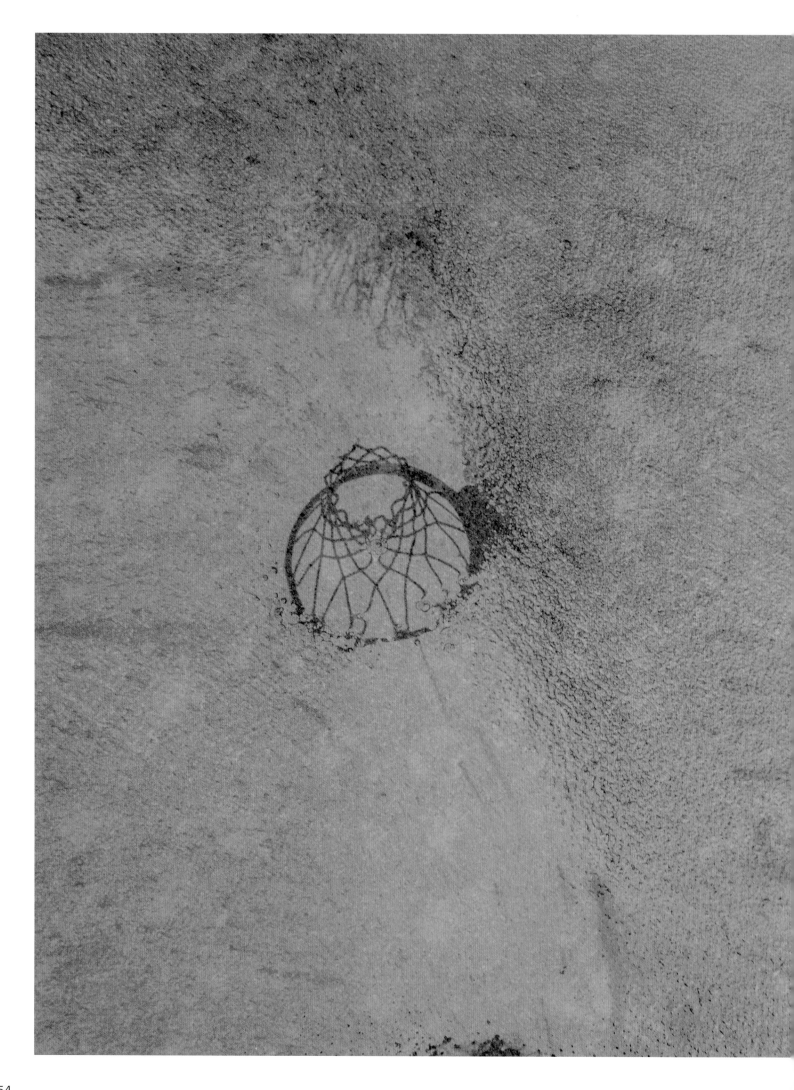

" At a young age, my father would take me with him to his recreation league games. During pregame warm-ups, halftime, timeouts, and after the game, I would run out on the court and shoot until play resumed. This was my first exposure to basketball.

I played other sports but I played my first organized basketball in the seventh grade. Basketball has opened so many doors for me. It paid for my college education, it allowed me to travel the world, and it has provided a secure life for me and my children.

Basketball prepares you for life. It teaches you how to handle disappointment, it teaches you how to be a team player, it teaches you discipline, it teaches you how to be successful, and it teaches you how to work with different personalities and cultures. Either through practice or through a game, you learn how to deal with every emotion: happy, sad, good, or bad."

— *Kim Mulkey*

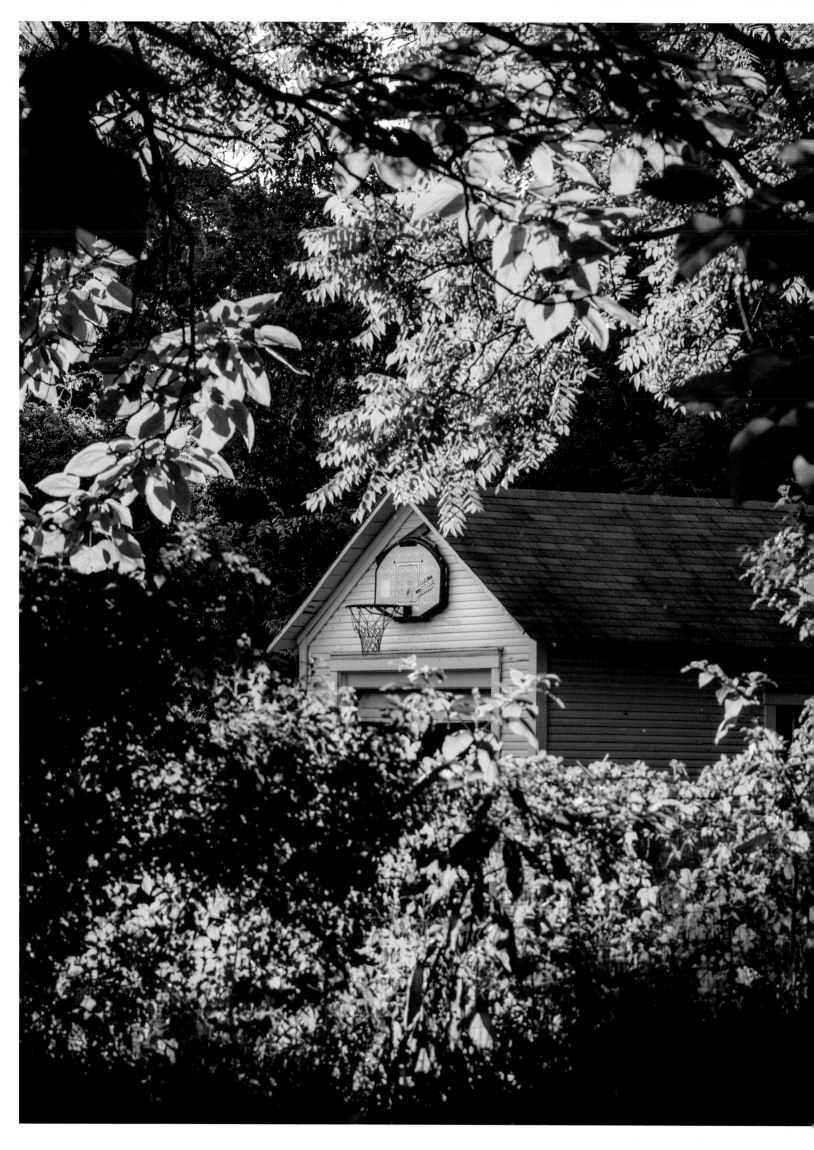

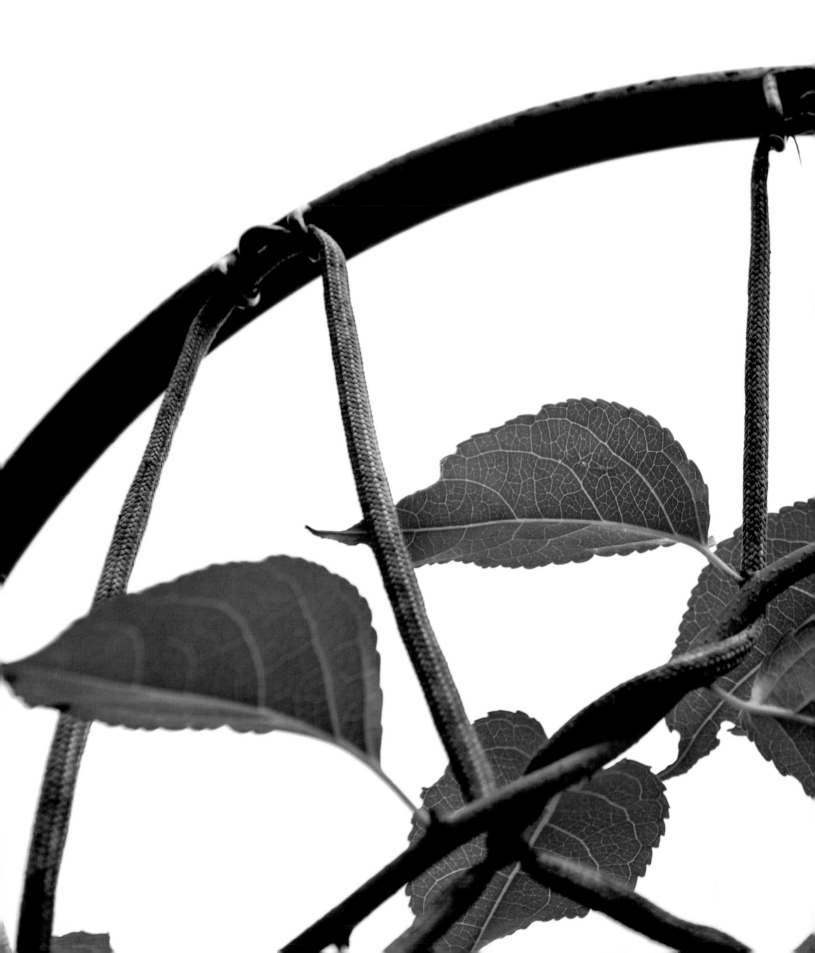

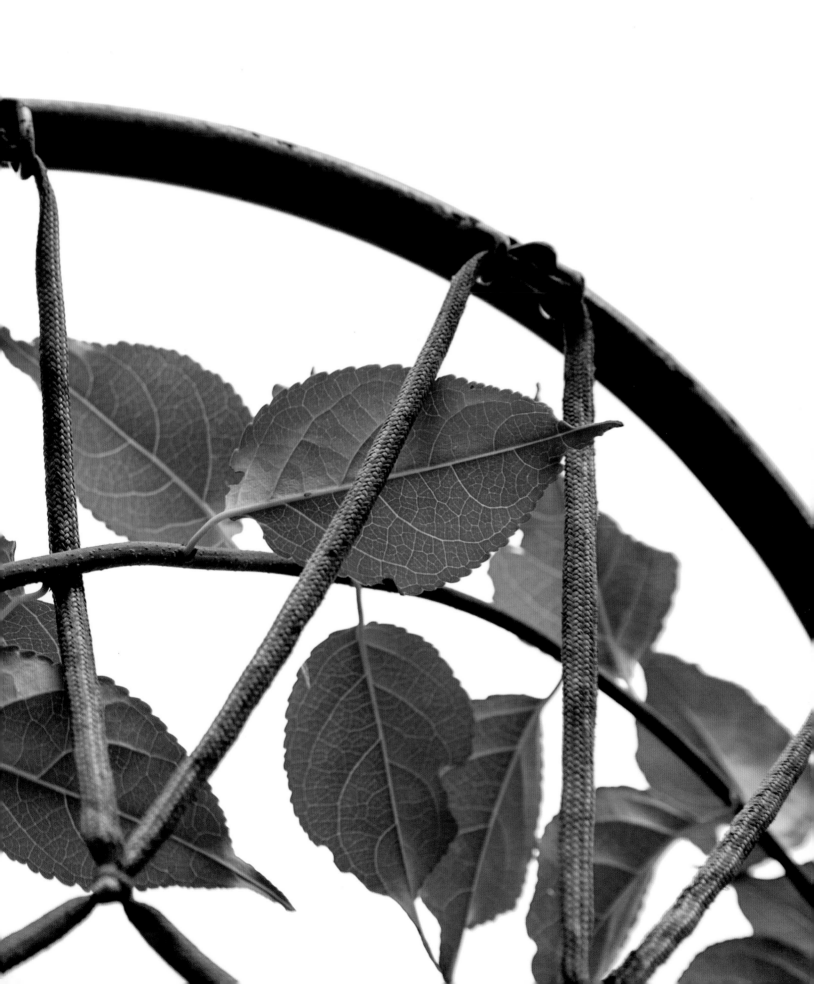

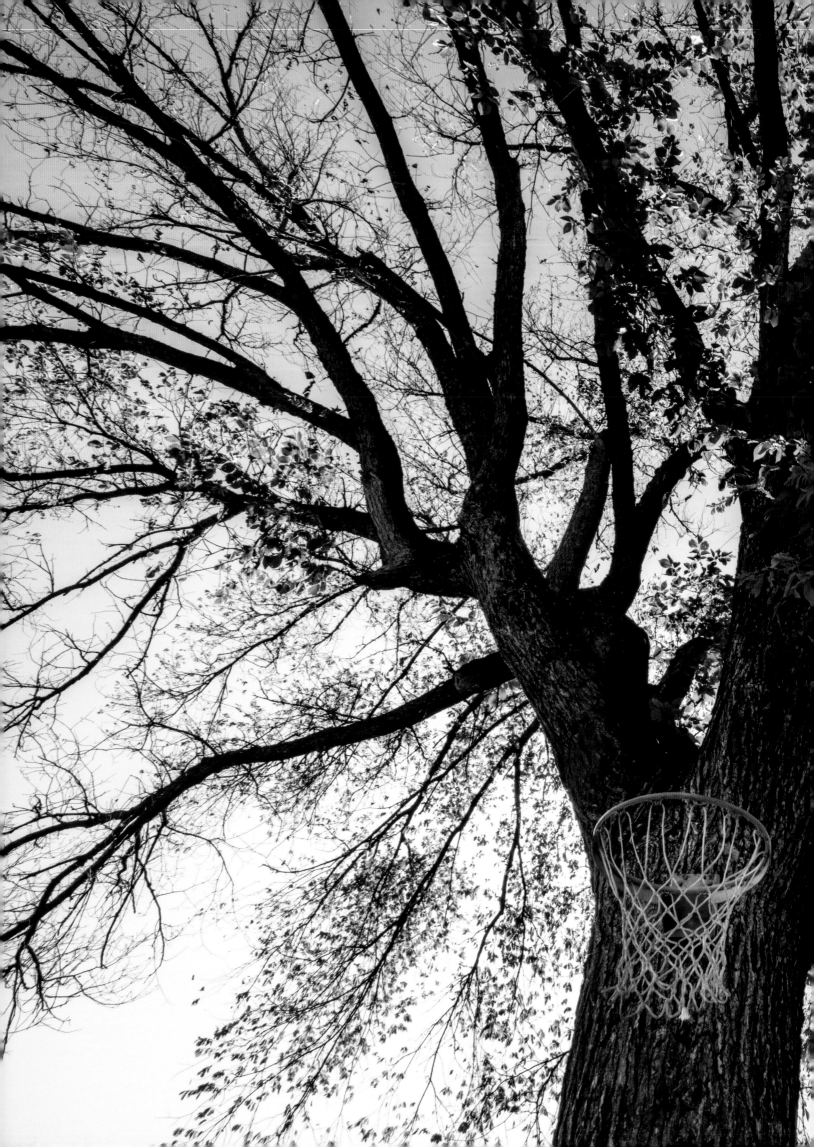

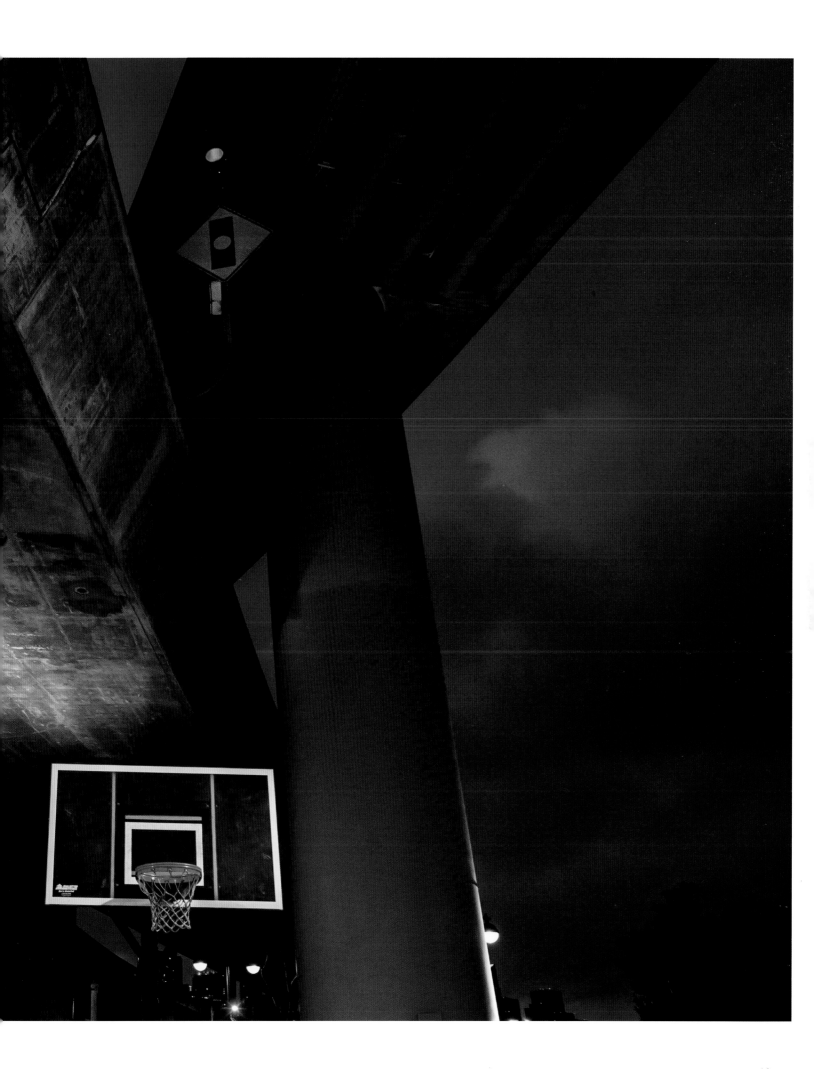

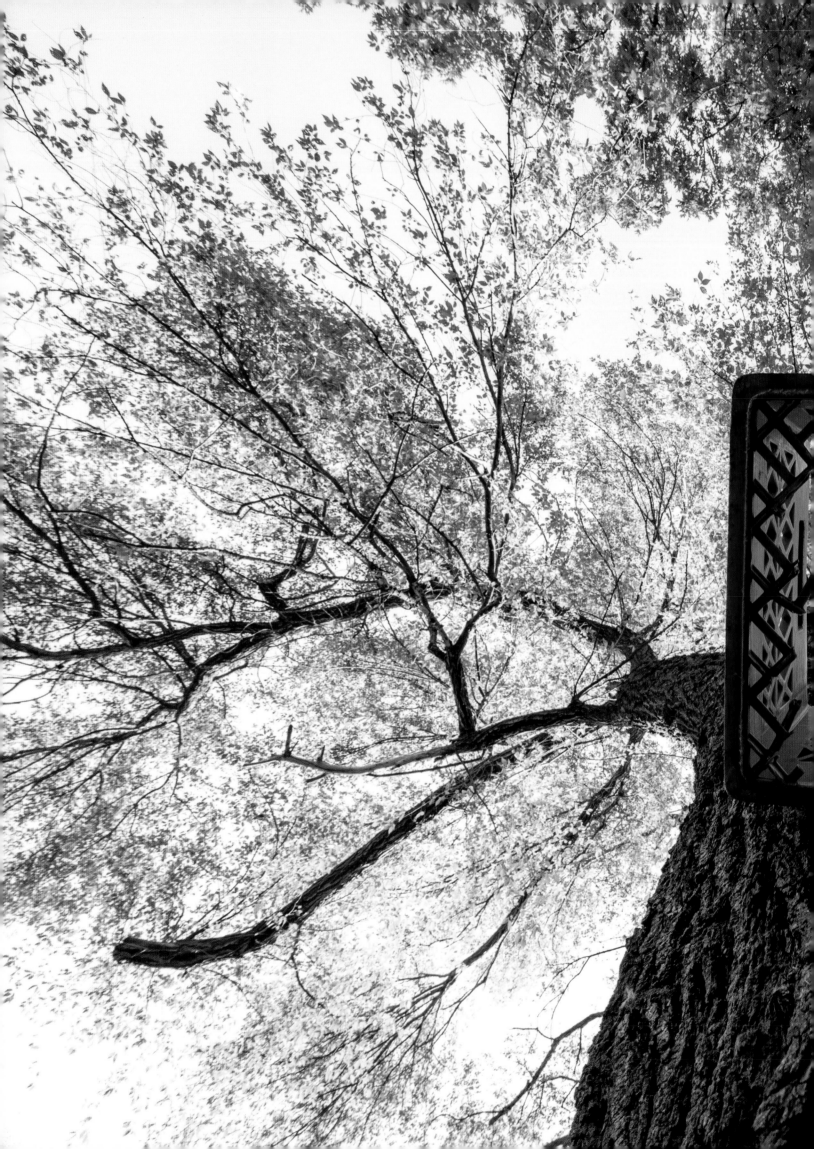

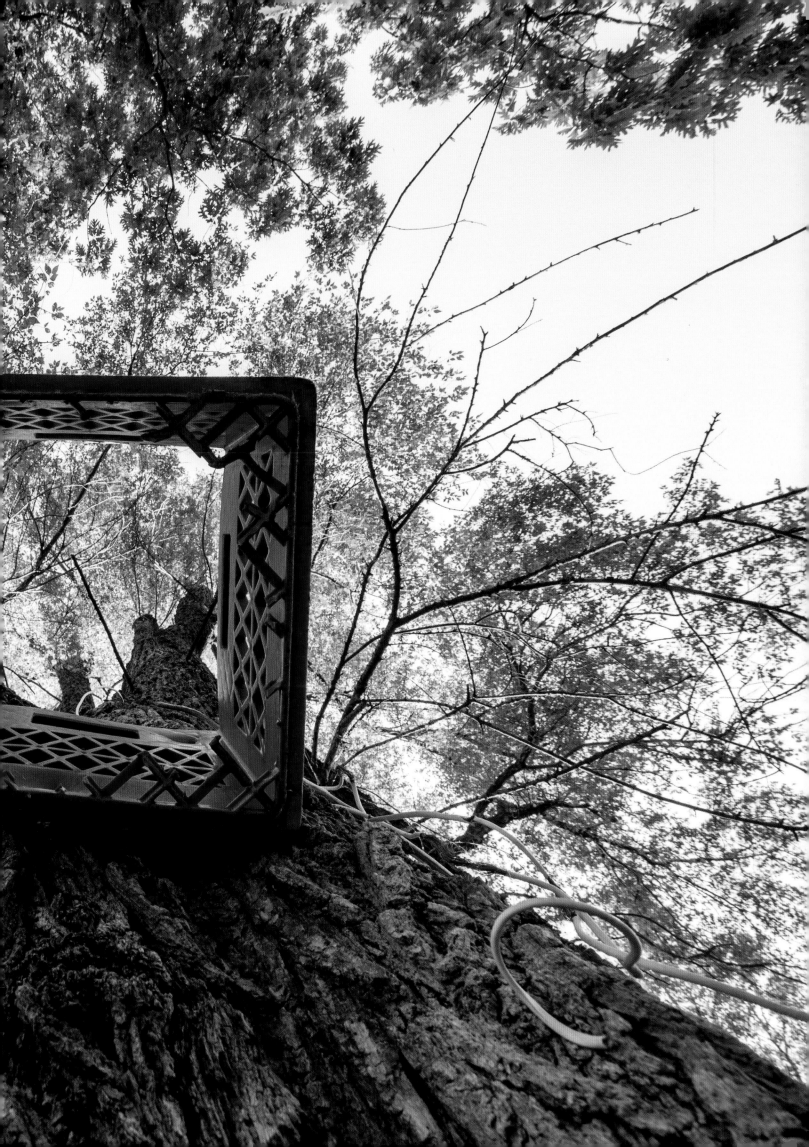

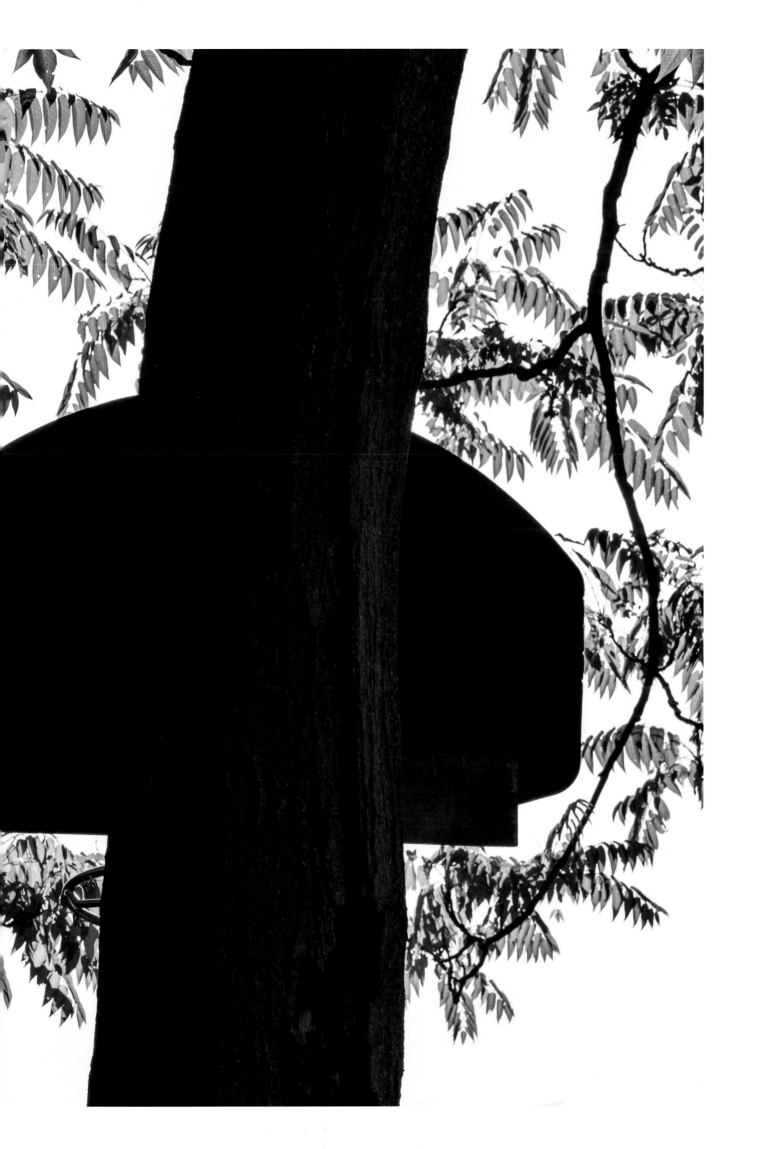

"I started playing basketball at 12 years old, which was pretty late compared to the other kids. I had to work harder at being a good listener, put in extra practice time, and play pickup almost everyday.

My middle school court was outside and I remember telling the coach. 'As long as I don't fall down, I'll play, but if I fall down on the concrete, that will be my last day of basketball.' It's a good thing that I didn't fall down. Our team went 7-0. I won my first trophy and fell in love with winning!"

— *Lisa Leslie*

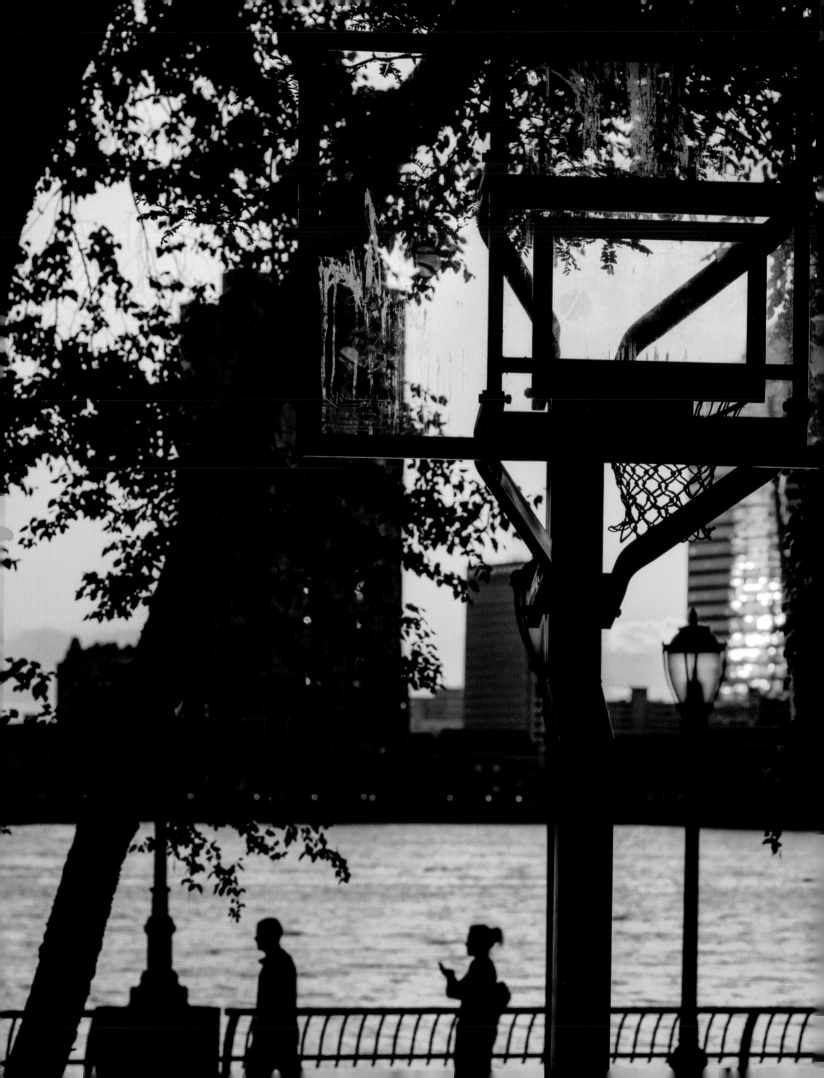

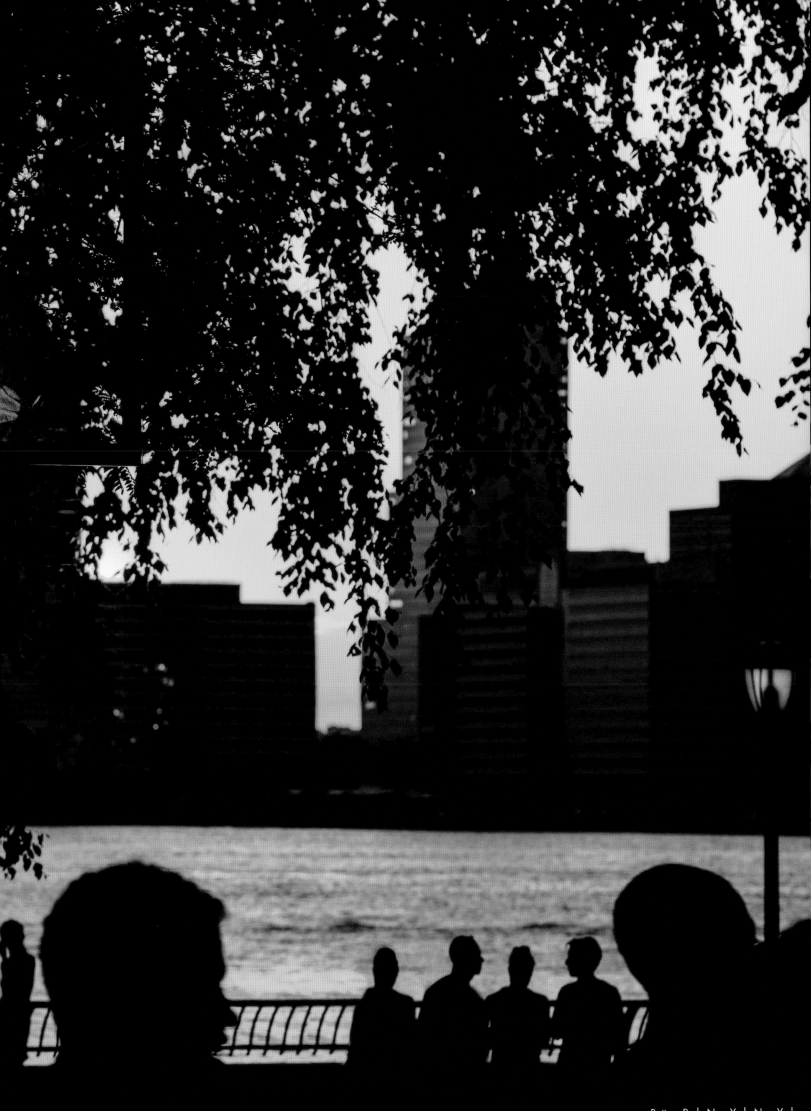

Battery Park, New York, New York

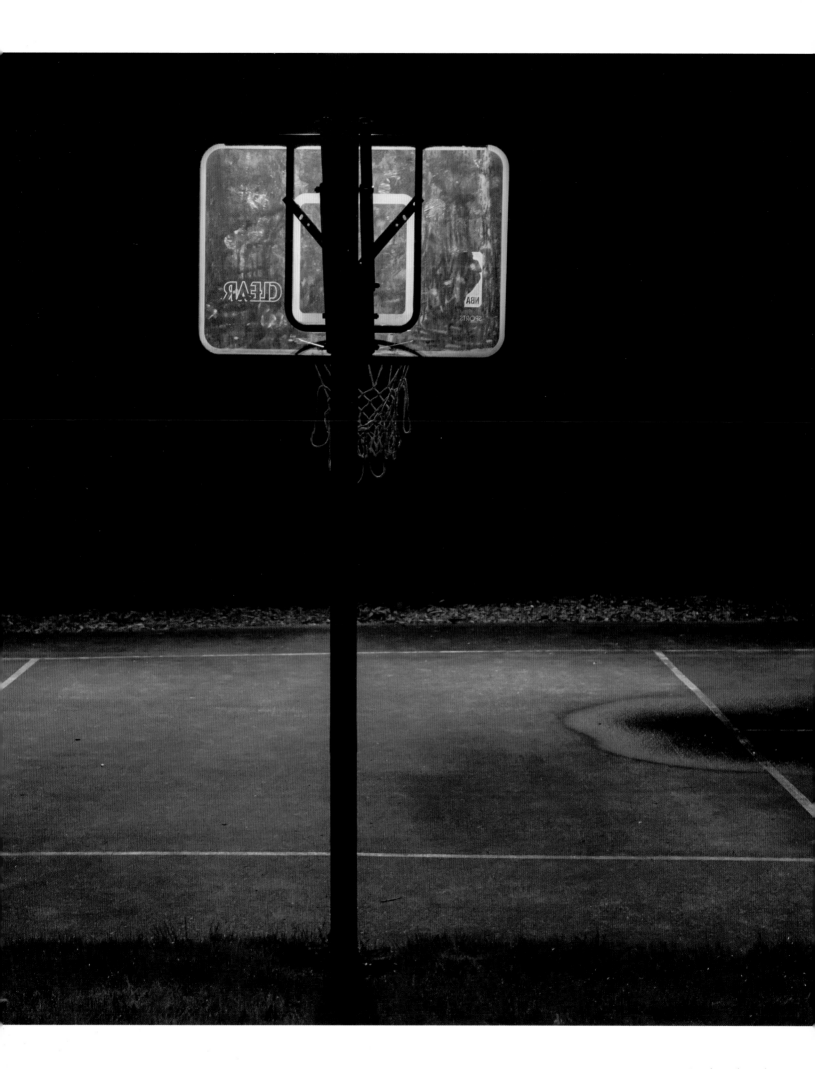

ABOVE North Bend, Washington
NEXT SPREAD Hillsboro, Kentucky

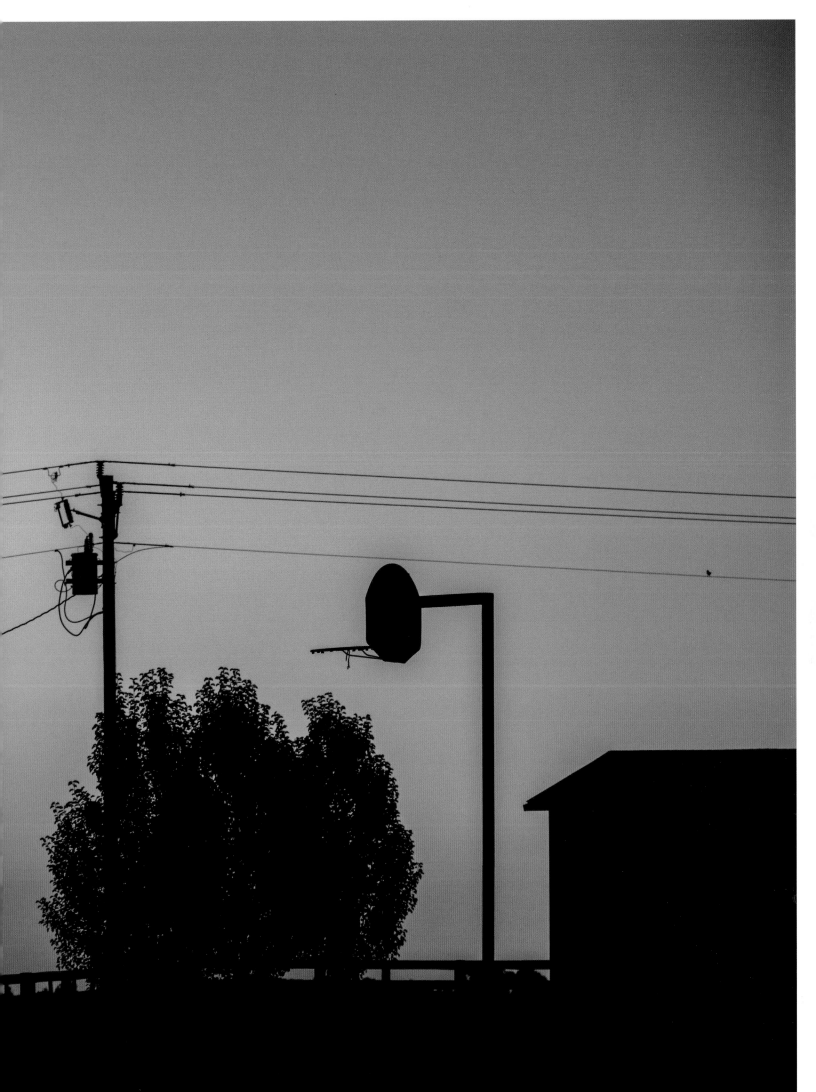

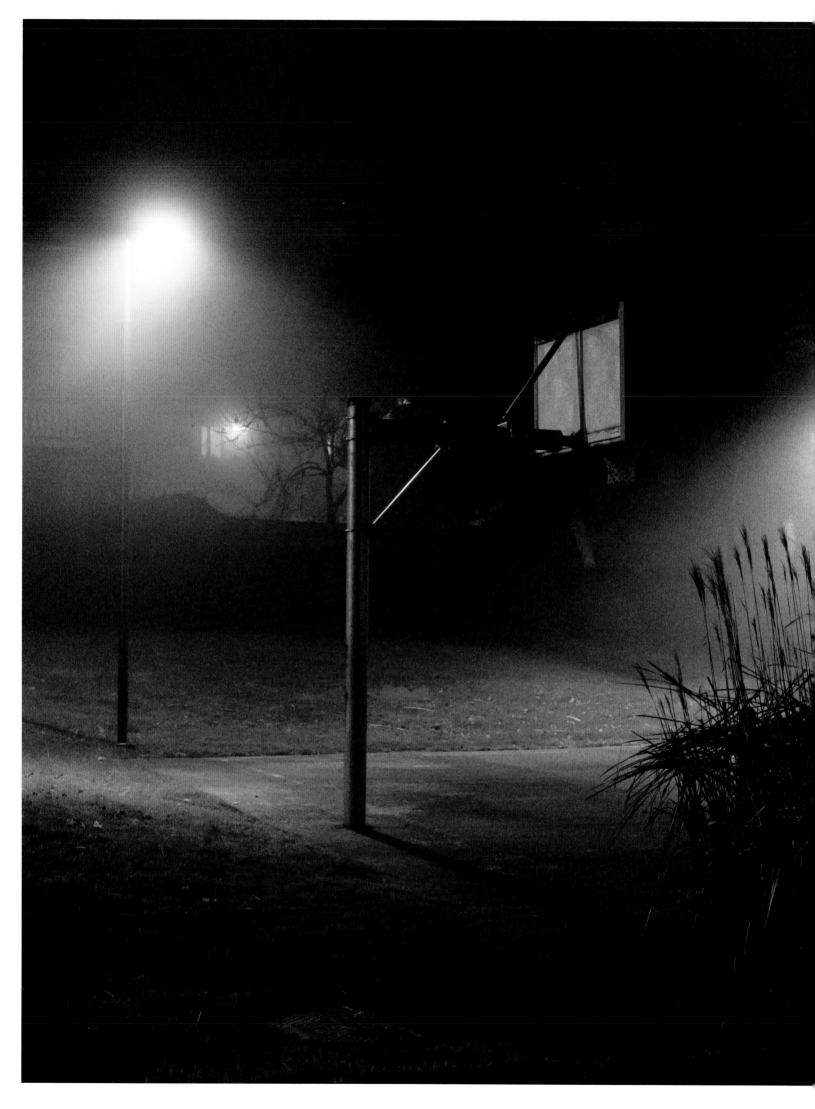

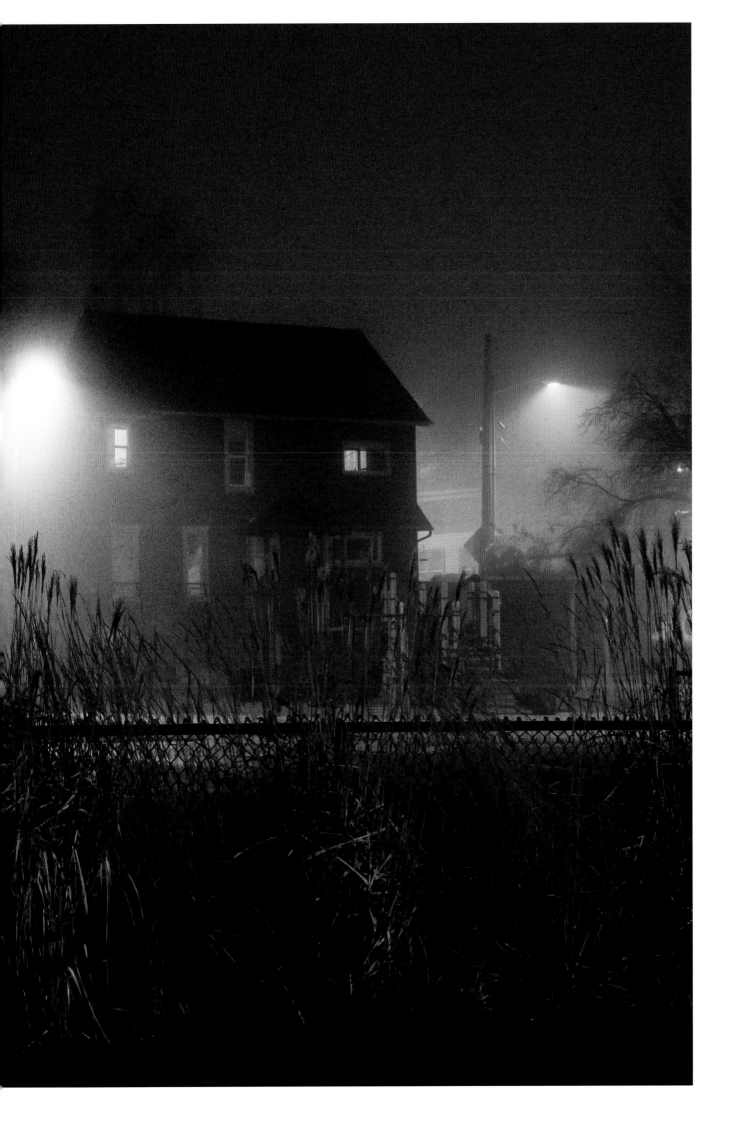

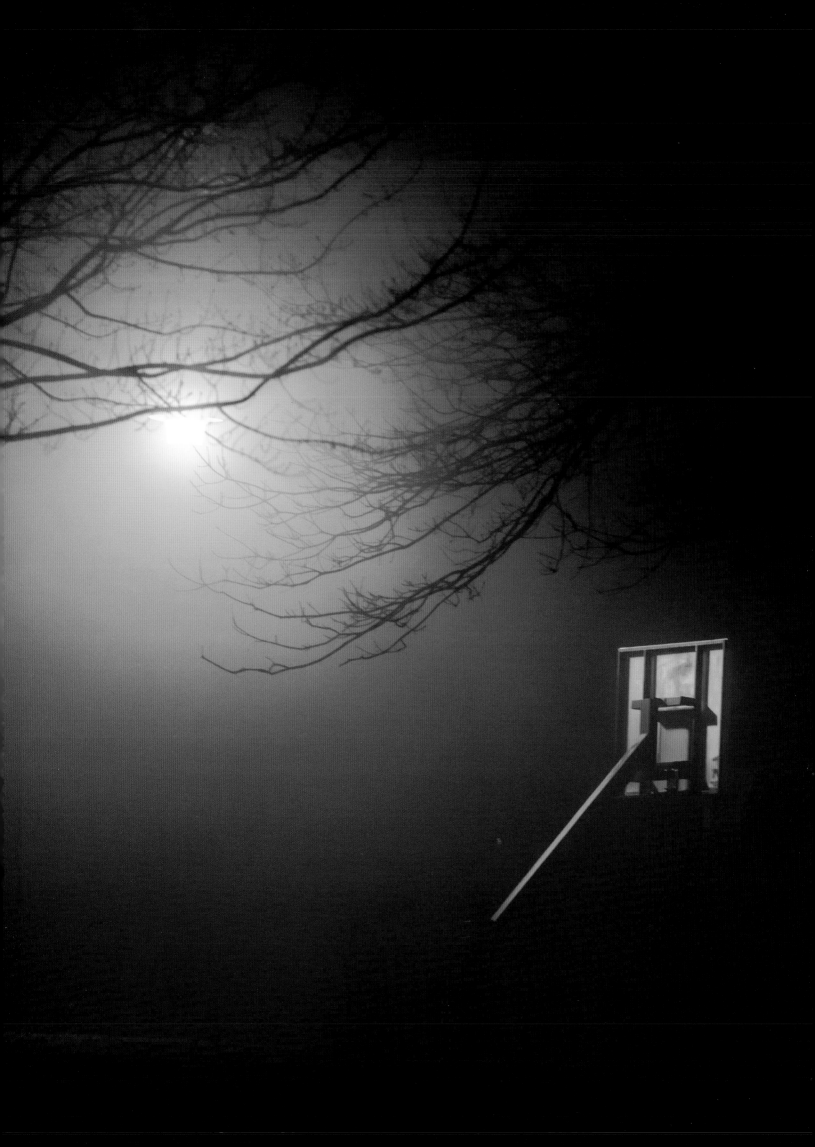

66 **In the public housing where I grew up, I was lucky enough that the outdoor courts had lights (which was rare). Where we lived, our apartment faced the basketball courts. My Mom left the curtains open so she could look out her window and see me playing. I could stay out late at night shooting, working on my game whether it was cold or raining, playing imaginary games with myself under the lights.**

Basketball is a round ball that's taken me around the globe. It's let me experience life through sports and to follow and achieve a lot of my dreams. It's afforded me the opportunity to have so many experiences that I would have never had if I had not picked up a ball. The best decision I made was to use the game of basketball to show me the world in a different way. I hope that through the things I do with a basketball that I'm able to provide that opportunity for another child some day."

— *Swin Cash*

" There is a park a block away from the house I grew up in and if my parents couldn't find me, they always knew to look there first. In a sense, it's where I first started my basketball career and the memories I have from this place will last forever. To this day, when I pass by, it all comes rushing back. It wasn't the most glamorous basketball court, and most days I was lucky if the rim had a net. But it was mine and it was perfect."

— Sue Bird

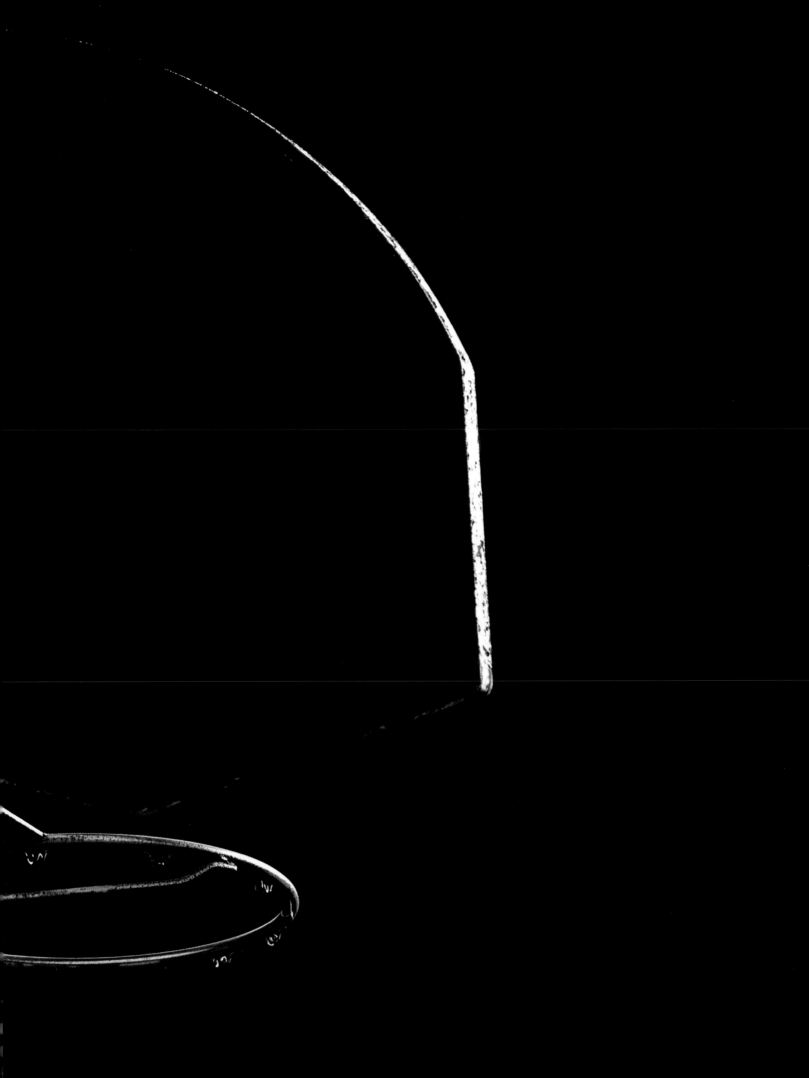

Childhood hoop of Sue Bird
Syosset, New York

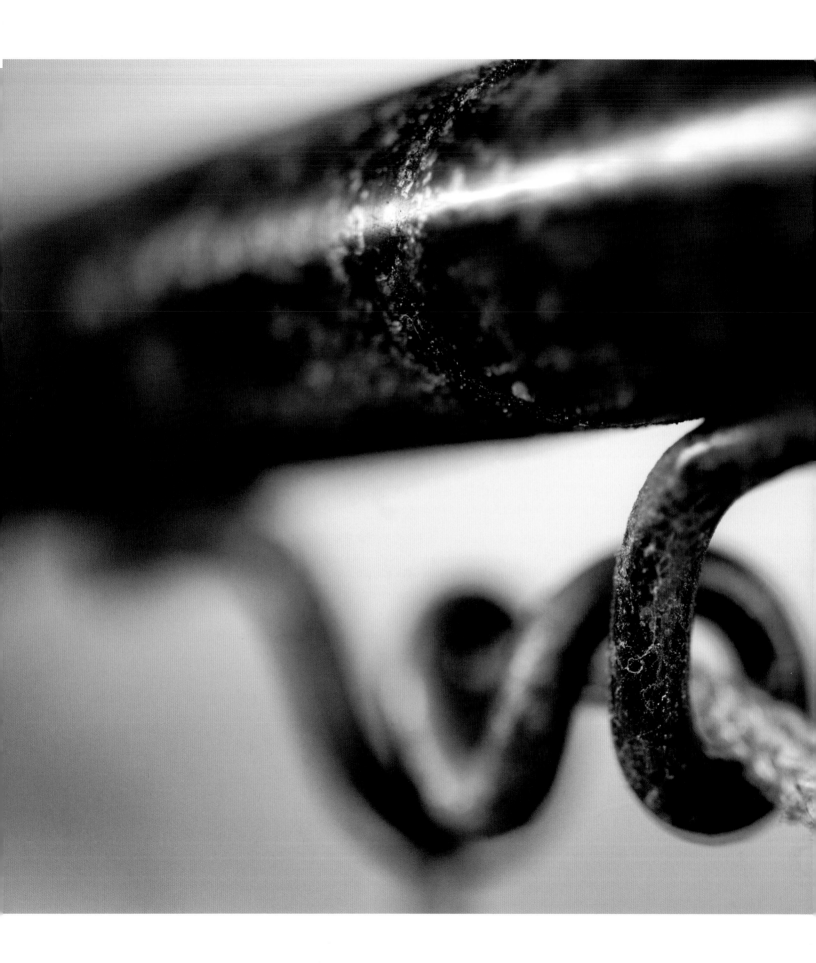

" I didn't really know about the game of basketball when I first picked it up. It was just love at first sight.

When I was eight years old, I used to play at the [Seat Pleasant] rec center. Coach Craig, 'Chucky' as we called him, told me one day that he thought I could be pretty good if I practiced and worked hard. He would tell me, 'You're the best player on the floor.' He gave me confidence when I didn't have confidence in myself. I loved going out there and learning and having fun with my friends.

He is the reason I began my journey to the NBA. We would watch the NBA draft together. He would say to me, 'I can't wait until we go and they call your name.' Since I was so young, I never believed him. But he always told me I would be there one day. He believed in me when I didn't believe in myself.

When I was a junior in high school, I received devastating news. Chucky was shot in the back while breaking up a street fight. He was at the wrong place at the wrong time. I was devastated. I couldn't believe he wasn't going to be around anymore. I didn't think anything could ever happen to him, because I thought he was Superman.

I wanted to do something nice for him, but I didn't know what to do. My godfather suggested to me to wear the number 35, because that's how old Chucky was when he died.

I'd give anything to have him sitting courtside at one of my games today, that would be a dream. Because he dreamed it all."

— *Kevin Durant*

66 **I feel like basketball has
contributed much more to my
life than I have contributed to it.
It taught me intangibles about
leadership, goal setting, and
dreams."**

— *Robin Roberts*

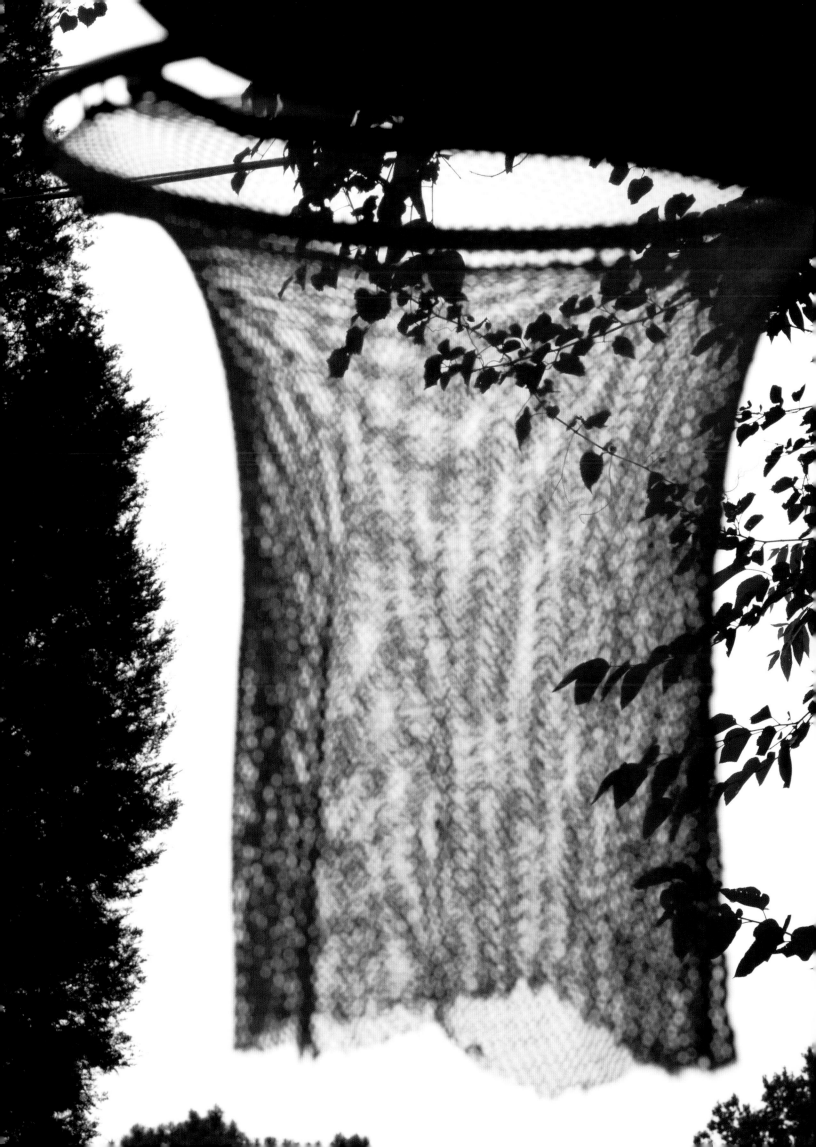

" Basketball has been the center of my life since I was a little kid. It always will be. Growing up in Akron, it was always the place where I could just be me. When I was on the court, nothing else in the world mattered. I always believed that one day I would play in the NBA and follow in the footsteps of the basketball greats I grew up watching. That was my inspiration and it drives me to this day. If you want it to be, basketball is so much more than a game. It is a mentor, a teacher, and a brotherhood."

— LeBron James

RIGHT Childhood hoop of LeBron James
Perkins Woods Pool
Akron, Ohio

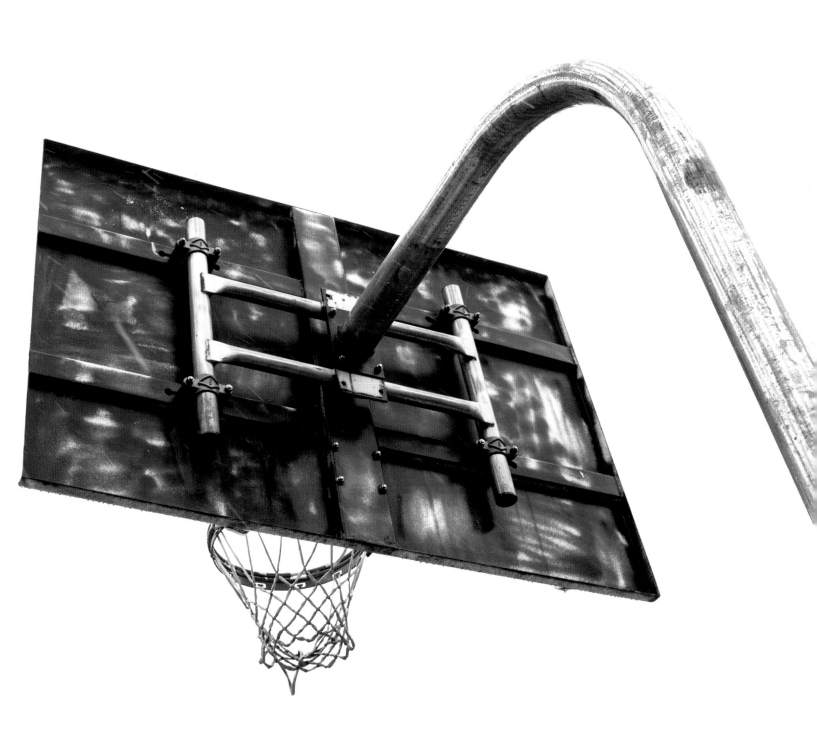

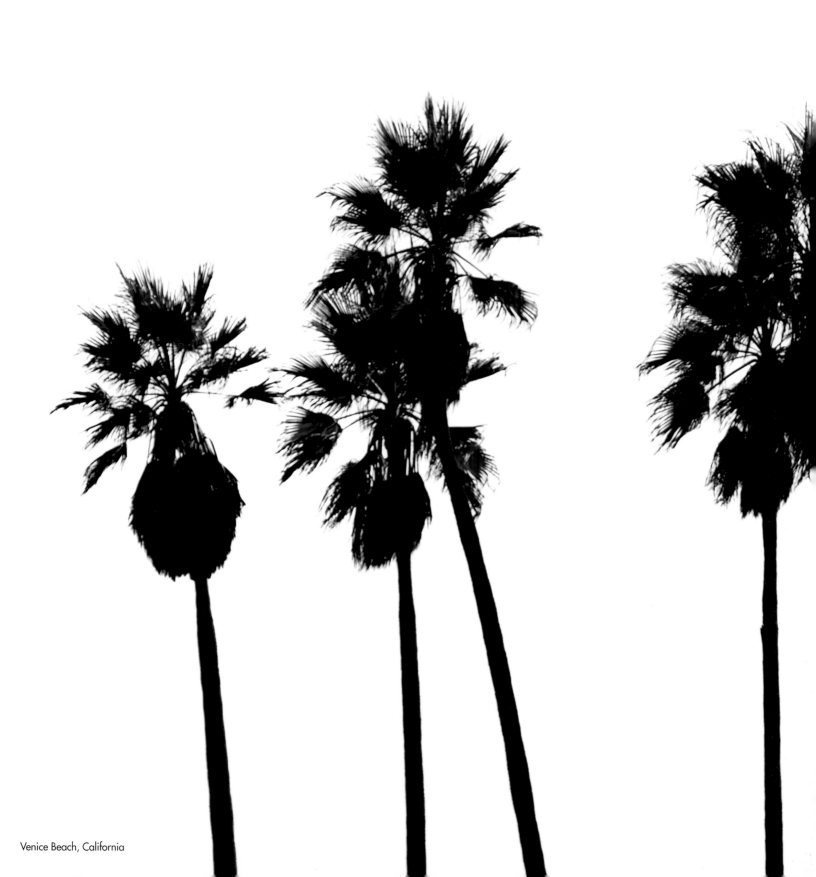

Venice Beach, California

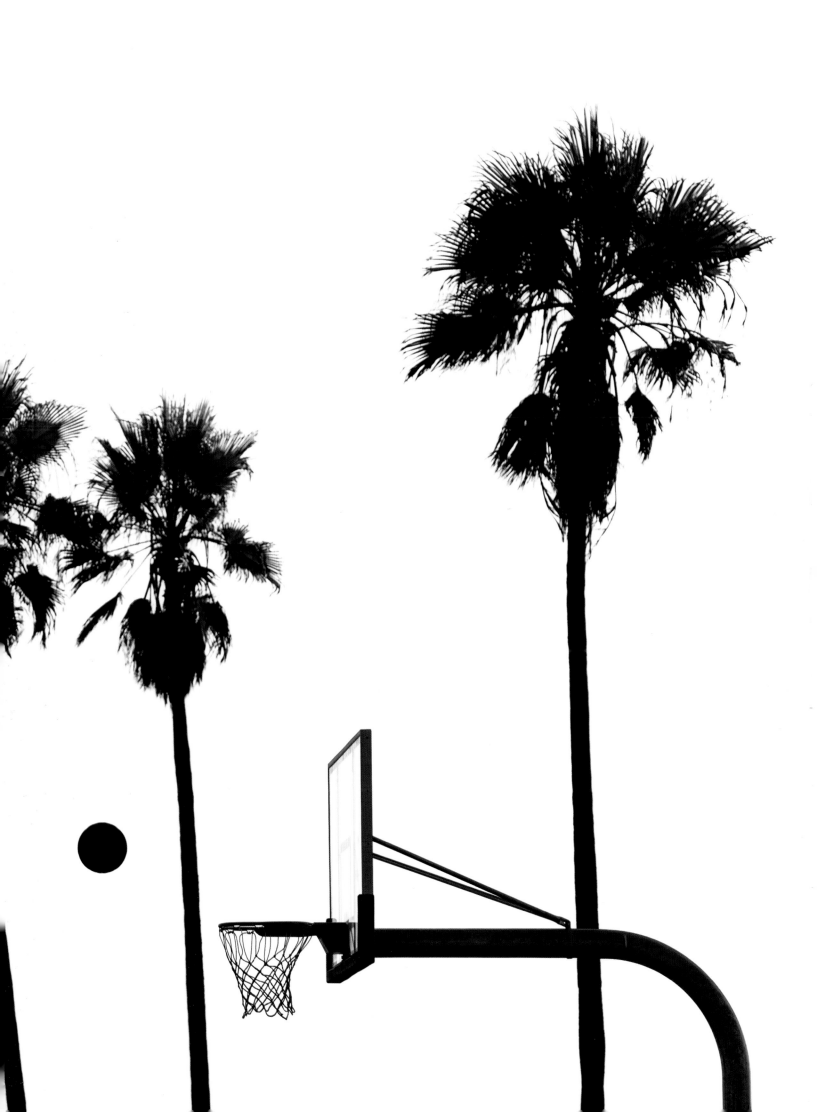

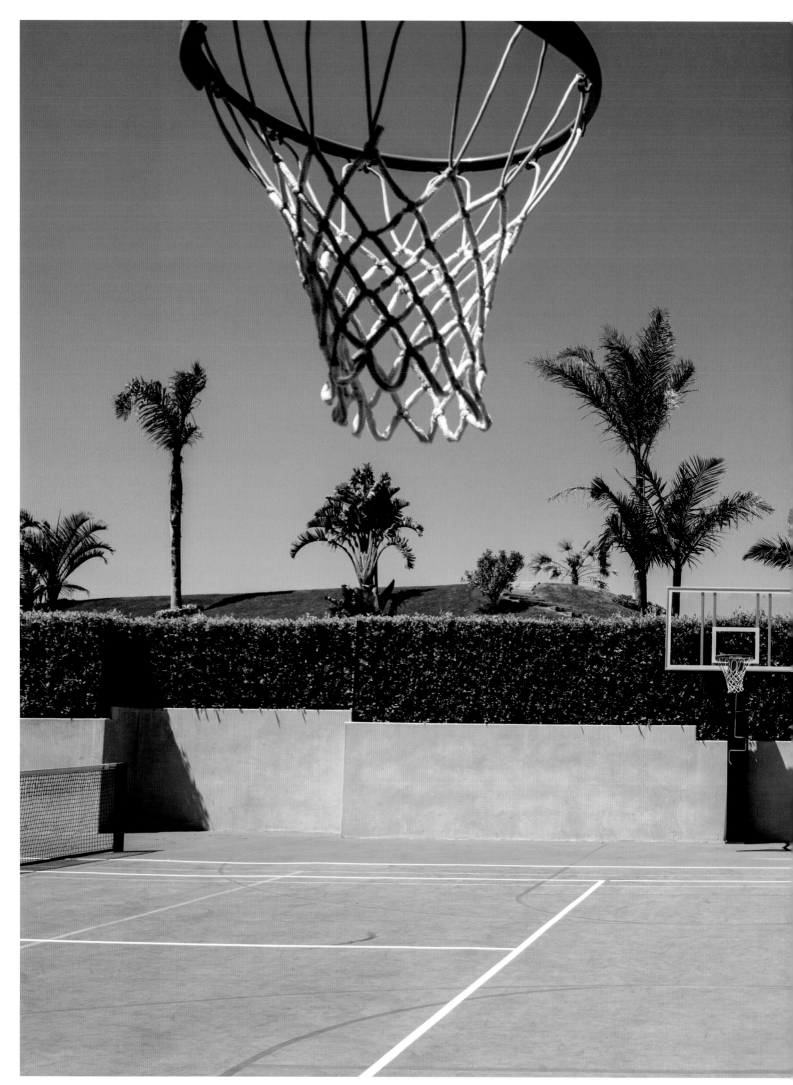

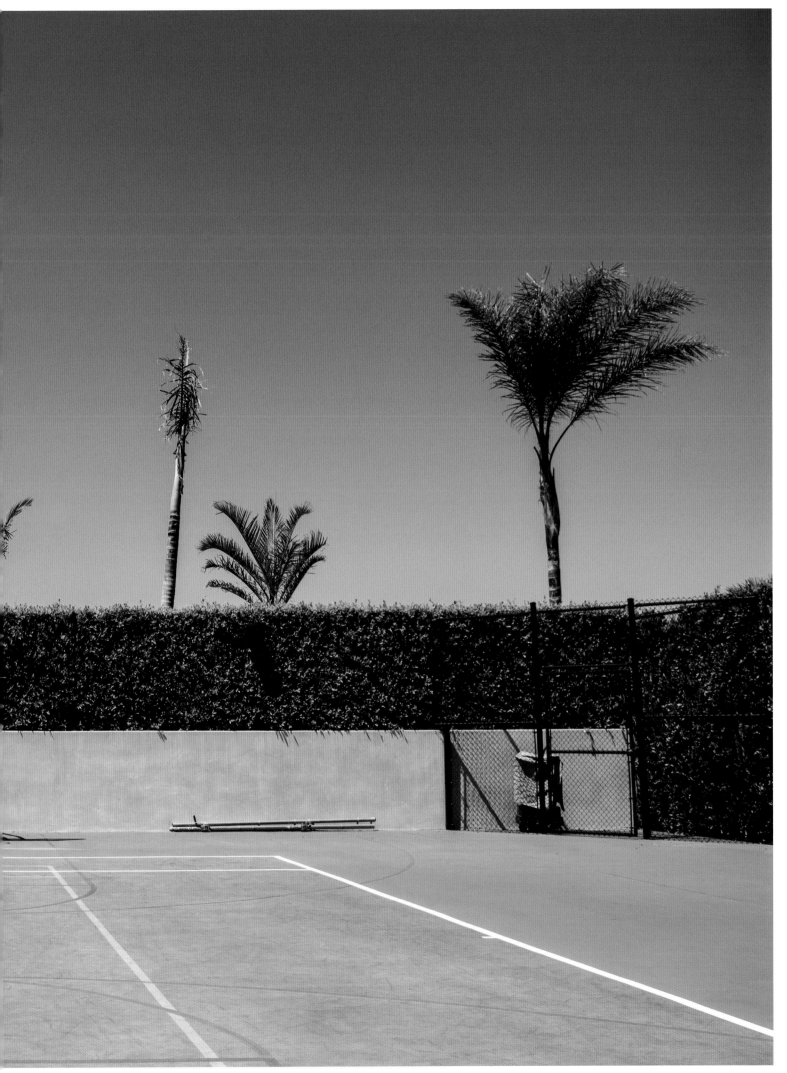

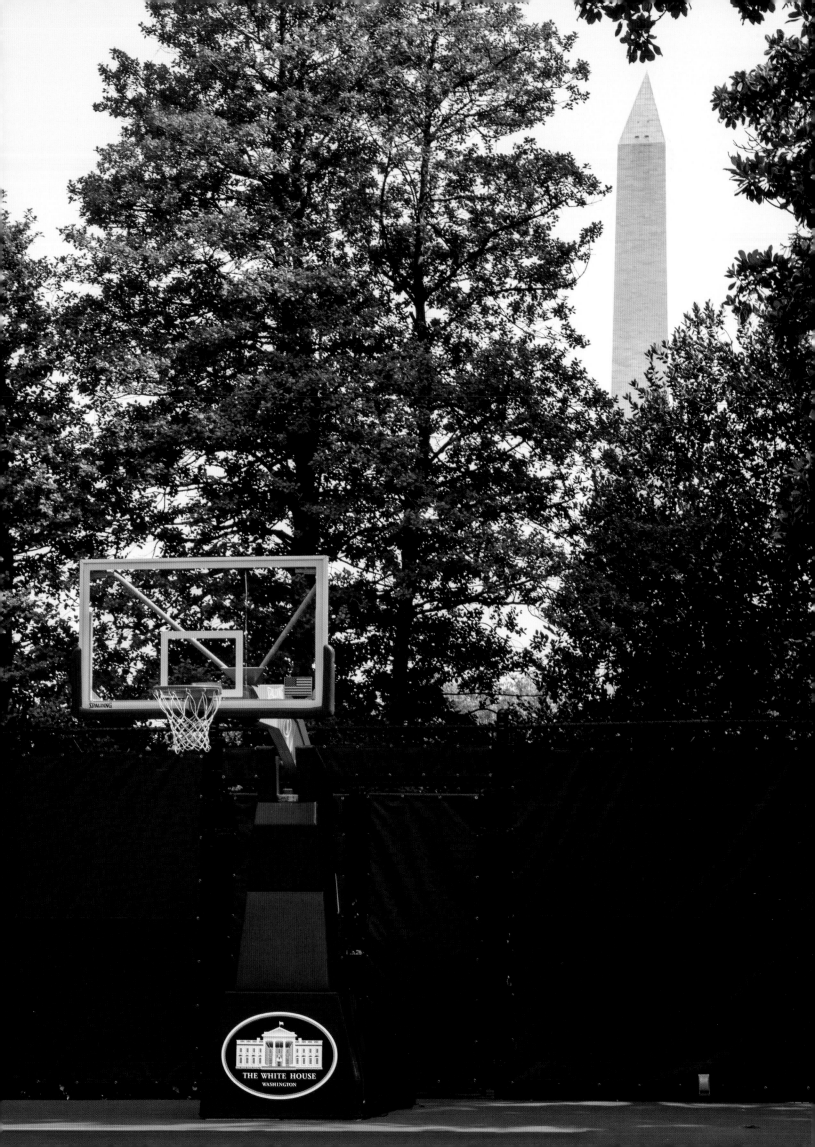

" I couldn't have been more than six or seven years old. The first hoop I had in my backyard was when we moved from a two-family house to a single-family home. It wasn't a regular basketball hoop. It was actually a peach basket, with no bottom, that my dad had nailed to a tree. A fairly skinny tree at that. The tree served as a backboard.

Within a year though, he got me a really nice hoop from an old garden center where my grandfather worked. It was the talk of the neighborhood when he put it up because it had a half-moon-shaped backboard with a thick rim and a nice thick net.

It was considered platinum level for a backyard hoop. The hoop had been discarded by a recreation center somewhere in Cleveland. My grandfather got it and my dad anchored it to the garage, and it was the neighborhood gathering spot from the age of nine until high school.

Anytime I got into trouble or did something that didn't please my mom and dad, they didn't have to spank me. All they had to do is say 'basketball is off limits for a while' and I would straighten up and fly right immediately. That's how much of a hold basketball had on me.

I owe everything in my life to the game, quite honestly; the fact that I was able to use basketball as a way to get a college education, to use it as a way to earn a living as a player for a short time in the early 80s. Over the last 25 years, being a broadcaster has taught me even more about the game. The coaches that I've had, teammates that I've played with, the experiences I've had in the game have really been transferable in so many ways. It's a huge part of the fabric of who I am.

If you have some ability in something and you do it well, and you're recognized and esteemed for it, it fuels confidence in other areas and that can be transferable."

— *Clark Kellogg*

LEFT The White House basketball hoop, Washington, D.C.

93

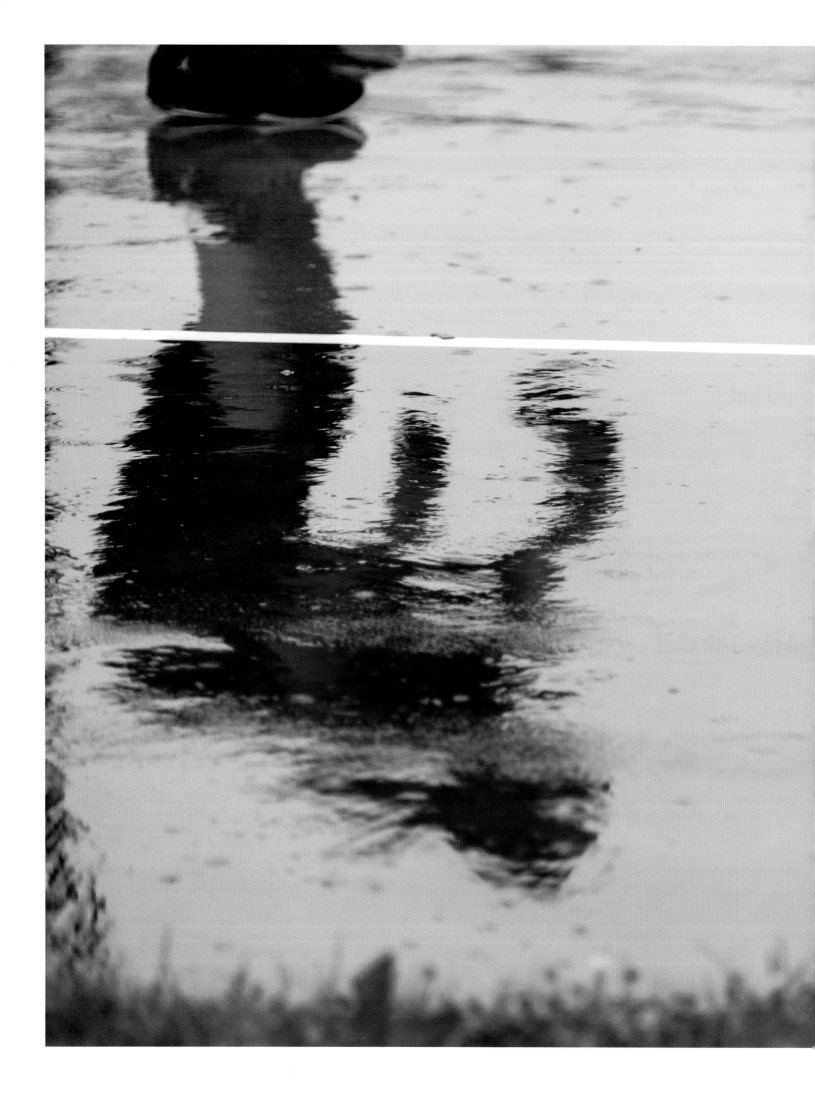

ABOVE Perkins Woods Pool, Akron, Ohio

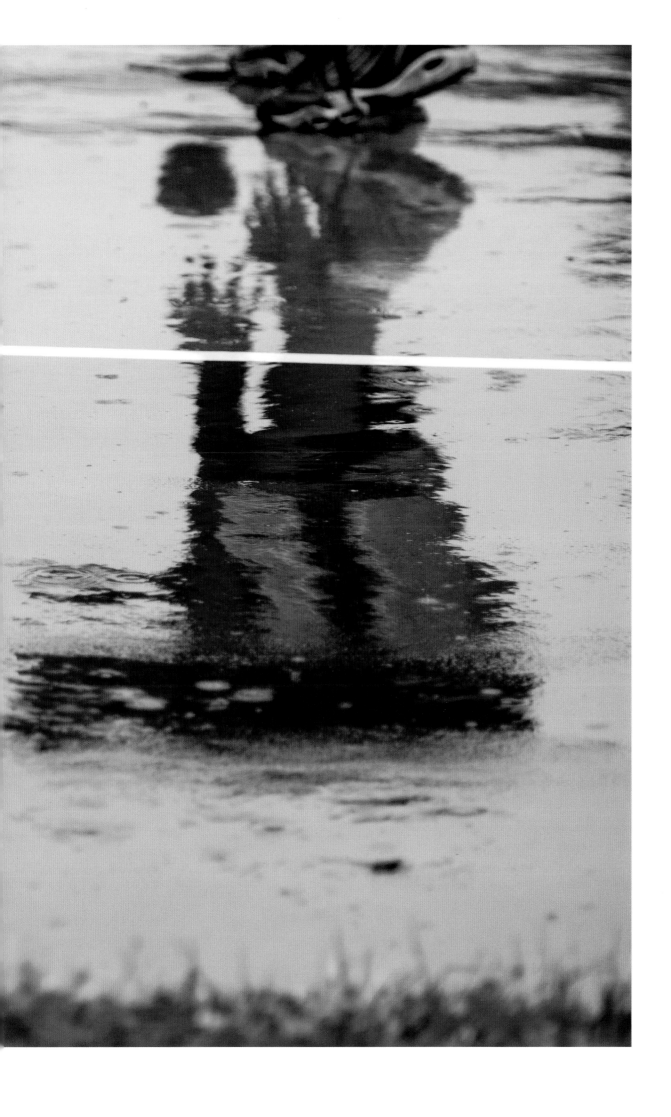

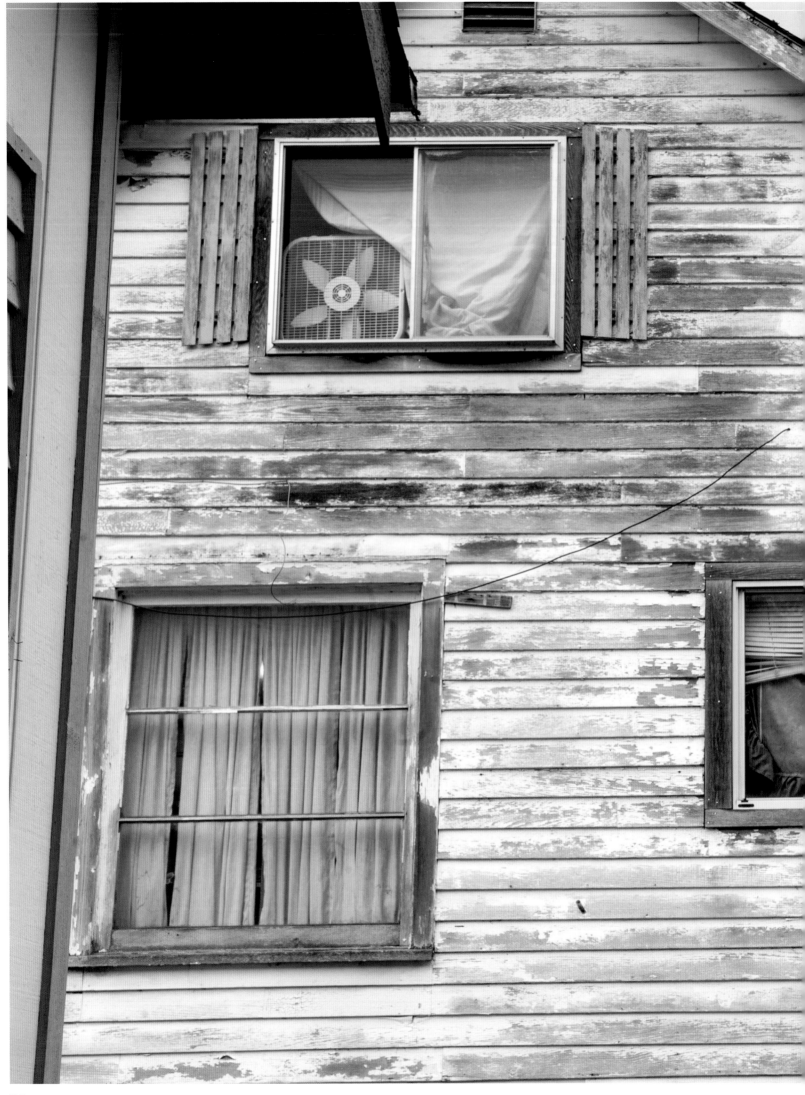

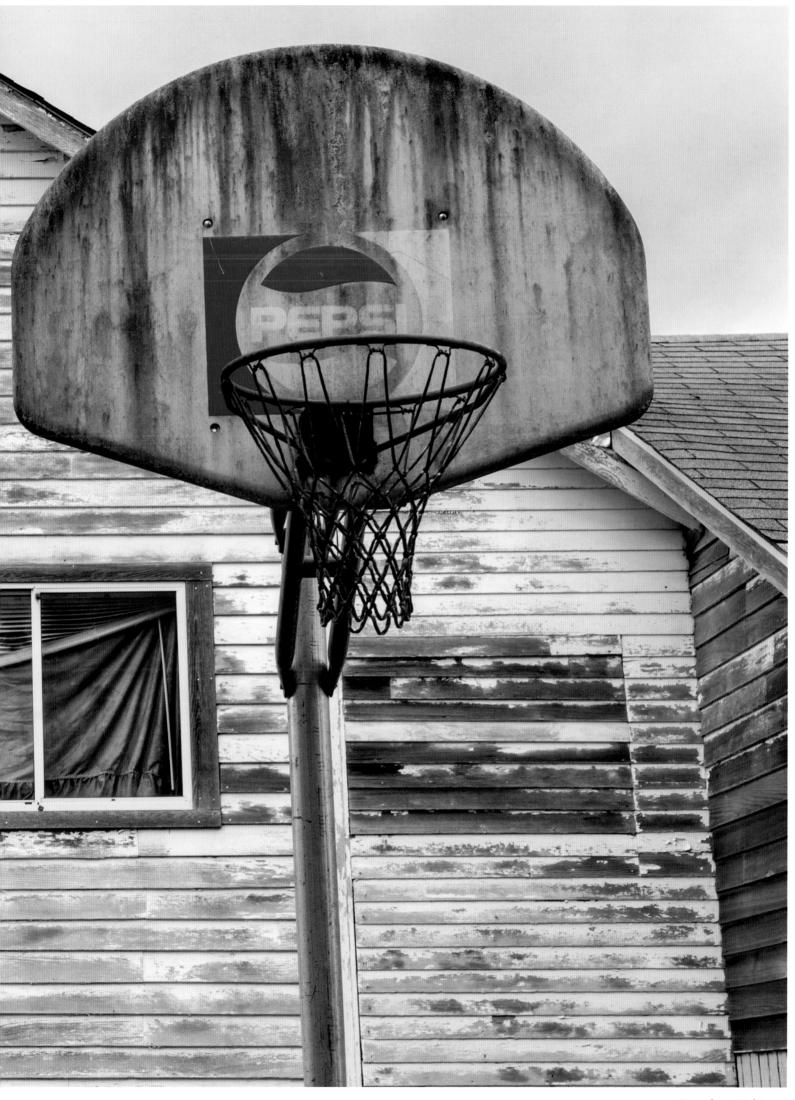

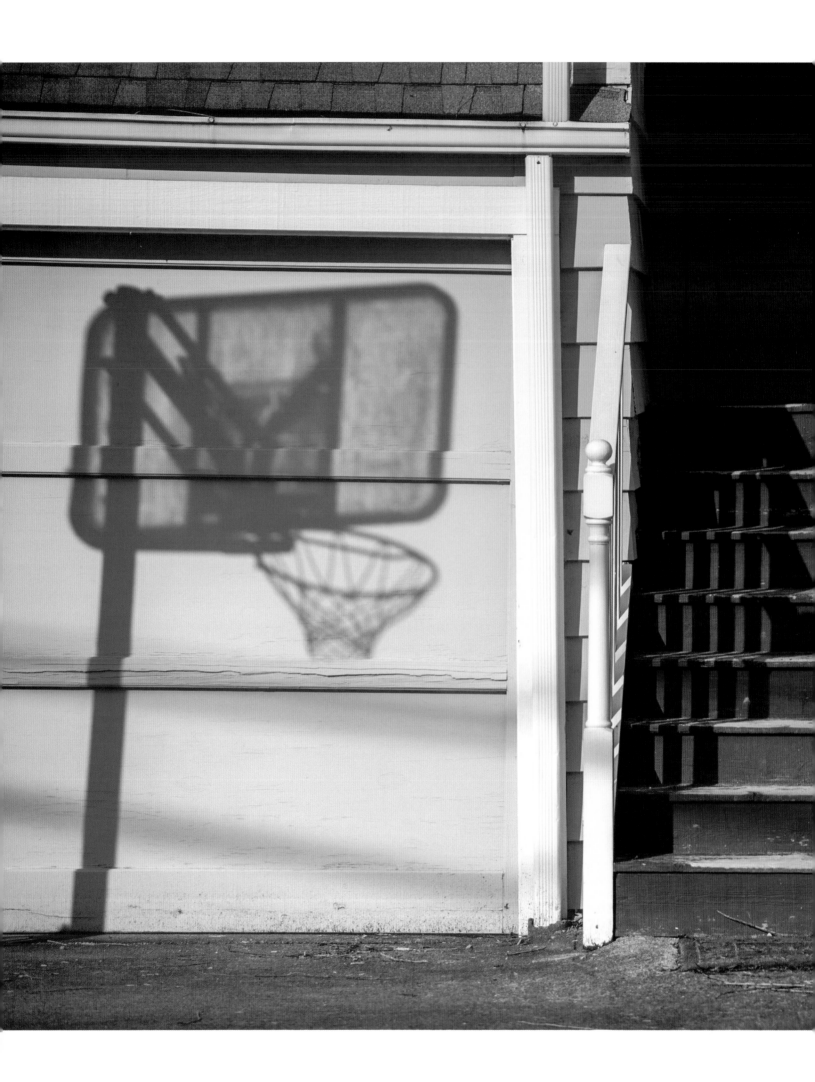

ABOVE Snoqualmie, Washington

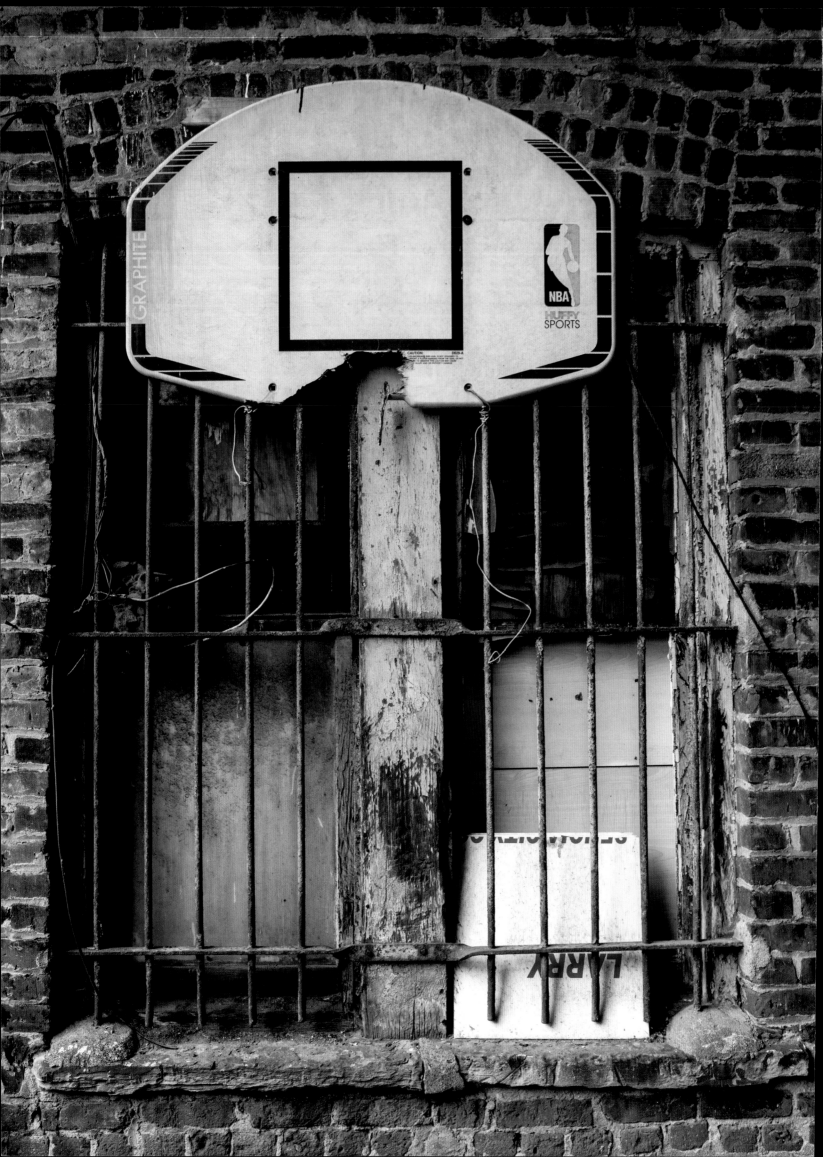

" Basketball has opened up the world to me. I've been able to travel around to different countries and meet amazing people and make lifelong friends. It's taught me some of the basic principles of life: learning how to work with people and how to accept people with different backgrounds and cultures. It's taught me how to work together with someone who is different than me.

To represent your country in the Olympics is an amazing feeling. I could have never imagined that the game of hoops would have taken me this far. I grew up in the projects in New York and was raised by my grandmother. She didn't let me hang outside much, but she would let me go to the basketball courts in the middle of the projects, because she could watch me out of her window.

It didn't matter if it was raining or if it was snowing, I'd be out there playing, working hard, and having fun.

With hard work and dedication, your dreams can definitely become a reality."

— *Chamique Holdsclaw*

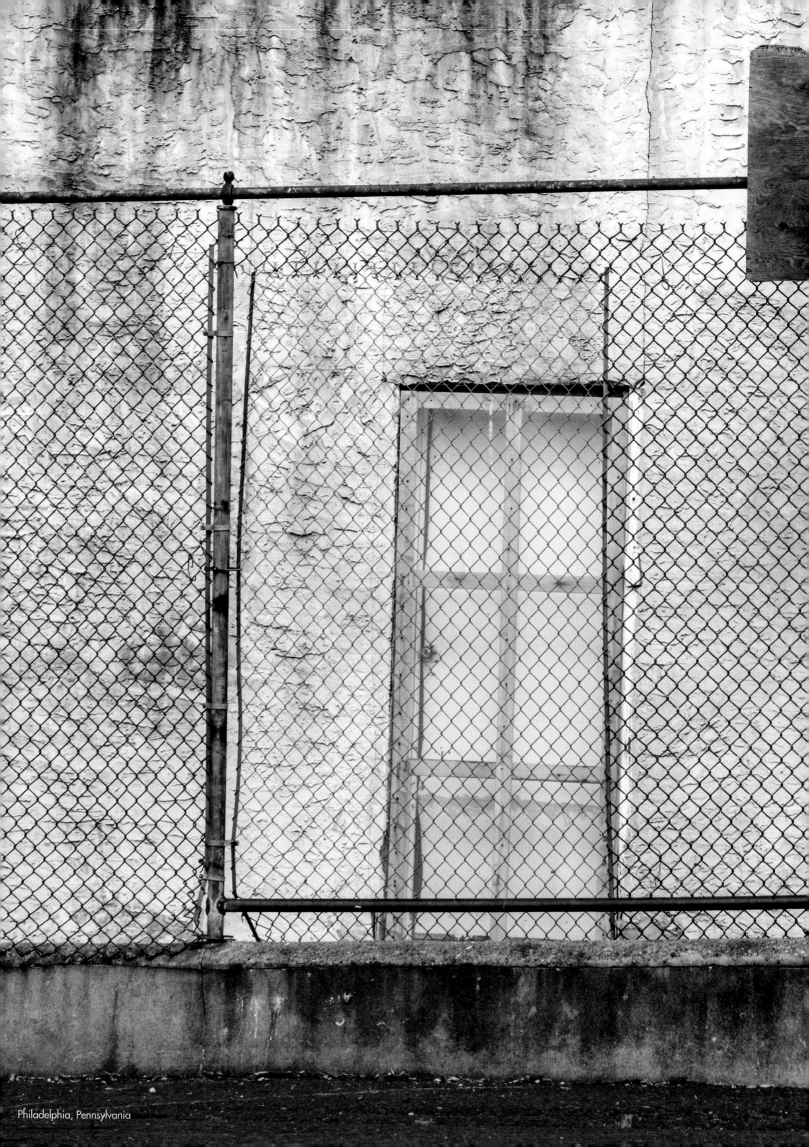

Philadelphia, Pennsylvania

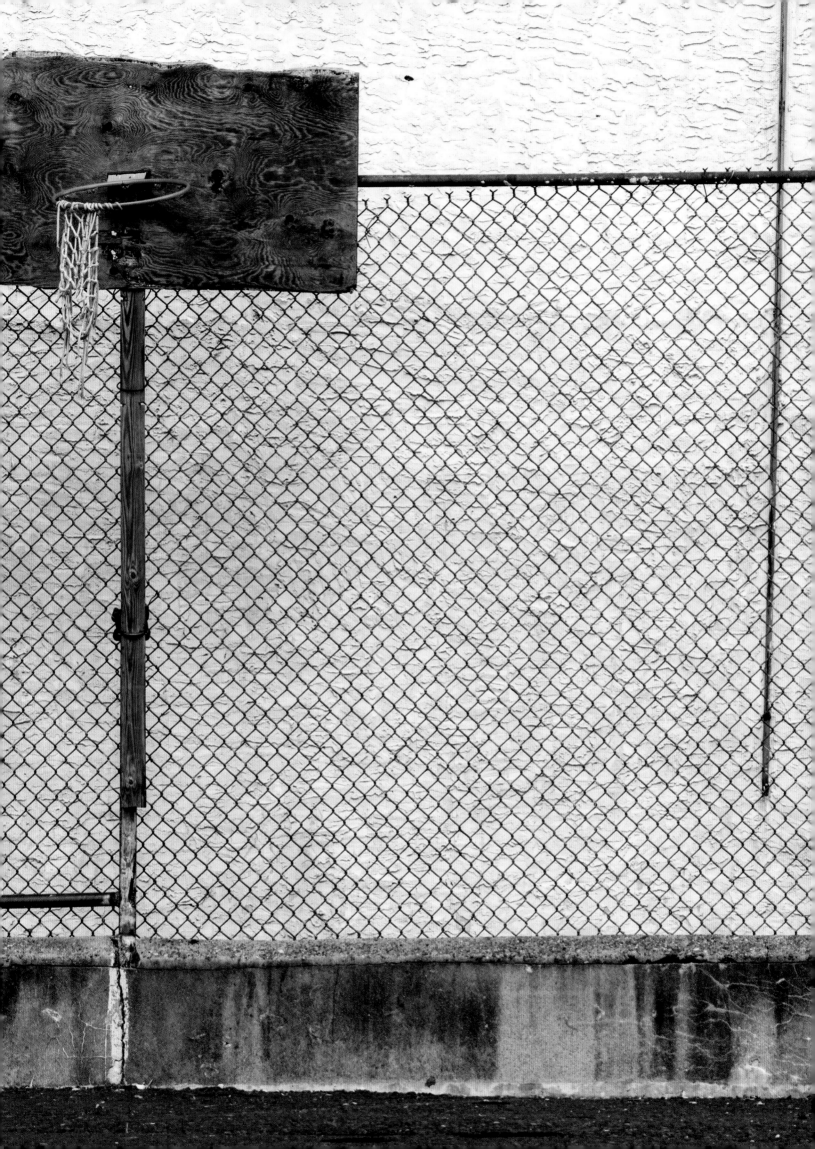

" I spent all of my time on outdoor and indoor courts. I loved the indoor court, because it was all pickup games and I loved being with my friends. The outdoor court is where I could be alone and work on my game. I really liked that 'cause it was just me and my imagination."

— *Danny Manning*

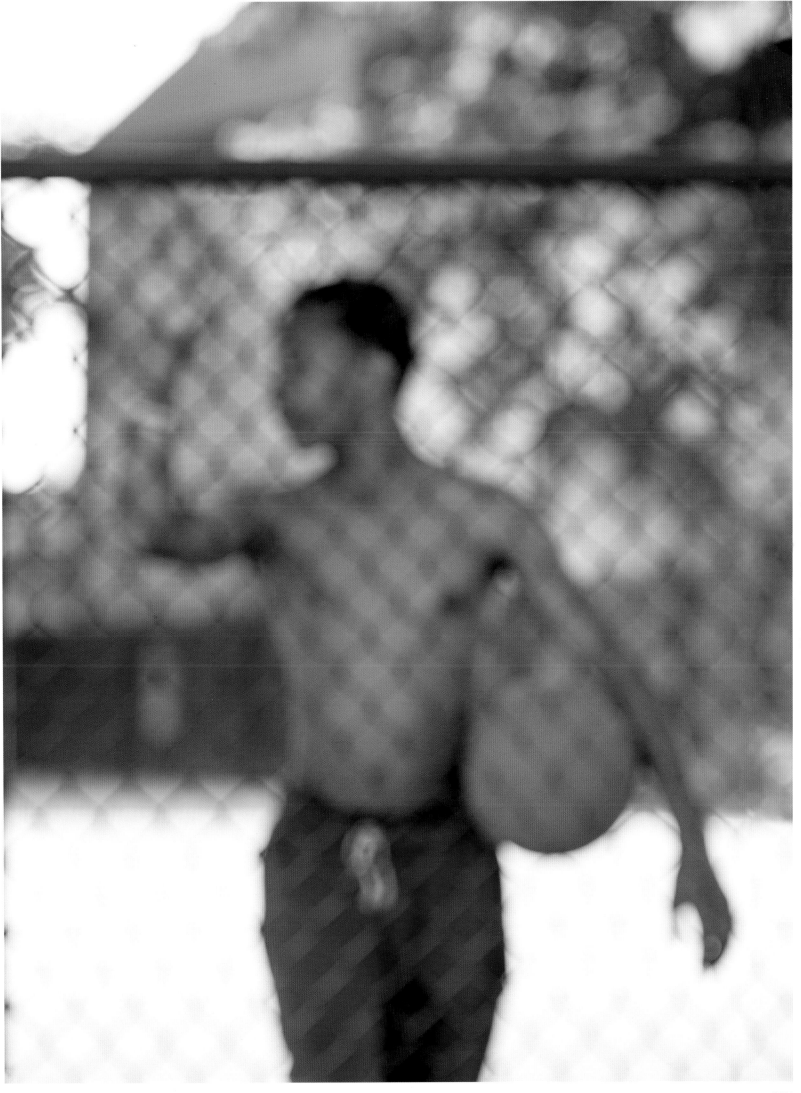

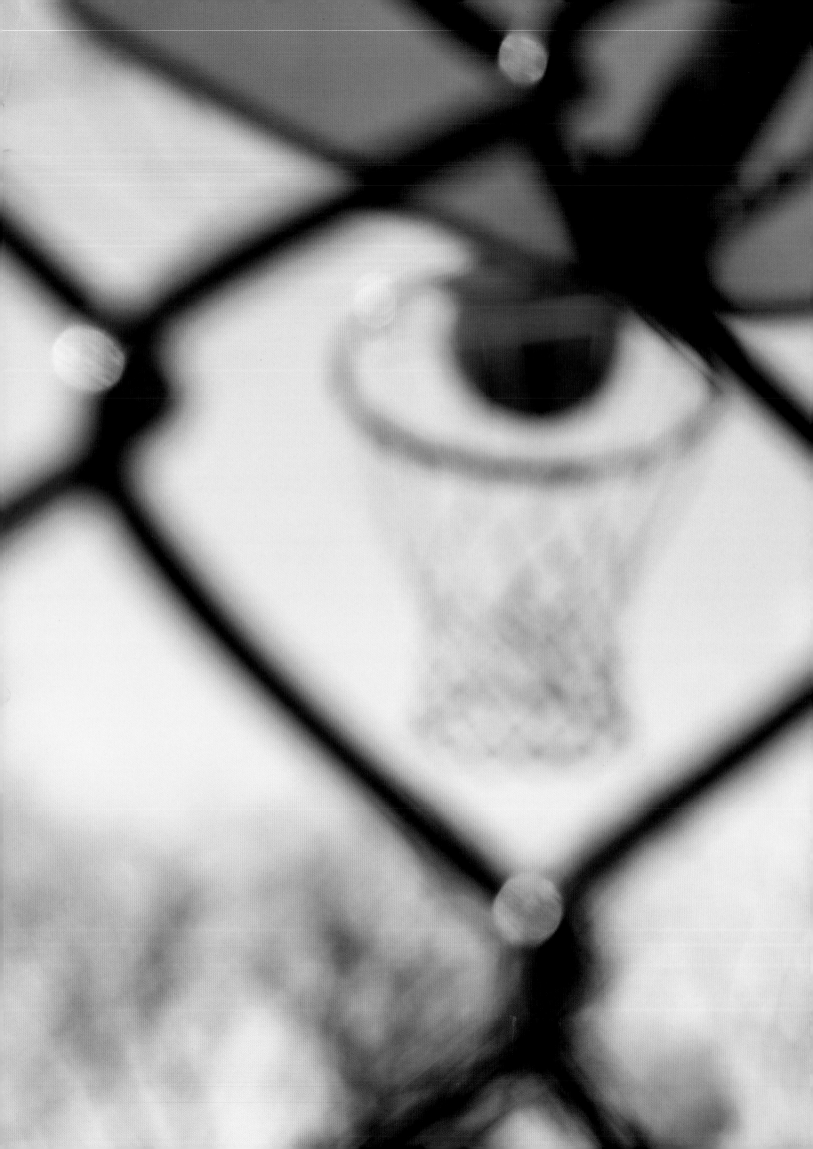

LEFT Central Park, New York, New York
NEXT SPREAD Snoqualmie, Washington

ABOVE North Bend, Washington

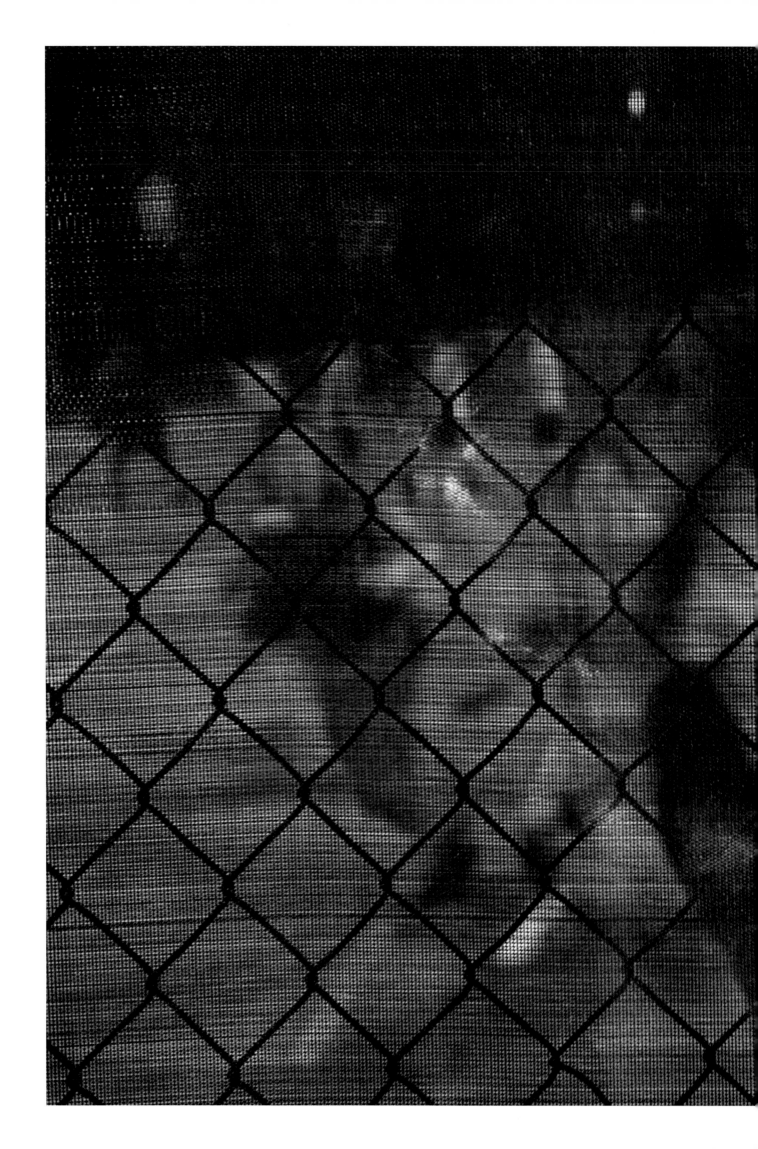

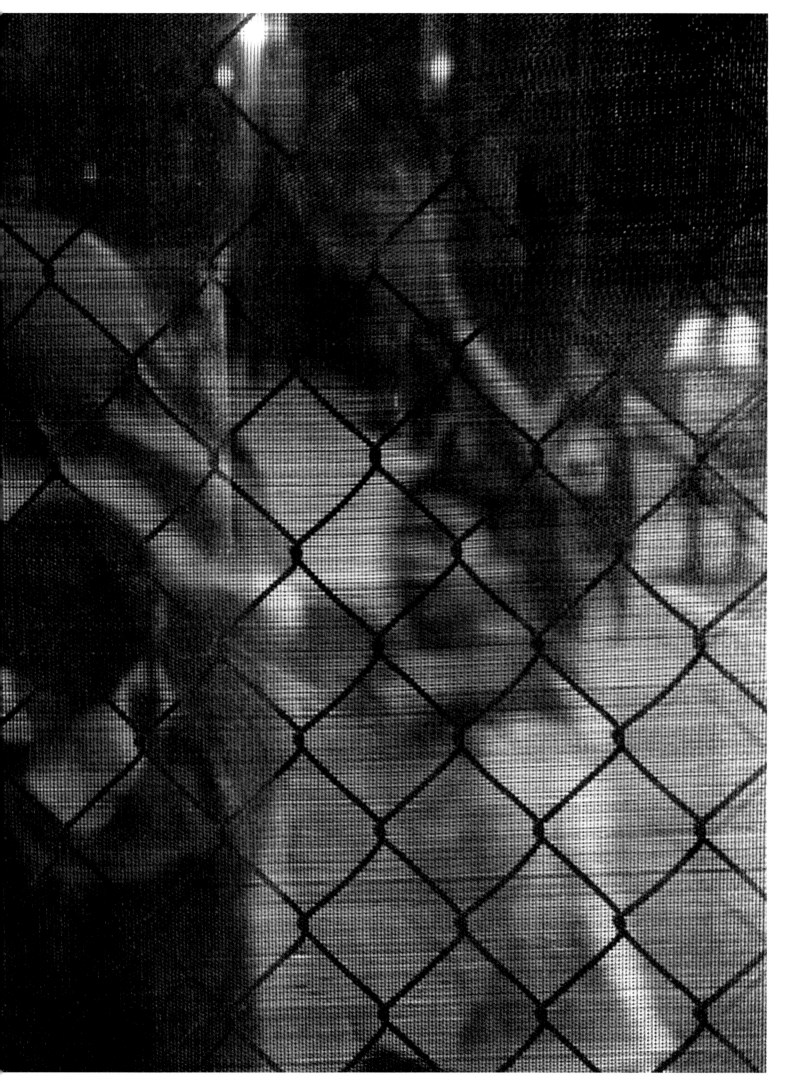

ABOVE Los Angeles, California

" When I first discovered basketball, I was in the seventh grade. My parents put a hoop out on the garage in front of our house and I used to go out and shoot for hours with my artificial legs on.

A guy drove by and asked me, 'Have you ever thought about wheelchair basketball?' He took me to a practice and I was the youngest person on the team. Everyone was in their teens and twenties but I made the team.

Being disabled all my life, basketball has made me feel like I was part of a team. It was the single most important rehabilitation that I have had in my entire life.

To be good at basketball you need patience, dedication, and you need to stick with it. You only get better by playing against people that are better than you.

Practice makes perfect."

— *Tom Brown*

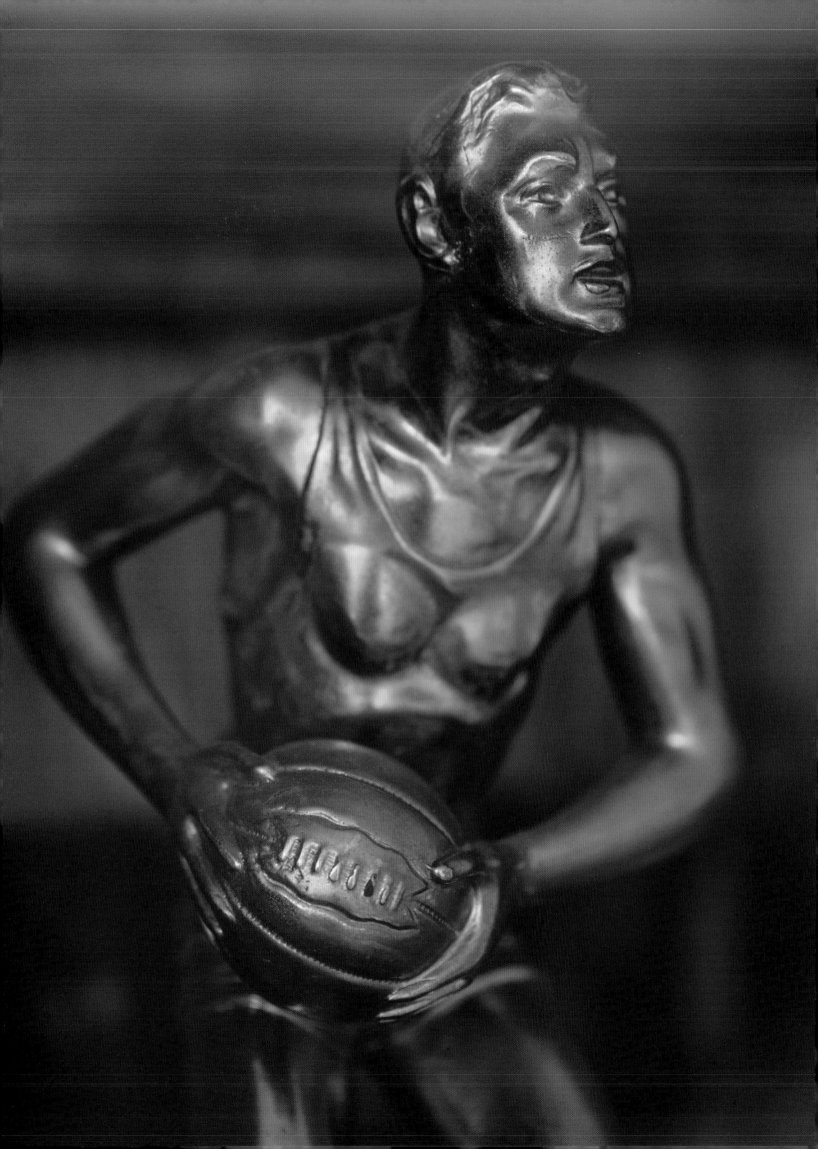

" We weren't playing to win a trophy in 1954. We were trying to win a state championship.

Back then, basketball was such an important part of every small town — and we were really small. On a good day we had 60 people in our town.

Milan had never won a game in the regional tournament in the history of the school and then suddenly, in 1953, we were in the Indiana State Final Four. We were beaten in the afternoon game and you don't get a memento for that. In fact you don't get anything. The only teams that got mementos were the final two teams. If you won, you got a gold ring and, if you lost, you got a silver ring.

I remember in 1954 we talked about getting back to the final game so we could at least get a ring, because that was important to us.

To describe what it felt like to make the winning shot... I can't. I had never experienced anything like that. There were 15,000 fans standing and screaming. I don't remember anything except exhilaration and happiness.

The trophy itself was just a symbol. The important thing was that it raised the expectations of the whole school and the entire community. During the previous four years at Milan, 15 to 16 students went to college. However, of the 30 students in my graduating class, 17 went to college. Of the 10 players that dressed for that final game, nine of us went to college. You don't have to do that to be a success but it does open doors.

It was wonderful to win the state tournament, it was wonderful to have the recognition, but what I'm most proud of is that all the players on my team turned out to be successful.

The movie *Hoosiers* has touched so many lives. People from all over have visited the Milan '54 Museum — from all 50 states and 26 foreign countries. And you have to want to go to Milan to get there."

— *Bobby Plump*

LEFT Milan High School's 1954 State Championship Trophy
Milan, Indiana

119

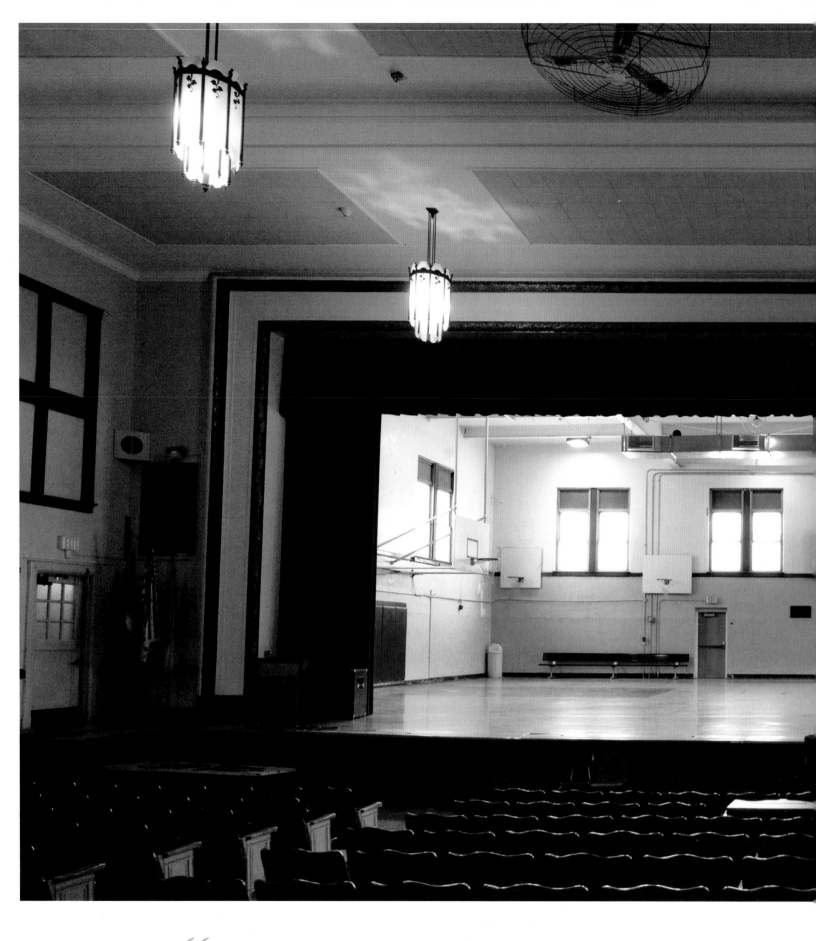

“ In the wintertime, when there was snow on the outside court
and we couldn't play, we'd find a way to sneak into the gym and
play just by the street lights or by the moonlight. To see the courts
at Roselle Park Middle School today—with the same baskets and
backboards that were there 50 years ago—is hard to believe.

There were folding doors that separated the auditorium from the
basketball court that actually took up part of the court and you had
to be careful not to run into the doors.

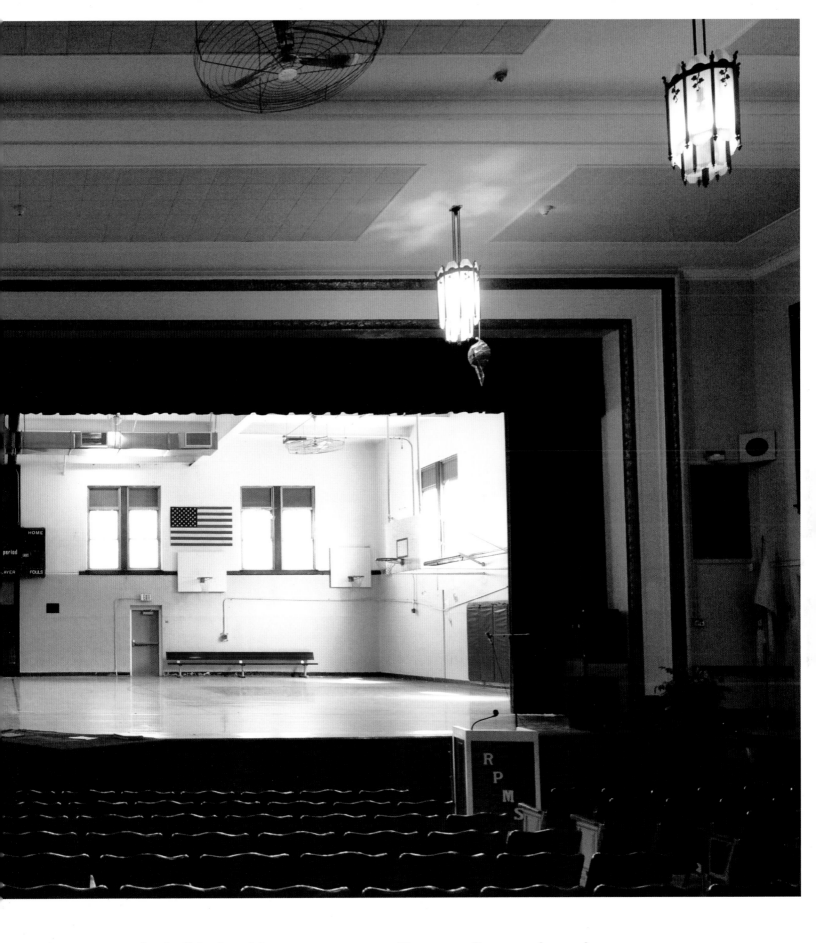

Basketball is the ultimate team game. There are five people on the court. All five people need to learn how to work together if you want to achieve success. It provides a great learning platform for life in general."

— *Rick Barry*

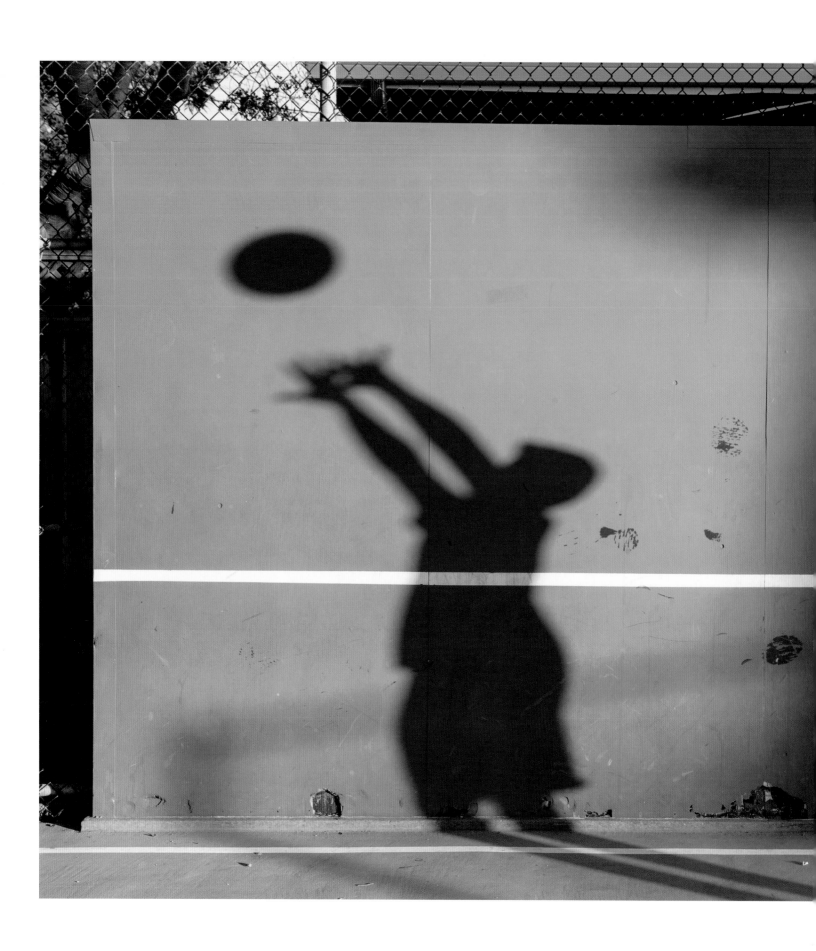

" Basketball is, and always has been, a huge, huge part of me — the canvas I tried to paint each time I stepped on the court and never stopped trying to perfect. It's been my life. It's been my love. I've hated it. Been frustrated with it, and delighted with it beyond tears.

At season's end, you knew that only one team was going to be truly happy and everyone else was going to be different degrees of miserable.

To me, the woods held the possibility of finding a magic elixir.

In all the years I played, I dreamed about playing the perfect game.

My life has been about trying to figure out my limitations and I know them quite well. Once you find out what they are, it really gives you a chance to find your niche."

— *Jerry West*

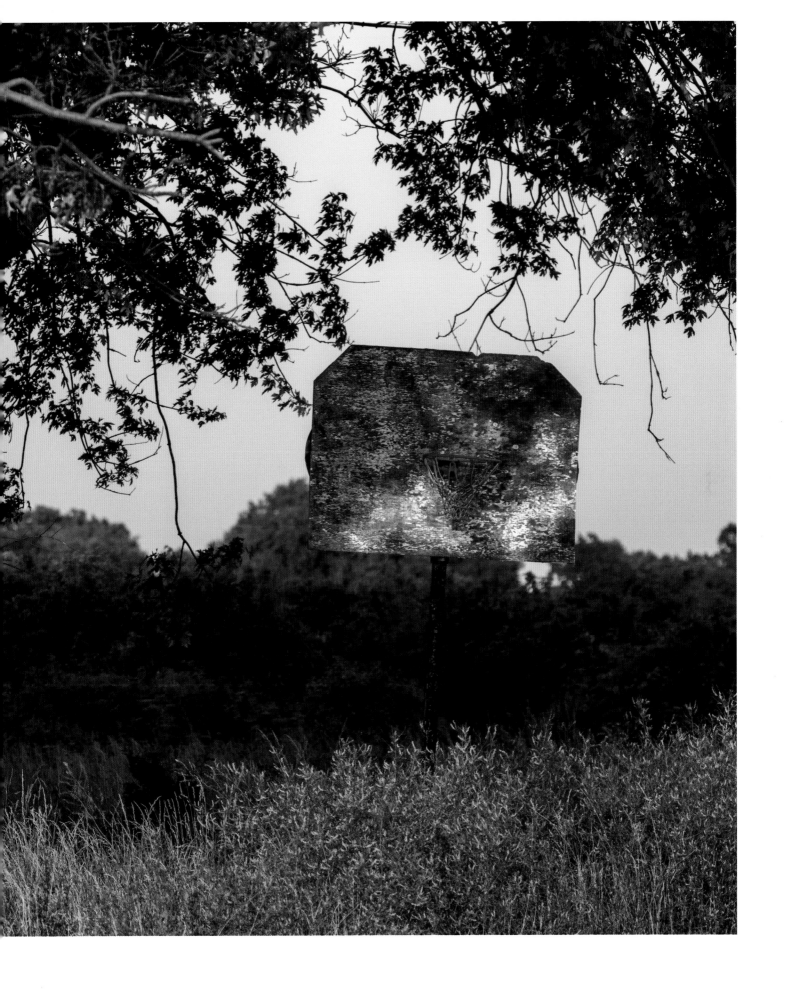

ABOVE Sandusky, Ohio
NEXT SPREAD Fort Washington, Pennsylvania

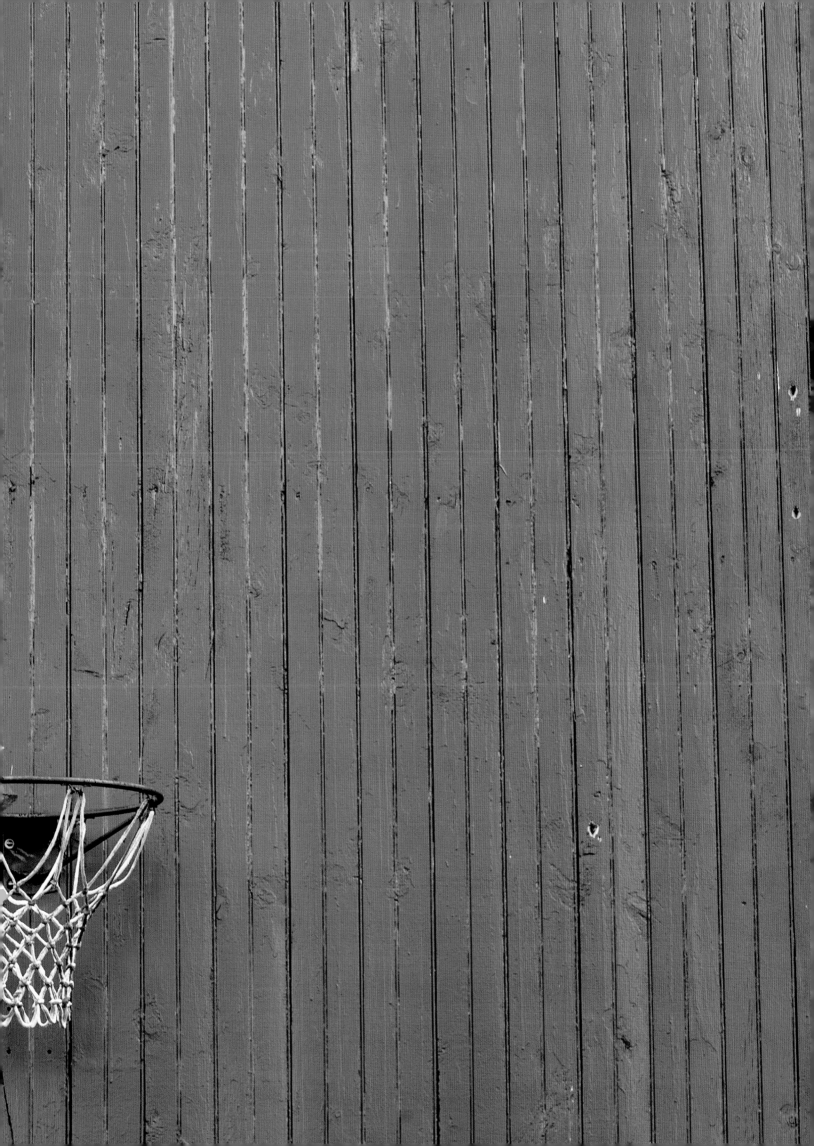

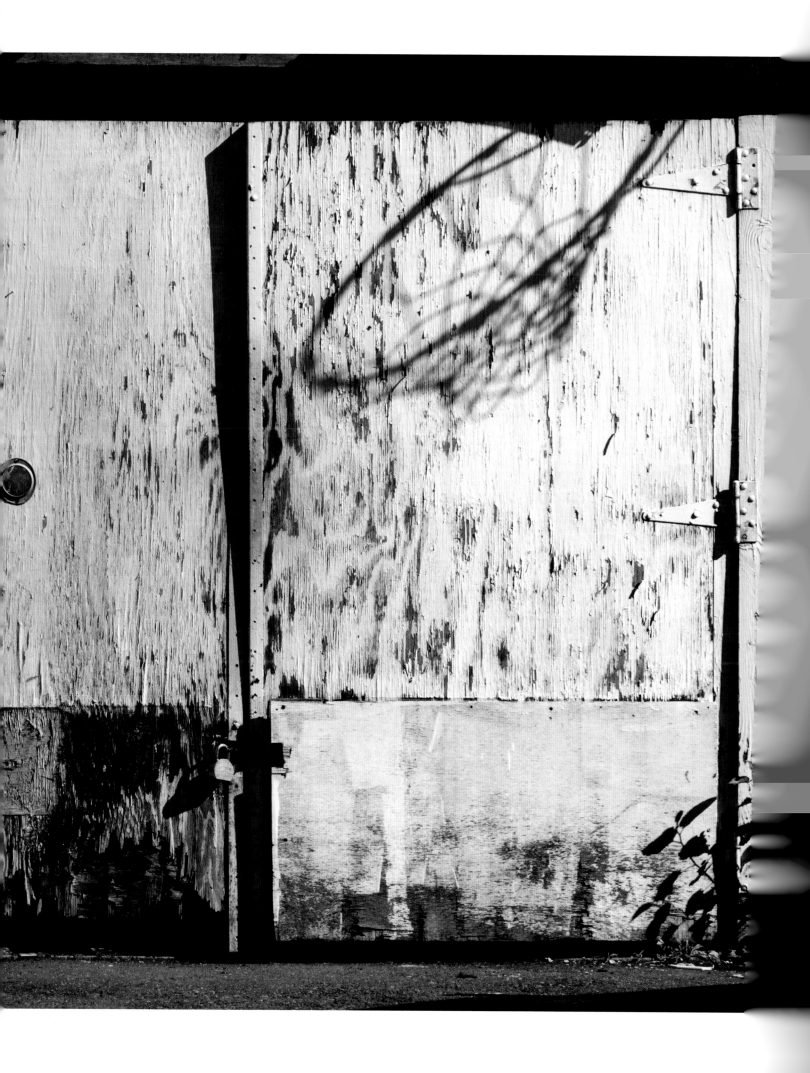

ABOVE Newark,

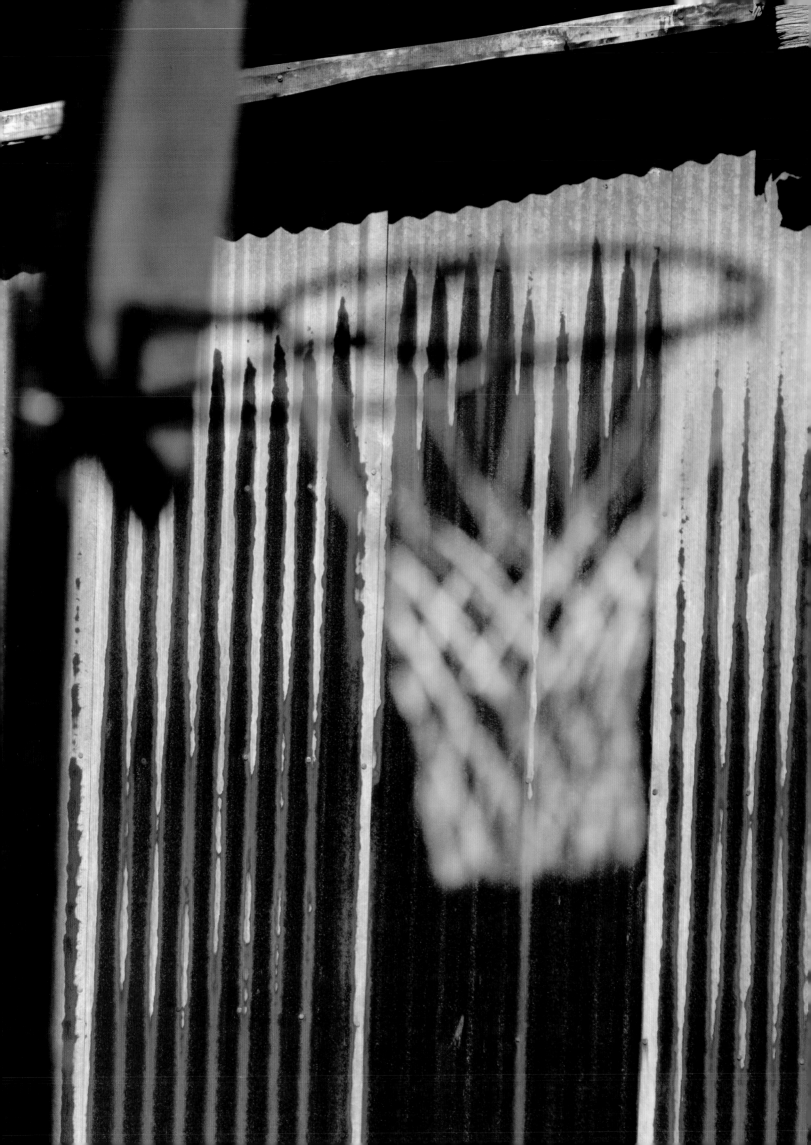

" When I was young, my parents moved to the farming community of Porterville, California. I remember my dad putting up a hoop on the garage of our little home, and I would go out there for hours and hours and shoot the basketball. I will never forget my parents making me come in the house to go to bed because I would stay out there even in the dark and practice and practice. Later on in life, I think that work ethic of practice and fundamentals was key to my success as a player and as a coach.

Basketball has brought so much to my life. I have been so blessed to be able to have a whole career doing something that I love. First as a player for the Boston Celtics, and then as a coach in the ABL, ABA, and NBA. I have been with the Lakers for 40 years as a coach, general manager, and consultant. I'm not sure if many people can say that they love what they do, and I am thankful every day for the opportunities in life that basketball has given me."

— *Bill Sharman*

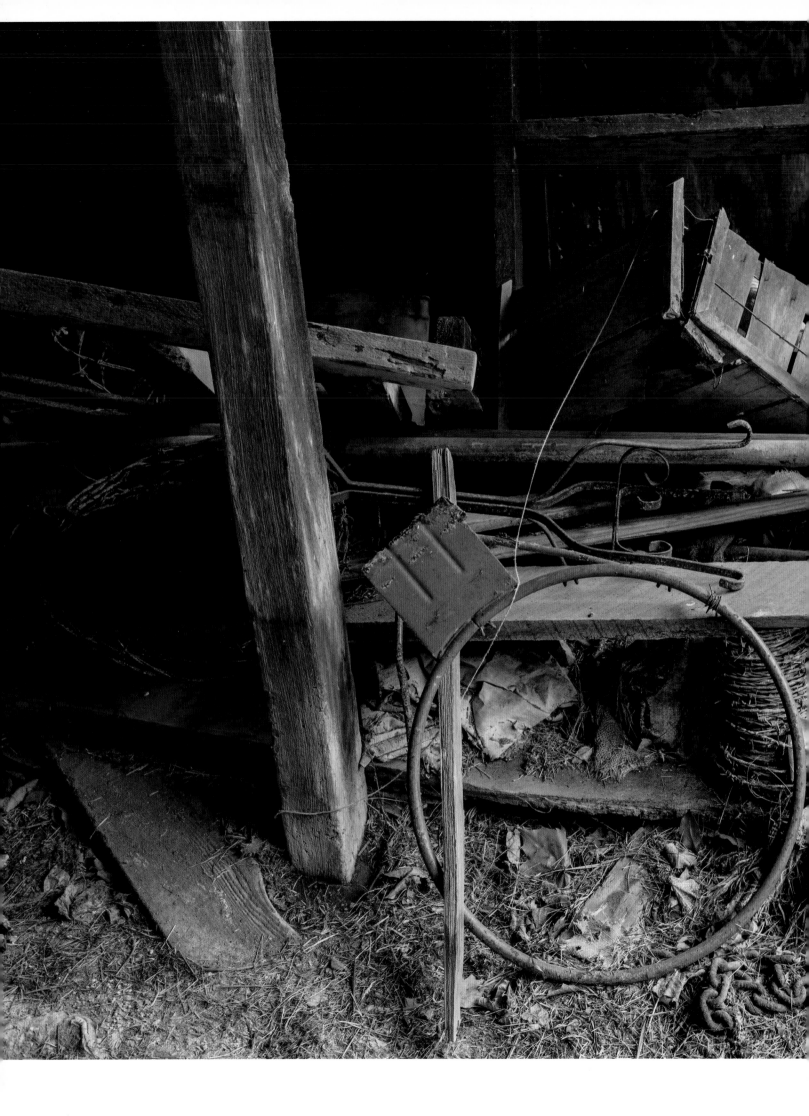

ABOVE Stockton, New Jersey

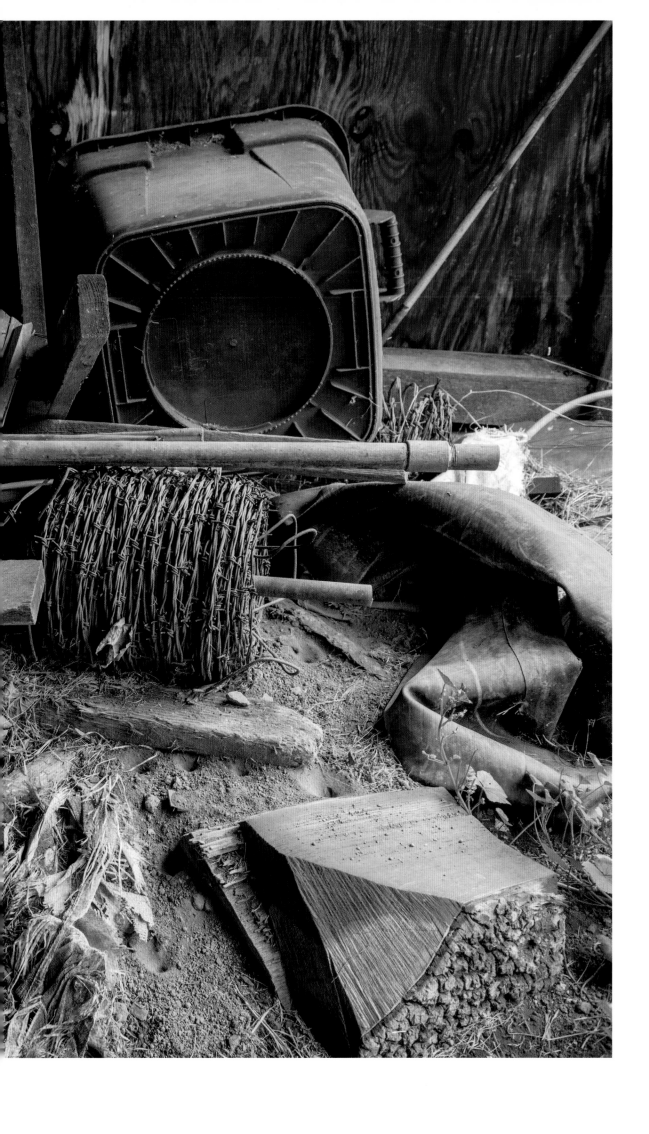

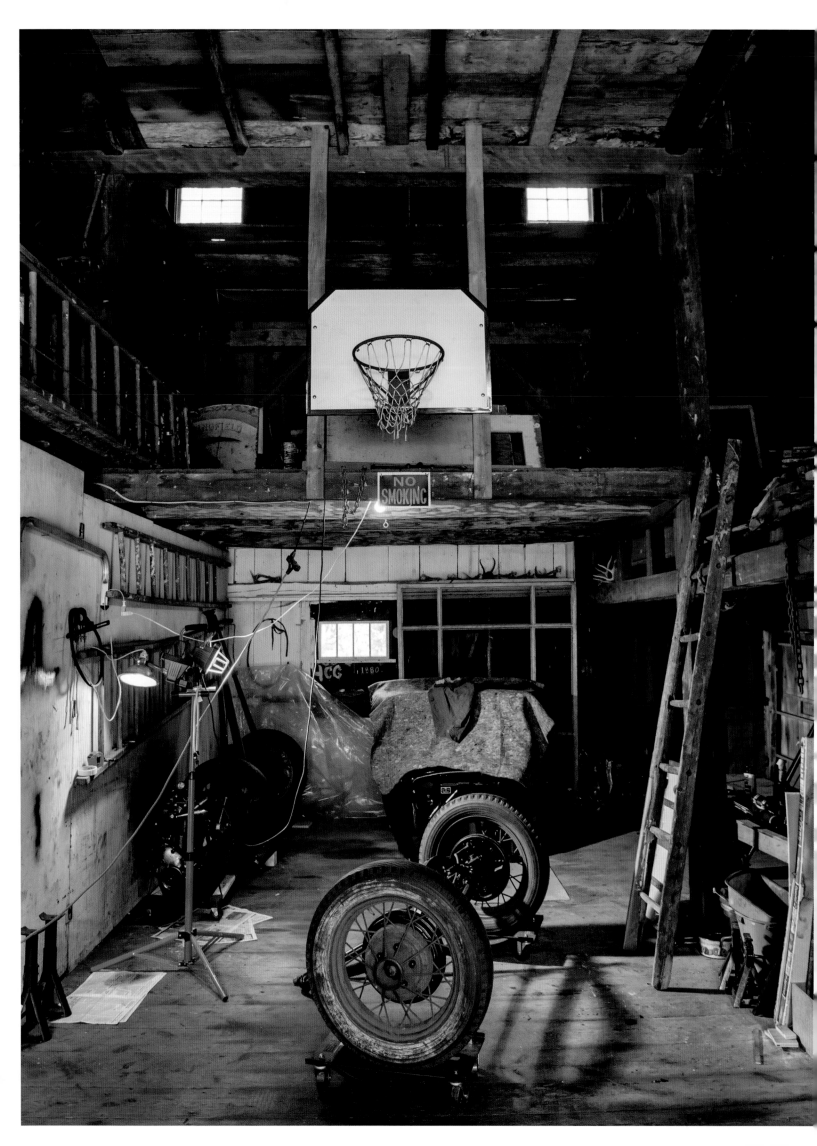

"Where we lived in the country, we didn't have playgrounds. We always had some type of rim or basket of some kind to play with that was attached to a tree or a telephone pole. But the problem was, we would run into the pole and get black eyes, bruises, and bloody noises. So my dad built a basket for us in our backyard that had the rim offset with the post behind it 4 or 5 feet. It sounds crazy, but that made all the difference in the world to us guys who were playing because now we could drive to the basket, dunk the ball and do all those things that we couldn't do before.

Basketball teaches you sharing and sacrifice and how to cooperate with other people.

The biggest thing is that it teaches you that you have to get along with other people. That's what a team is all about."

— Wes Unseld

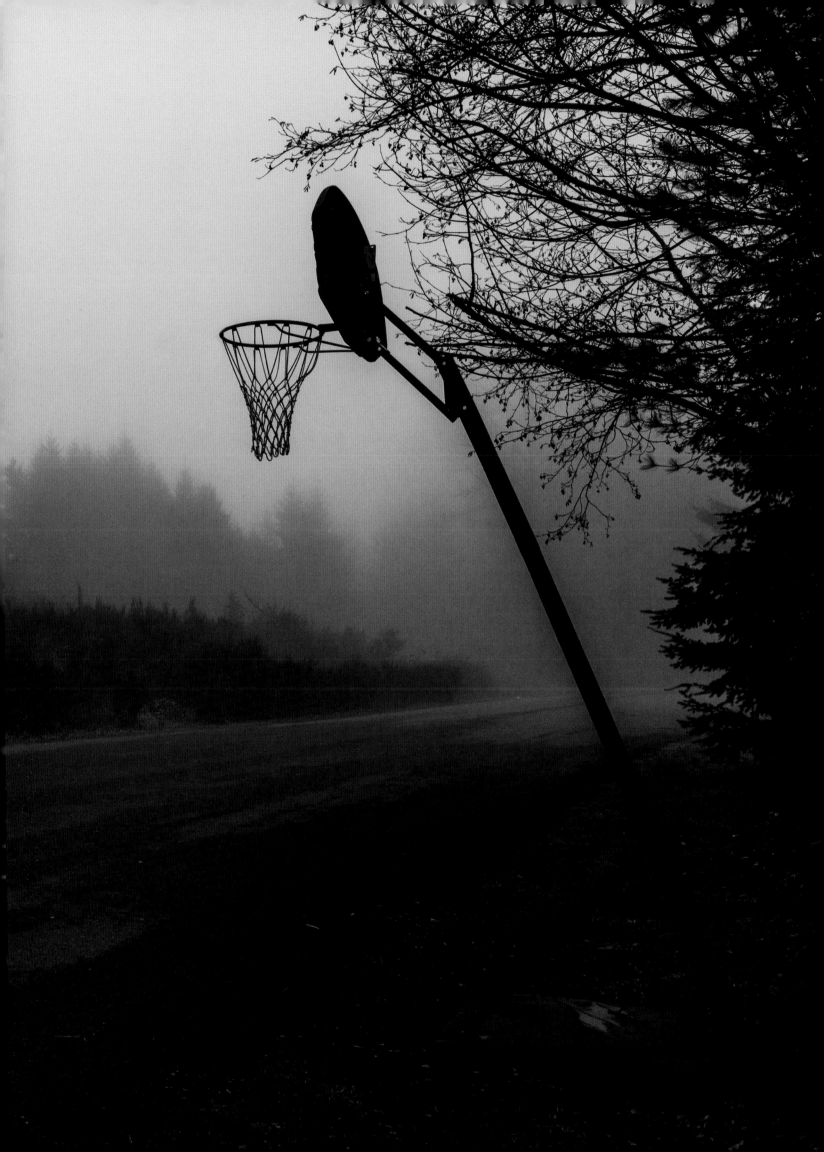

"My passion for the game came way before I ever put a uniform on.

I grew up the youngest of eight kids. Our family grew up fighting in the house, so my mom threw us out in the backyard and we worked things out through the basketball hoop. It was just a rim with a wood backboard on the garage, nothing fancy. We spent hours and hours working out our differences there. I couldn't go inside until I had 25-50 "nothing-but-net" kind of shots. We would shoot for hours and hours until the lights came on. Our neighbor even put up a spotlight so we could play at night. There were pickup games and different courts we played on, but the backyard at the Donovan house is where it all went down.

I lost myself in basketball. I was a really shy, introverted kid who was always taller than anybody, more gangly than other people. I just found a comfort level and sort of lost myself in the game. And in return, the game has given me so many of the rewards in my life.

Find what you love and then lose yourself in it. It will return goodness to you."

— Anne Donovan

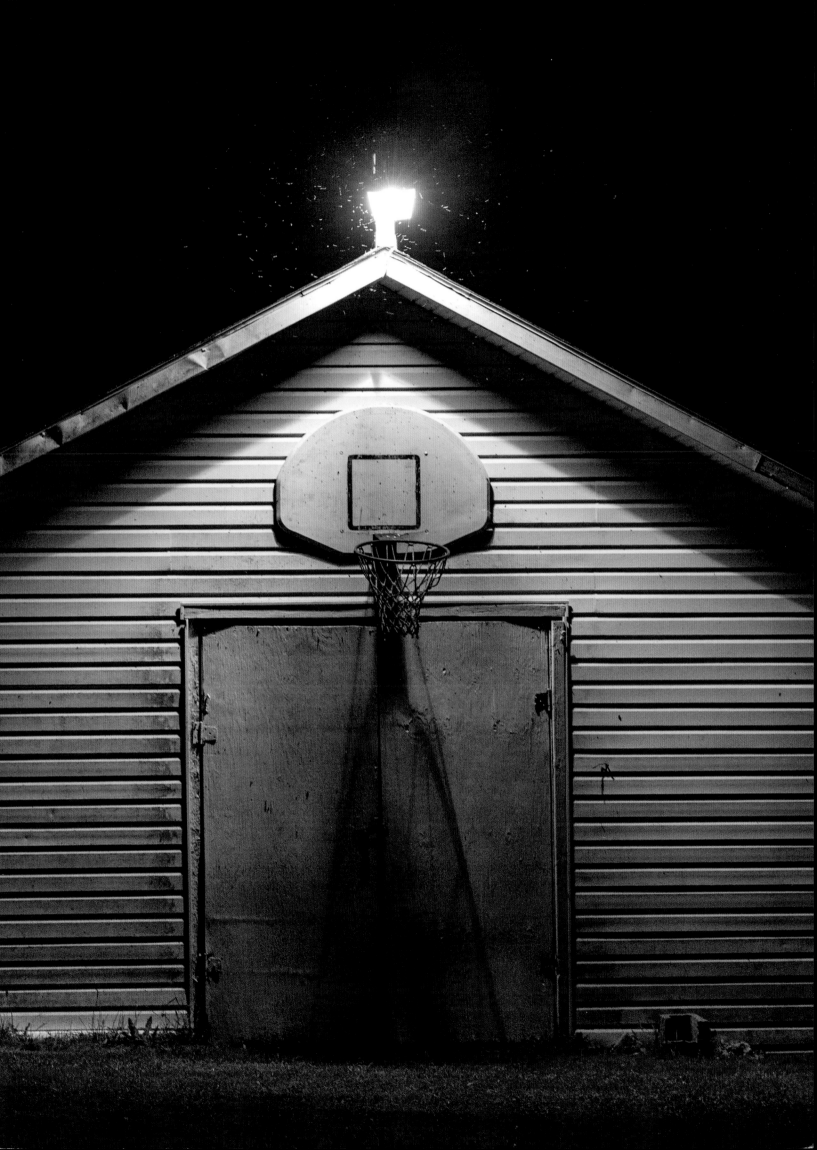

ABOVE North Bend, Washington

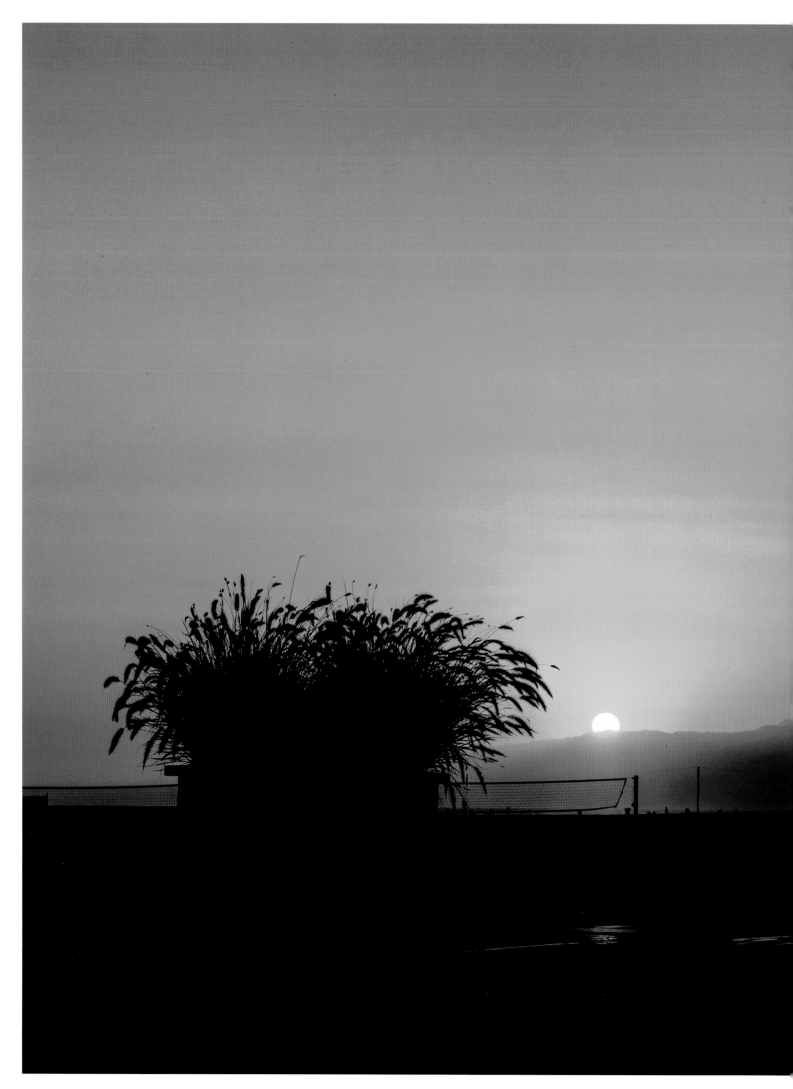

ABOVE Venice Beach, California

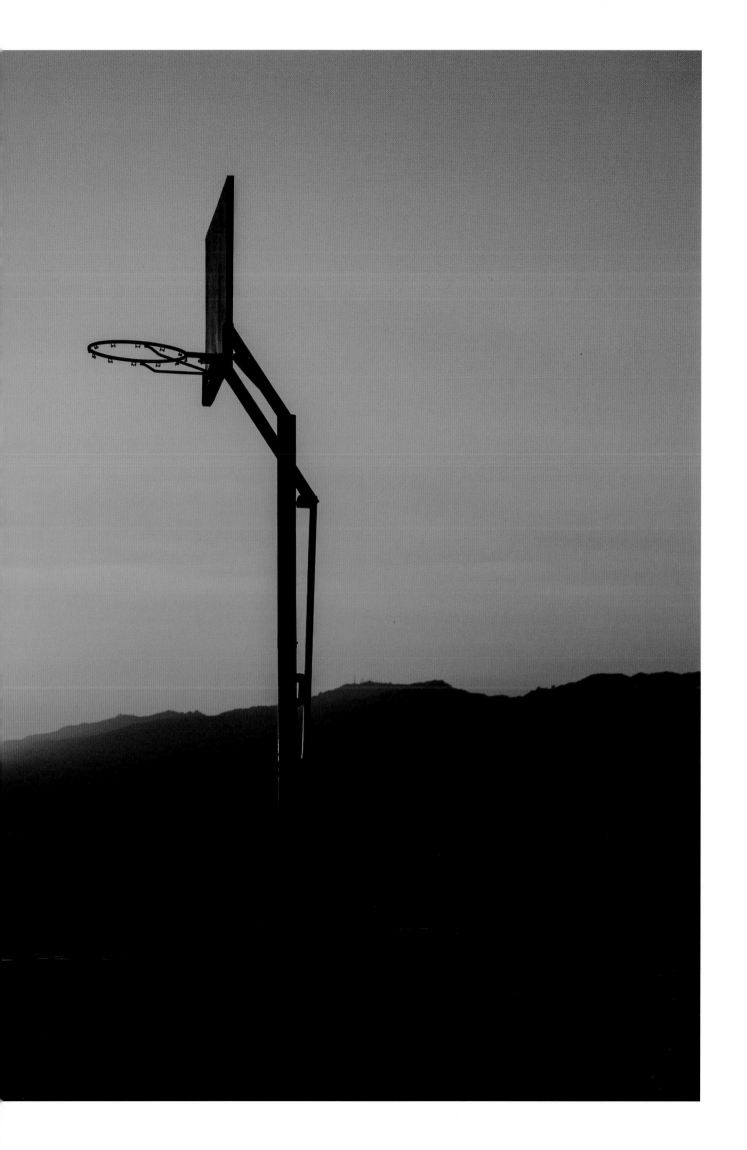

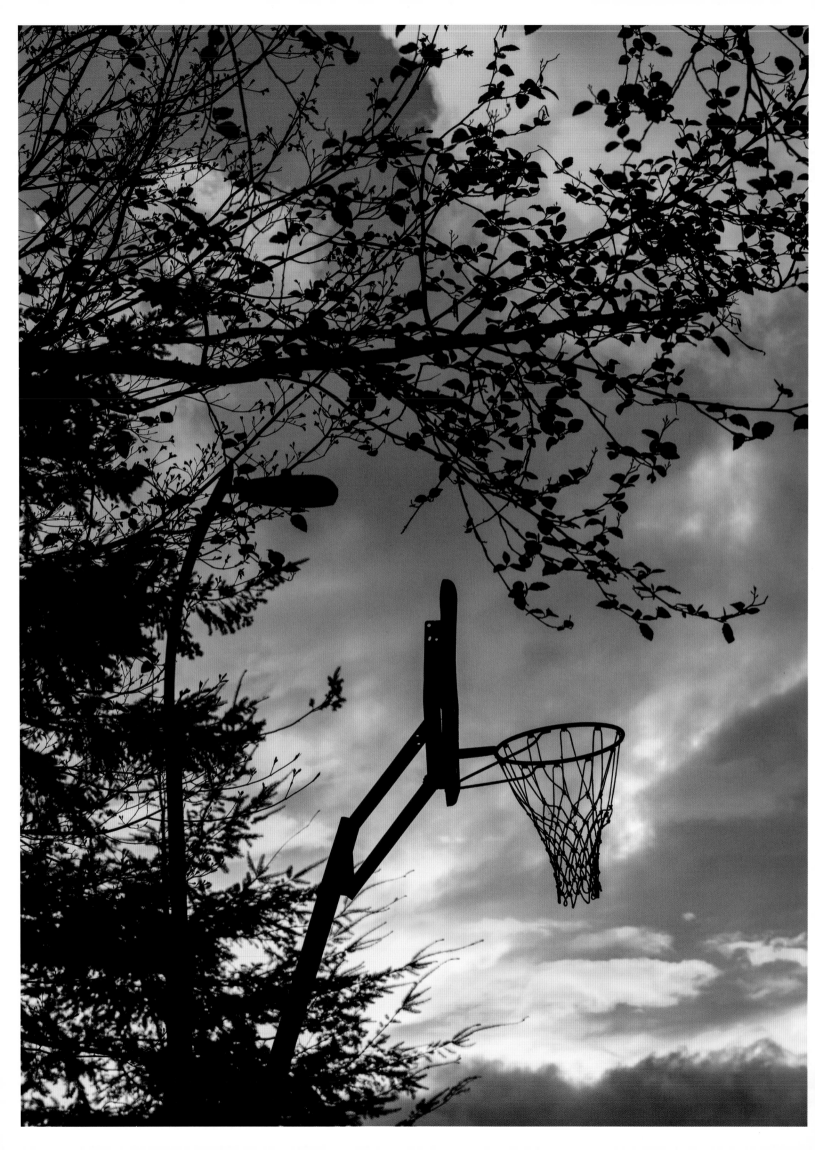

" I have a brother who is six years older than me. He played high school basketball when I was in elementary school (third–sixth grade). I would go to his games and sit in the row of bleachers right behind the team. I loved listening to the huddles and watching the coach draw up plays and then look to see if the boys ran them correctly. (I also secretly enjoyed hearing the coach cuss — since my parents rarely did.) I had no idea at the time that I would spend the rest of my life in huddles as both a player and later as a sideline reporter for ESPN. I'm still looking to see if the players run what the coach has drawn up. (Fortunately, the cussing no longer excites me.)

Basketball is where I learned to love being a tall, young girl. The confidence and self-esteem I developed from basketball stay with me to this day. Without the sport, I would have become a much different woman, and a different mother of three tall girls, than I am now."

— *Rebecca Lobo*

RIGHT **DeWitt Clinton Park,**
New York, New York
NEXT SPREAD **North Bend, Washington**

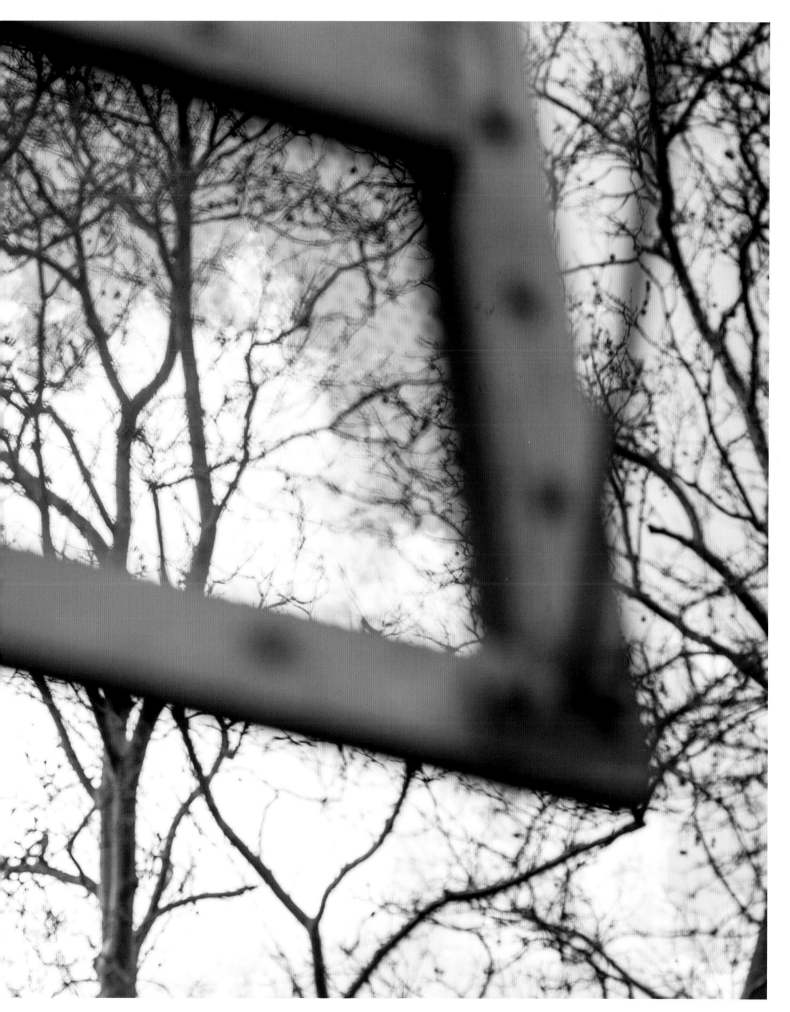

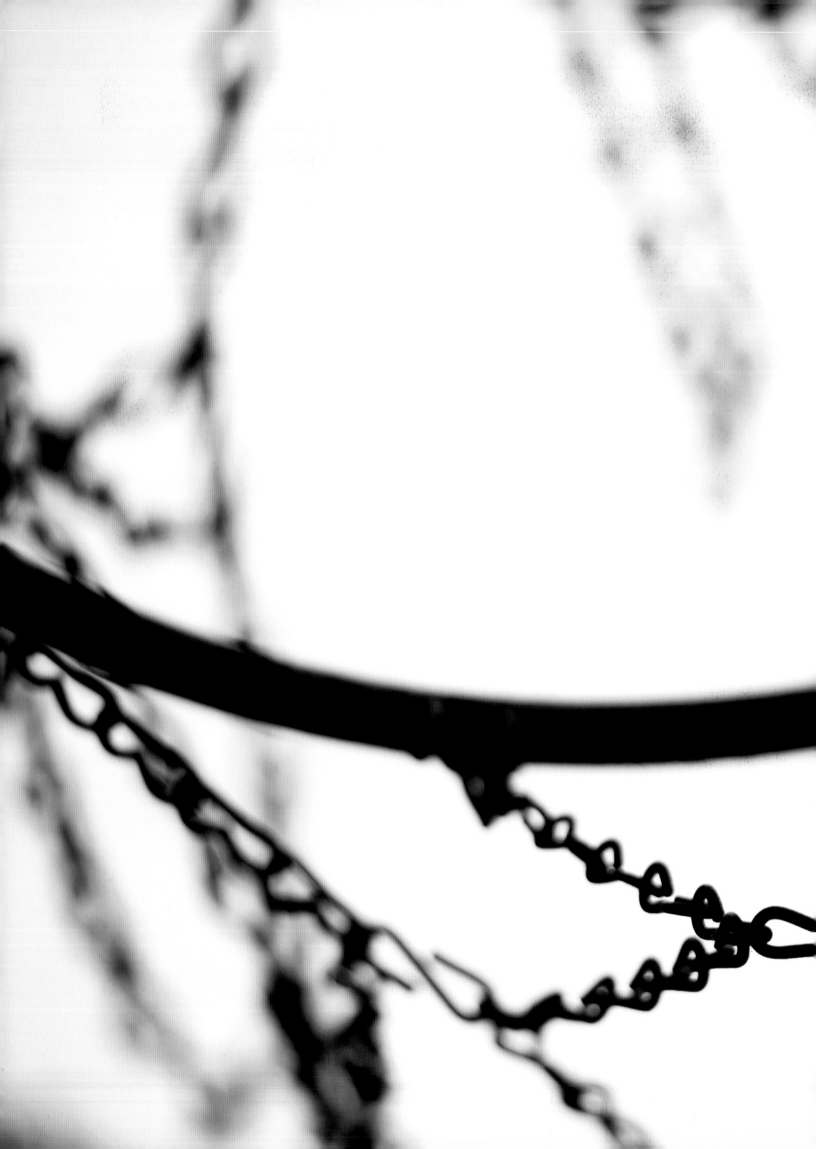

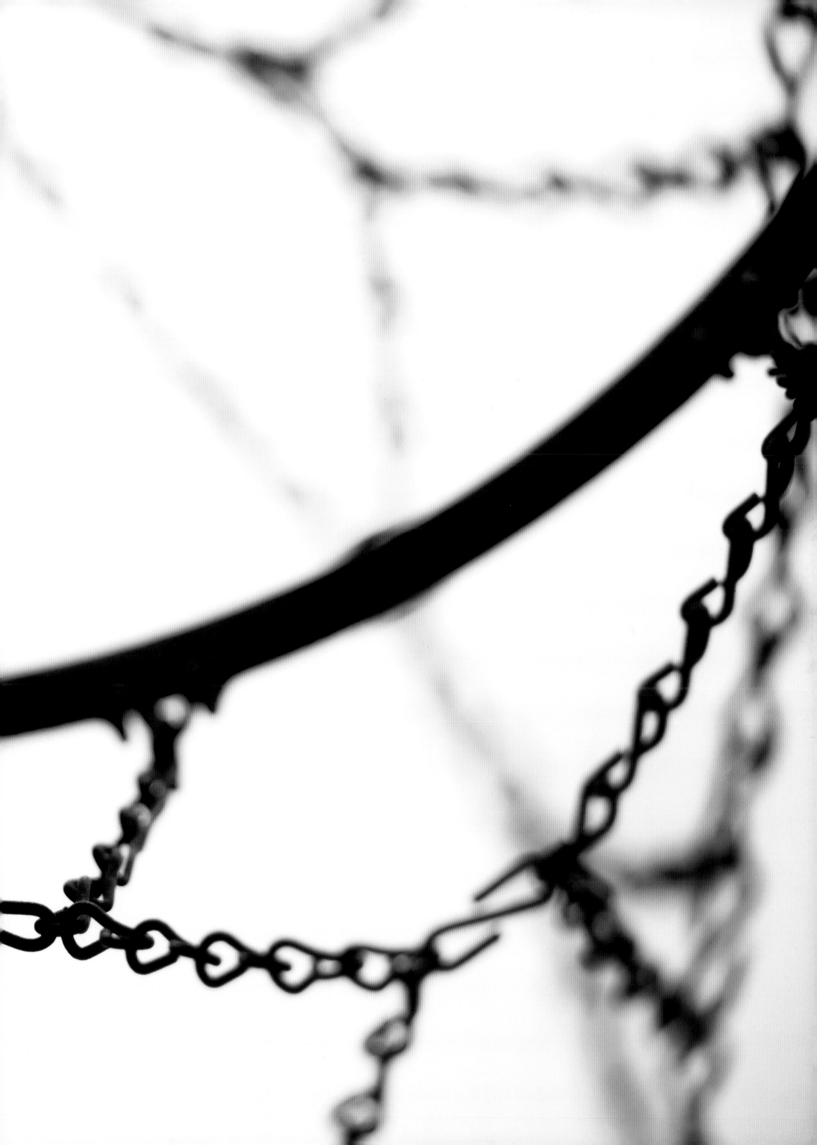

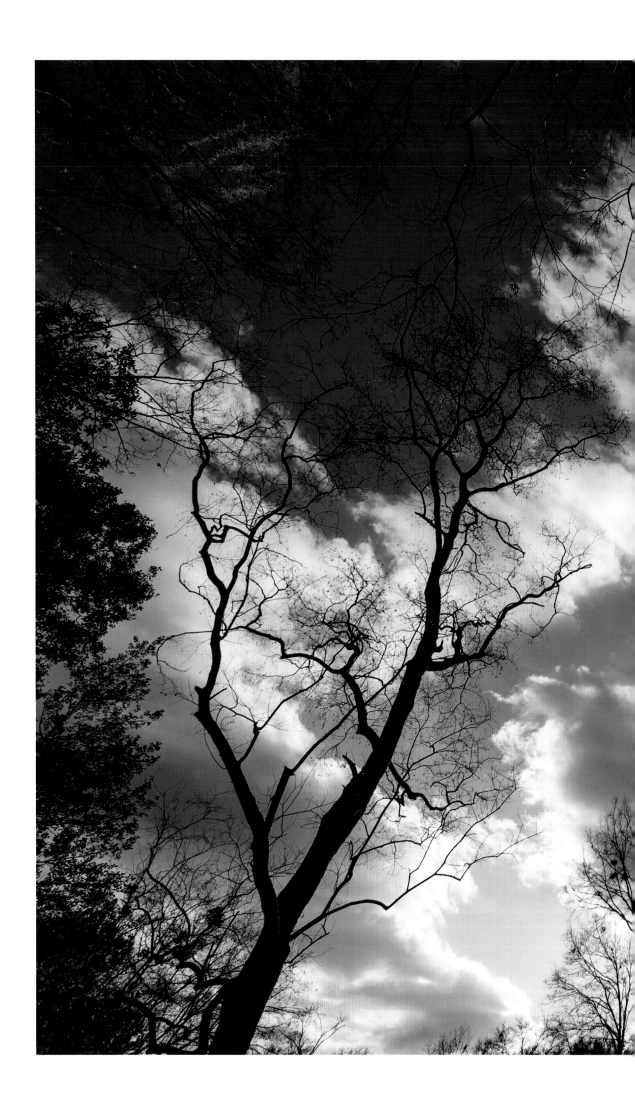

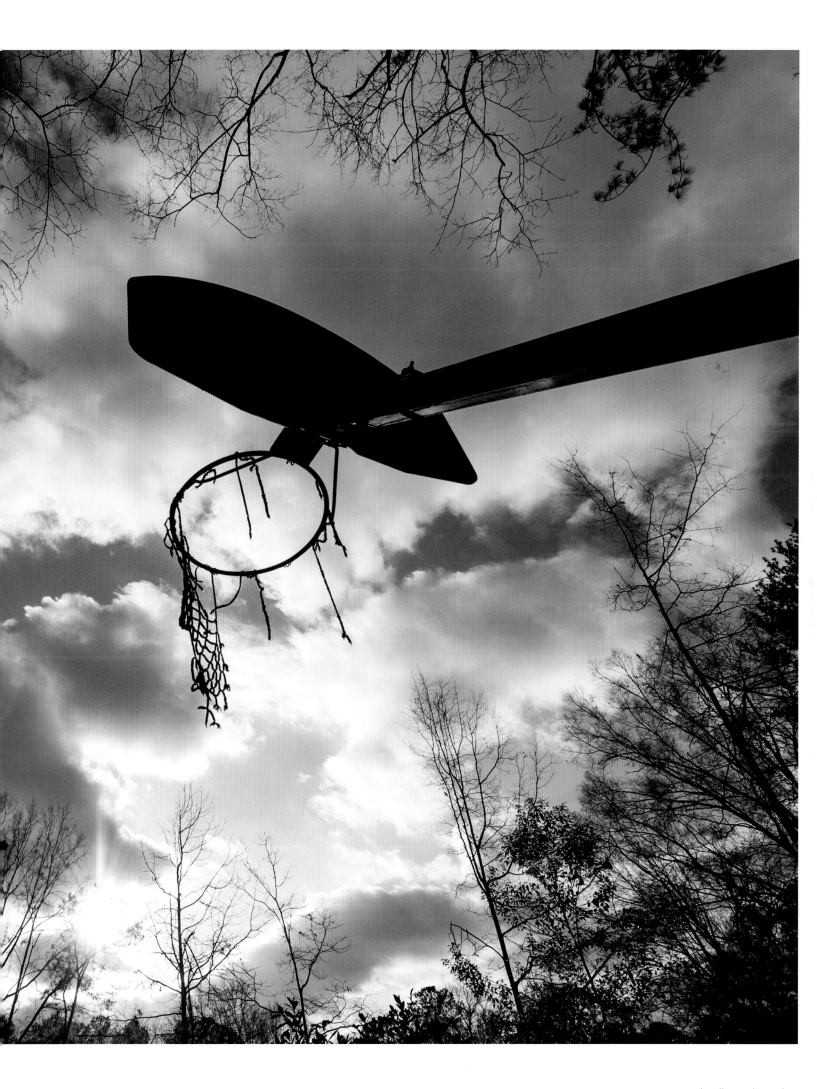

ABOVE Hardeeville, South Carolina

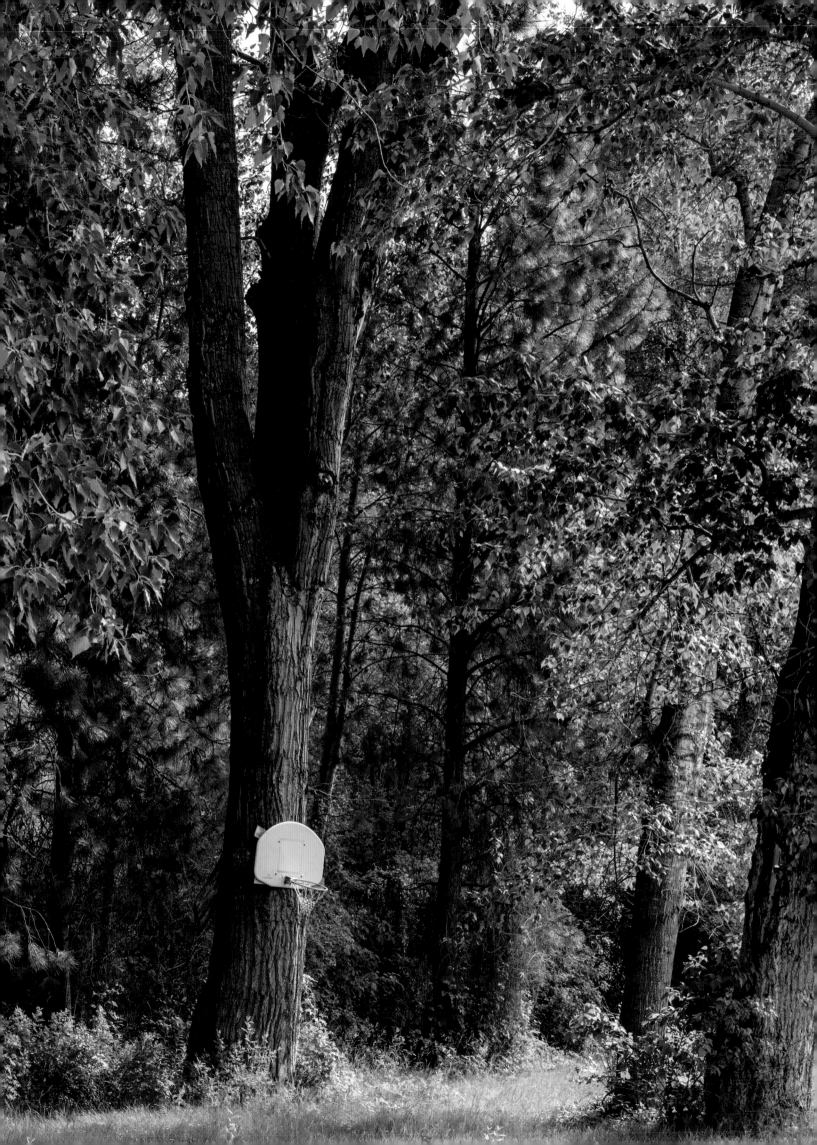

“ I grew up in rural Tennessee. If it wasn't for basketball, I'd still be sitting on my momma's back porch, swinging. I knew in second grade how much I loved to play basketball. I just fell in love with it on day one. I went to a two-room country school. I started playing on a real team in the fifth grade when I changed elementary schools. My momma made me a uniform because they had already given them all out.

I worked my way through college and graduated in the 60s, prior to Title IX. I got to play for 30 years. Basketball was the best part of my life in a lot of ways.

My dad was very influential in my life. In the 50s, I was playing divided court — three forwards on one end and three guards on the other. I played guard in my freshman year and then switched to playing forward in my sophomore year. I can remember the first newspaper write-up I ever got, when I was 15 years old. I never knew I was that good, but I can still tell you what that write-up said. I don't remember what I was saying or how I was acting, but I remember thinking how good I was while playing in the next game. We won.

On the way home, my Dad told me, 'Doris, if you ever act like that again, I promise you, you won't ever walk back on that floor again.' I said, 'Why Daddy?' (although I knew what he was talking about). He said, 'You were strutting around out there like a banty rooster. I was so embarrassed. Just remember this: If you're good, you don't have to act like it because everybody already knows it. If you aren't good and you act like it, everyone will know you're a damn fool.'

I had always heard practice makes perfect. My coach said, 'It's not practice that makes perfect, it's perfect practice that makes perfect. If you keep practicing the wrong way, you won't get any better.'

My dad cut down a tree and put a basketball hoop on it. It didn't have a net or backboard, so I never could work the angles on the backboard. Looking back, I think it was too high, but it worked."

— Doris Rogers

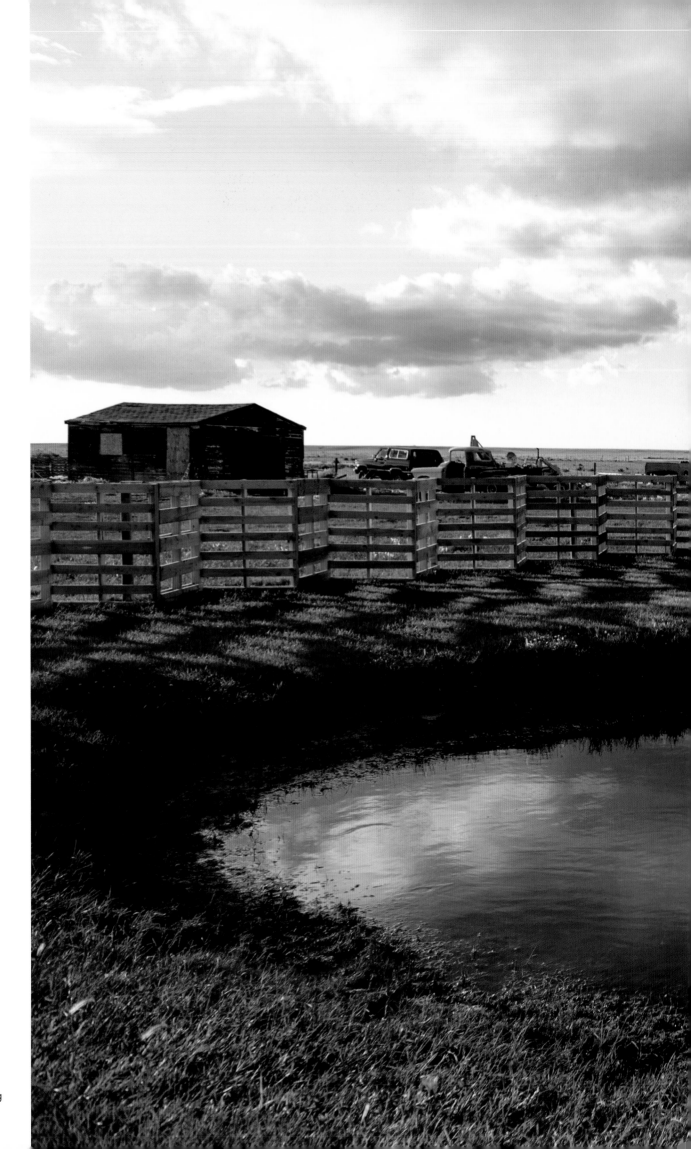

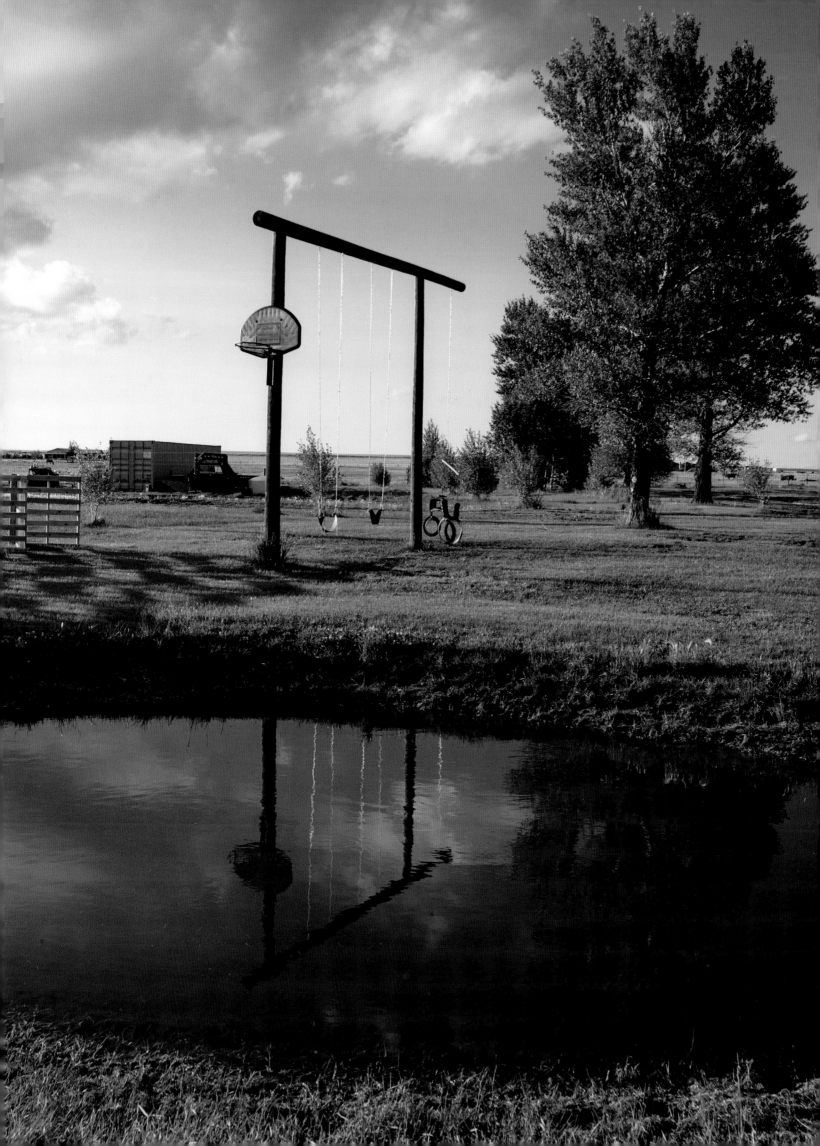

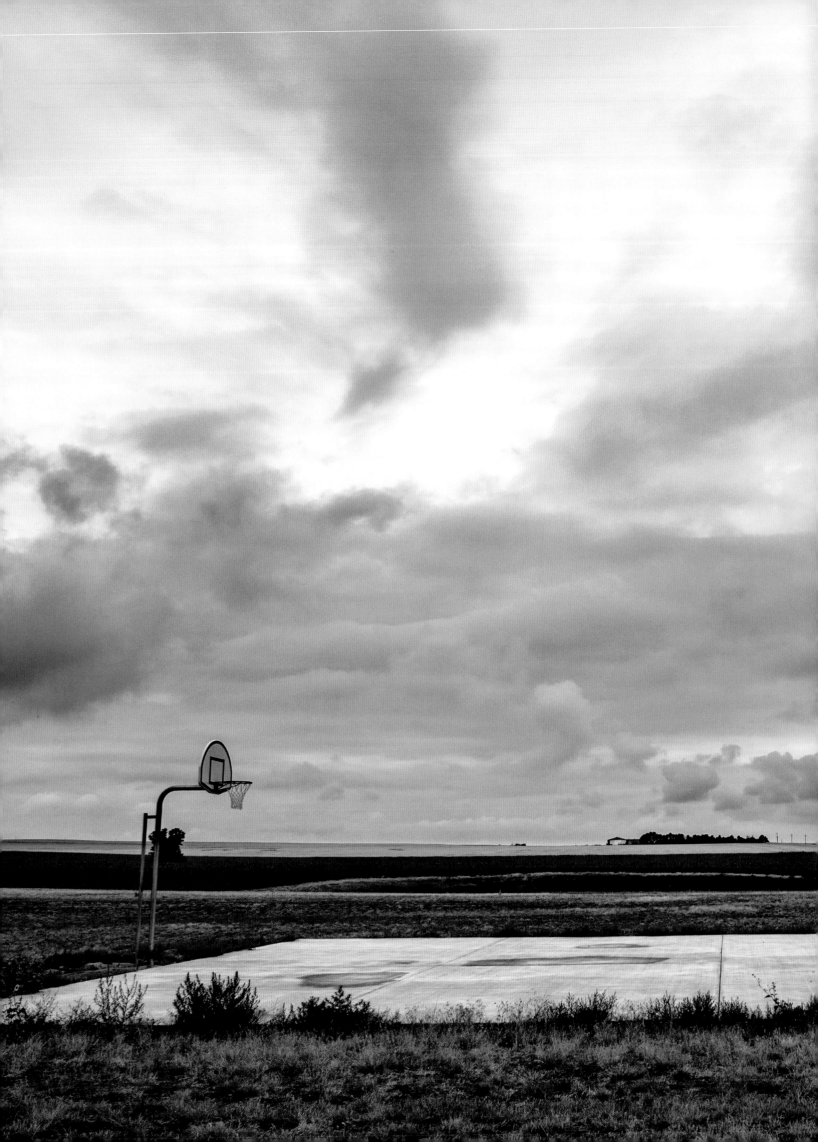

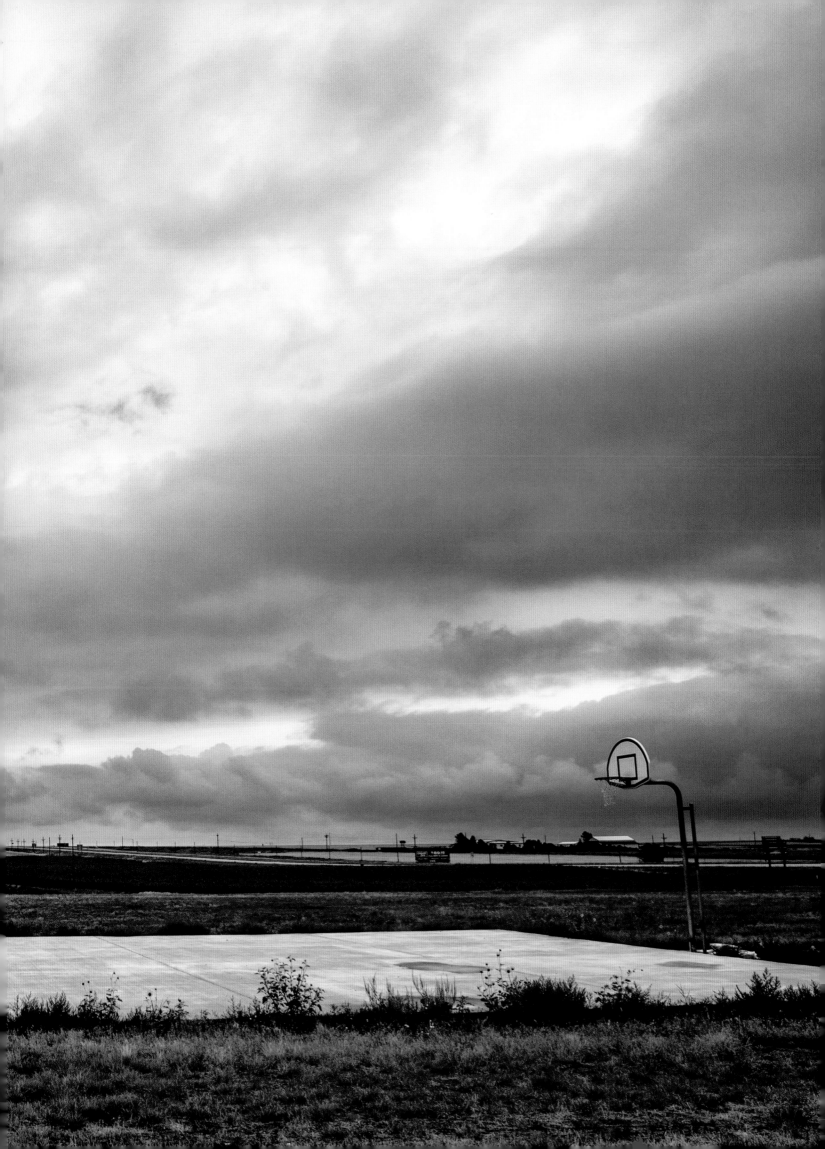

"Indianapolis had racial problems all around, so we stayed in our own neighborhood. For the four of us, kids who had no money to go anywhere, basketball was the thing to do. The most exciting thing for me, as well as the other guys I played with, was we had a chance to play at the Butler Fieldhouse when we were very, very young. The reason it was so special was because we had never been on a hardwood court before and we got the opportunity to go out there and play on it. It was fantastic, just fantastic."

— *Oscar Robertson*

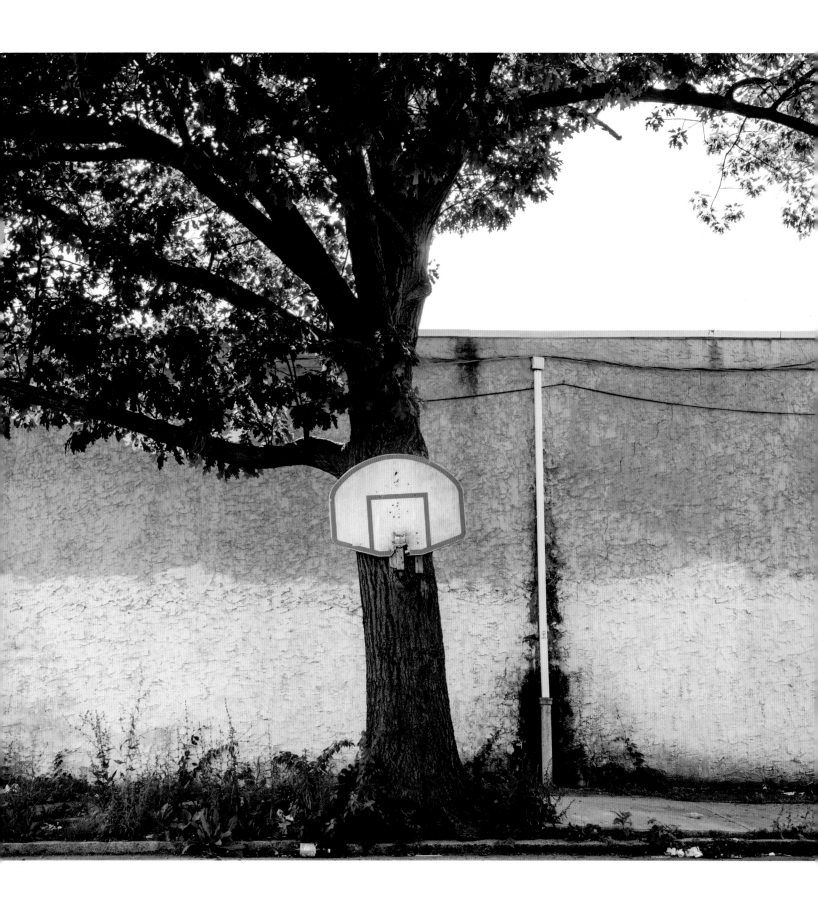

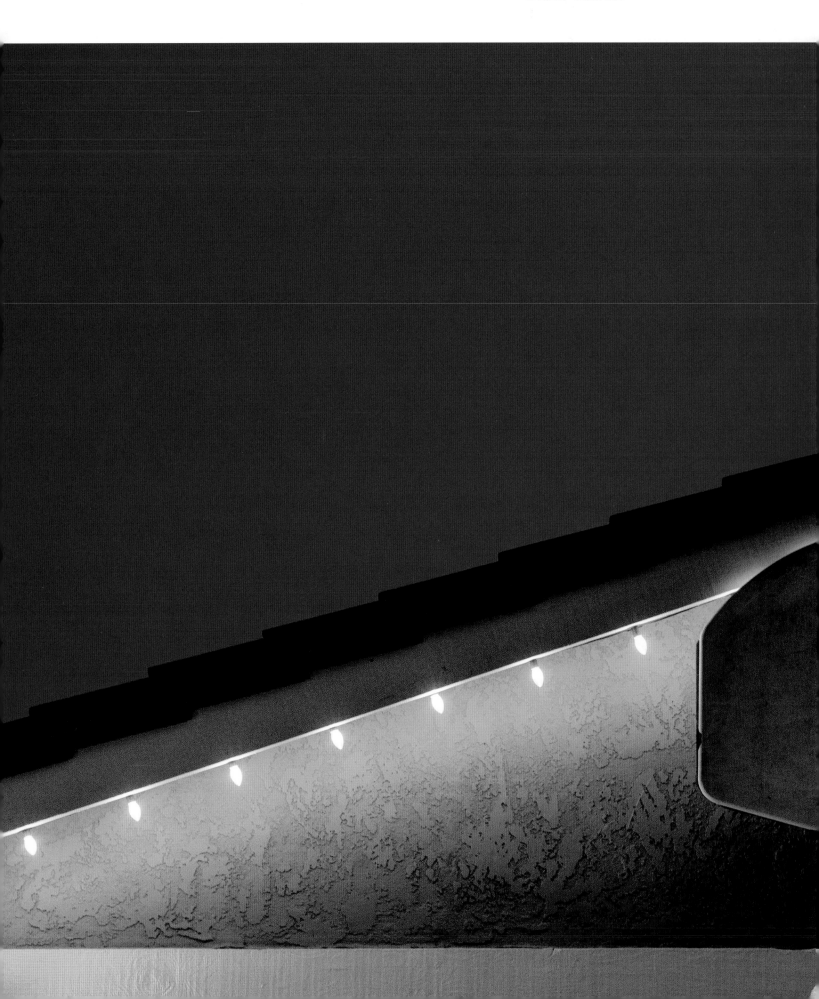

" Everyday I couldn't wait for the sun to go down! Just
me and my hoop. I can still hear the sounds of love."

— Diana Taurasi

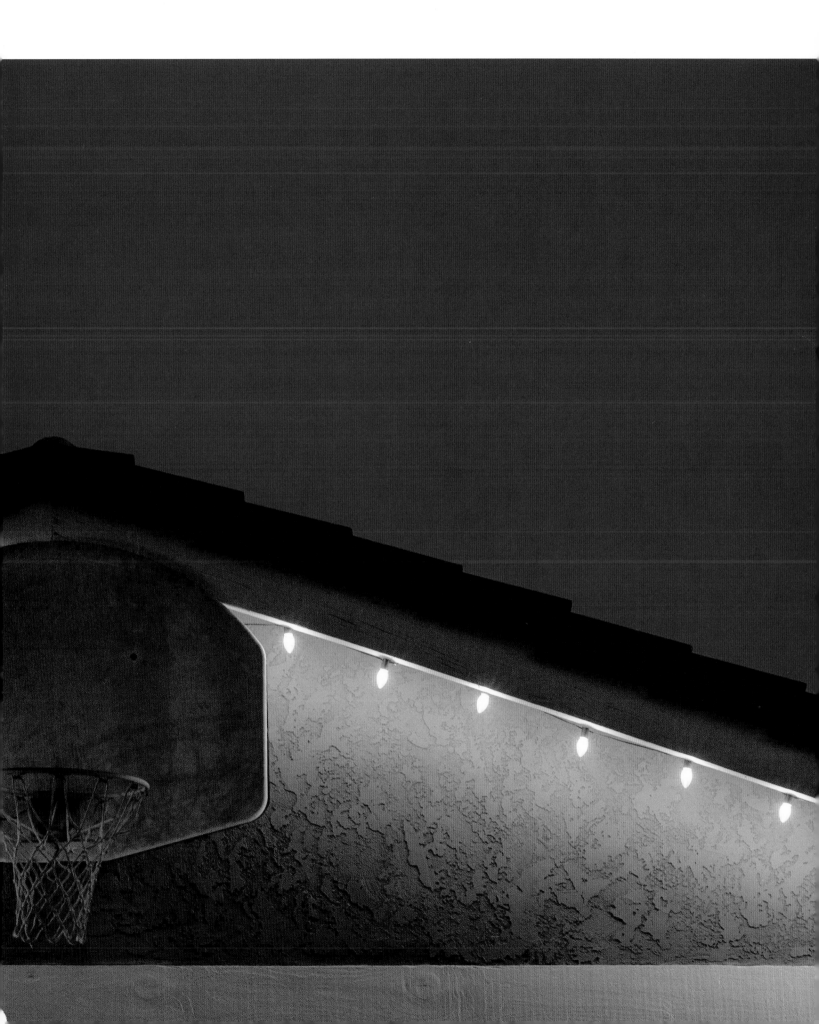

ABOVE Federal Way, Washington

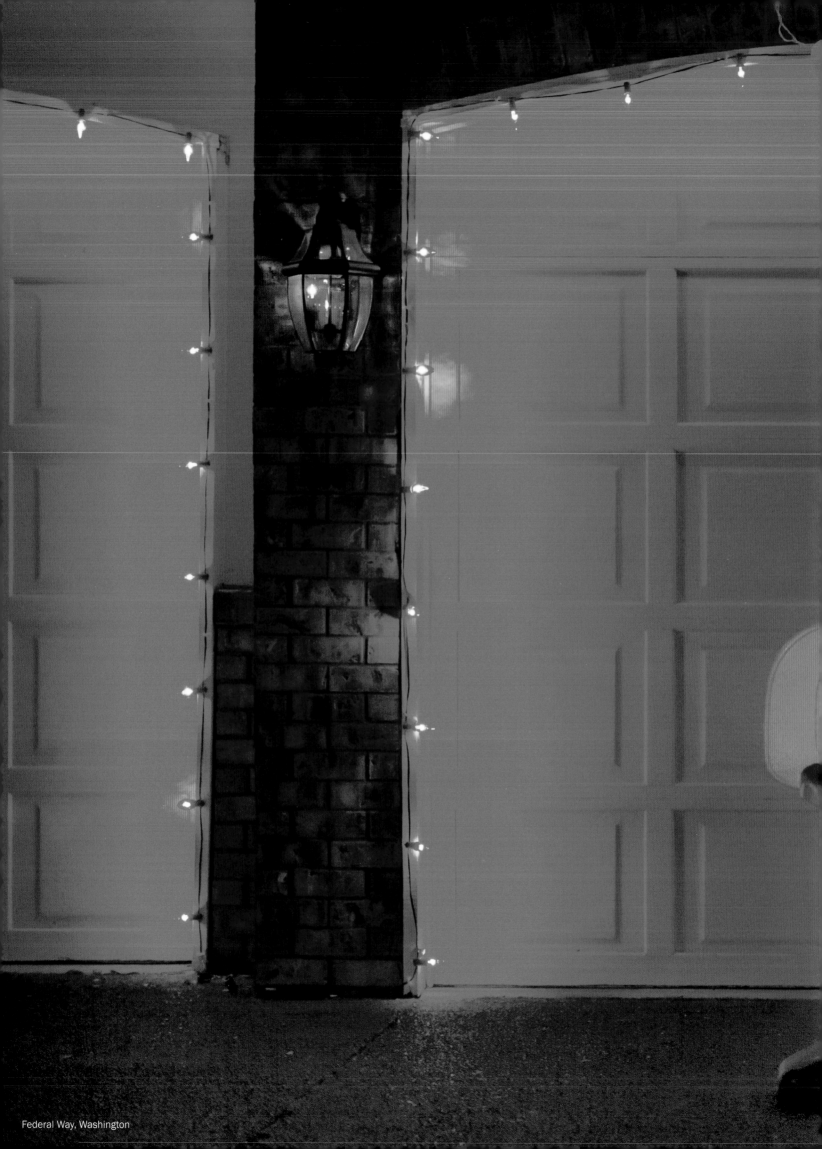

Federal Way, Washington

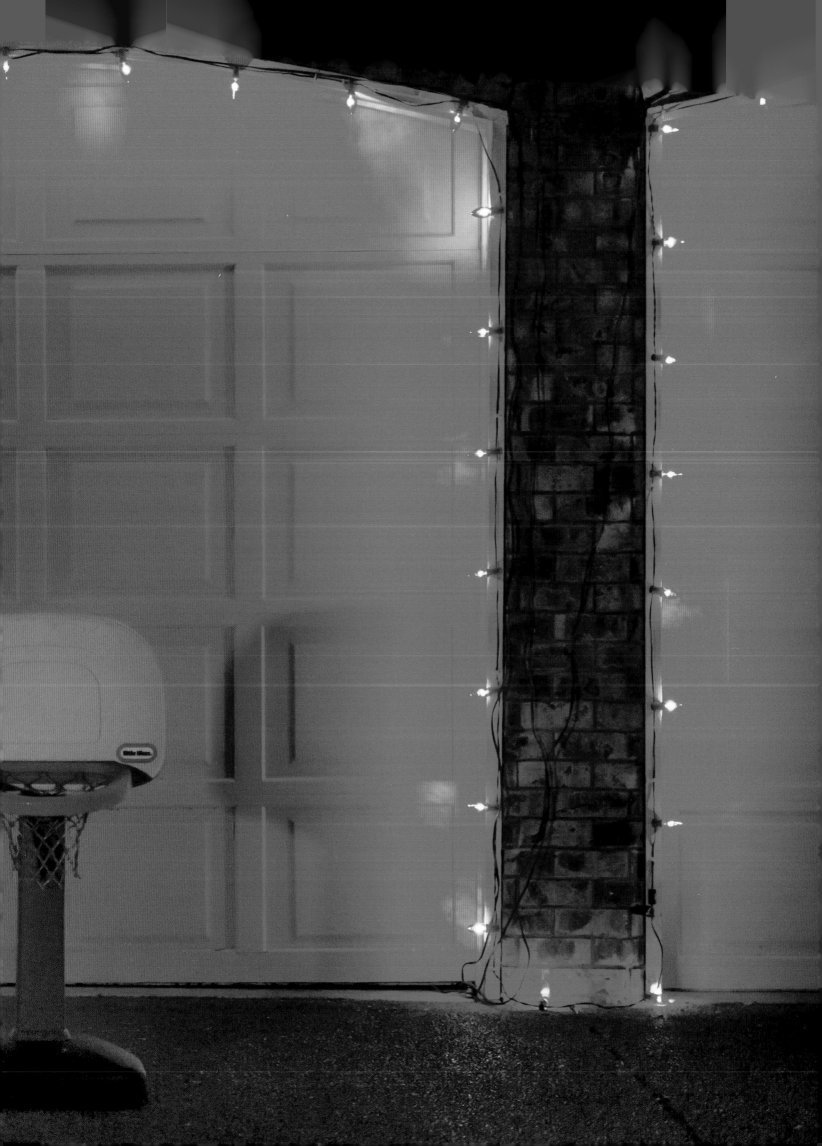

" We didn't have video games when I grew up, so I played sports a lot at the Boys and Girls Club and on a playground near my home in Washington, D.C. That way, my parents would know where I would be. But the one thing that was for sure is that I had to be home before the street lights were on, not when they came on, but before. Everybody in the neighborhood knew it. I could be playing ball or doing something and all of a sudden, my friends would see my mother and father come around the corner and they would give me a signal. They wouldn't call my name, but they would all give me a signal like a whistle or screechy noise to let me know I better run and go the back way home.

Basketball has taught me you have to be prepared and working together is the best way to accomplish a single goal. It teaches you how to interact to achieve that goal."

— *Austin Carr*

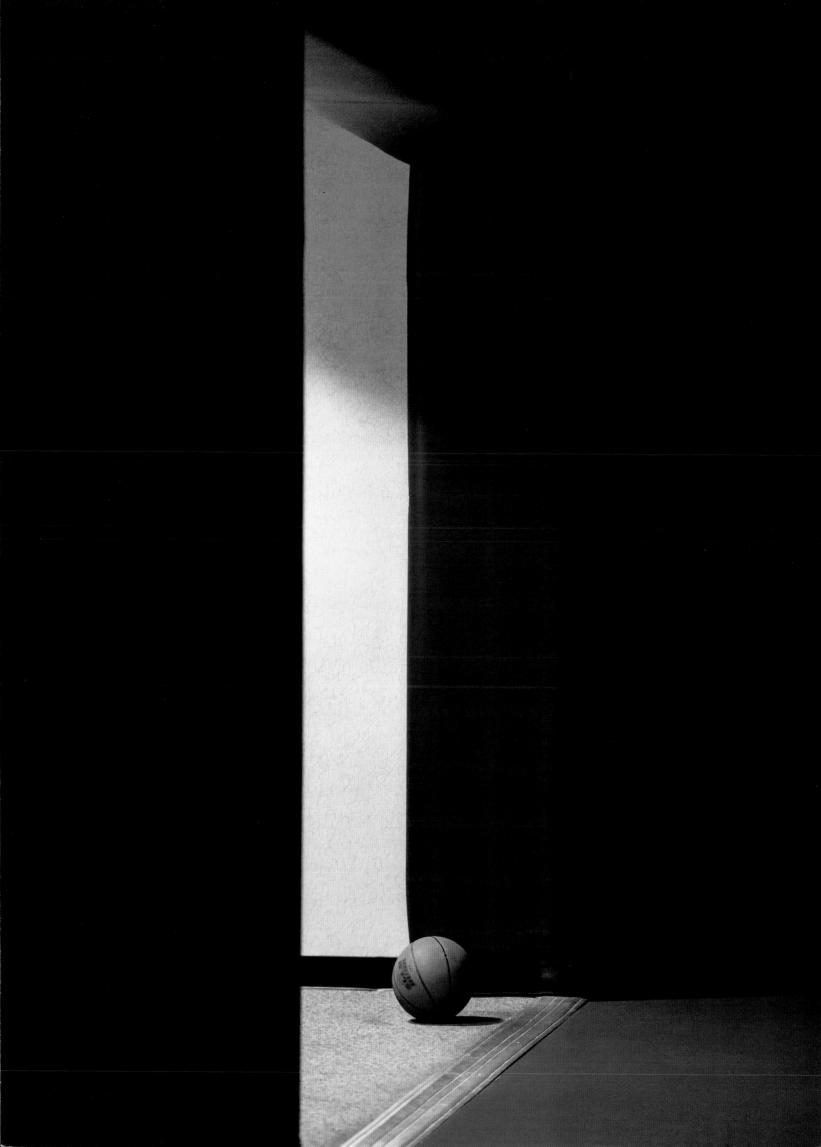

SUE BIRD

Sue Bird is one of the most popular and charismatic players in the game today. She has been a championship player at every level, winning two New York state high-school titles, two NCAA national championships, two WNBA titles, four Euroleague titles, and three Olympic gold medals. The college Player of the Year in 2002, she finished her career as the University of Connecticut's all-time leader in three-point field goal percentage and free throw percentage. She also set the UConn record for assists in a season. She is a seven-time All-WNBA player for the Storm and was named one of the top 15 players of the WNBA's first 15 years. A selfless player, Bird is known for creative playmaking that lets her teammates shine.

Courtesy of UCONN Athletics

SWIN CASH

Swintayla Cash lives up to the meaning of her name, "astounding woman." She is one of only six women to win an NCAA title, a WNBA championship, and an Olympic gold medal. In college, she led the University of Connecticut to two national titles and an undefeated season. She was named All-American in 2002 and MVP of the Final Four. As a professional, she has been a key player on three WNBA Championship teams (Detroit Shock in 2003 and 2006; Seattle Storm in 2010). A versatile scorer and rebounder, Cash is a four-time WNBA All-Star and has twice been named MVP of the All-Star game. She played on the USA's gold-medal-winning Olympic teams in 2004 and 2012. Cash currently starts for the Chicago Sky.

Courtesy of McKeesport High School

TAMIKA CATCHINGS

One of the most complete players in basketball, Tamika Catchings has led the Indiana Fever in points per game, rebounds, assists, and steals eight times. No other WNBA player has led her team in as many categories even once. The 2011 MVP has been the league's Defensive Player of the Year five times and is the WNBA's all-time leader in steals and free throws made. In 2012, Catchings and the Fever won their first WNBA title. Catchings is also a three-time gold medalist with the USA's Olympic team. She was a four-time All-American at the University of Tennessee, leading the Lady Vols to a national title in 1998. A tireless volunteer, Catchings has been universally lauded for her considerable public service.

Courtesy of Tamika Catchings

ANNE DONOVAN

Courtesy of Virginia Sports
Hall of Fame & Museum

Ann Donovan is the only person to have both played on a national championship collegiate women's team and coached a team to a professional title. She is also the first female coach of a WNBA Championship team (Seattle Storm, 2004). As a college player, she led Old Dominion to two AIAW National Championships and set ODU career marks for points, rebounds, and blocked shots. She averaged a double-double for her entire career, with 20 points and 14.5 rebounds per game. Donovan played on two Olympic gold-medal-winning teams and coached the 2006 team to a gold medal in Beijing. Donovan has been coaching since 1989 in both the college and pro ranks and is a member of the Basketball Hall of Fame.

ANN MEYERS DRYSDALE

Courtesy of ASUCLA Photography

At basketball powerhouse UCLA, Ann Meyers Drysdale stands atop the record book. The first four-time All-American women's basketball player, she scored more points in school history than any other player — male or female. In 1978, she led the Bruins to the AIAW national championship and was named Player of the Year. She also became the first player to record a quadruple-double in NCAA Division 1 history, with 20 points, 14 rebounds, 10 assists, and 10 steals. Meyers was the first high school student to play on the USA national team and helped win the World Championship in 1979. She was the first woman drafted by the Women's Professional Basketball League and, in 1980, made history as the first woman to sign an NBA contract.

CHAMIQUE HOLDSCLAW

Courtesy of Chamique Holdsclaw

Chamique Holdsclaw first gained notice as a high school player in Queens, NY, leading her team to four straight state championships. At the University of Tennessee, she put together one of the most remarkable collegiate careers of all time. She was a four-time All-American as the Lady Vols completed their first undefeated season and won three straight national titles. The leading scorer in SEC history, Holdsclaw was twice named national Player of the Year. She was a six-time WNBA All-Star and, in 2002, had a season for the ages, leading the league in scoring, rebounding, defensive rebounds, double-doubles and points per 40 minutes. She also helped the USA win an Olympic gold medal in 2000.

LISA LESLIE

Courtesy of USC

One of the inaugural members of the WNBA, Lisa Leslie retired 12 years later holding the league records for points (6,263) and rebounds (3,307) She is a three-time WNBA MVP, 10-time All-WNBA player, two-time Defensive Player of the Year, and a four-time Olympic gold medal winner. Leslie helped the Los Angeles Sparks win two WNBA titles and was the first woman to dunk a basketball in a WNBA game. As a collegian at USC, Leslie was a three-time All-American and the National Player of the Year in 1994. Leslie is also the USA's all-time leading scorer, rebounder and shot-blocker in Olympic competition. Retired since 2009, she is a fashion model, actress, and sports commentator.

REBECCA LOBO

Courtesy of The Republican by Don Treeger

Rebecca Lobo remains one of the most admired female basketball players of all time. The 6-foot-4 center led Connecticut to its first undefeated National Championship in 1995. She won multiple Player of the Year awards and was the Associated Press Female Athlete of the Year. She was the youngest member of the gold-medal-winning team at the 1996 Olympics. After graduating Phi Beta Kappa, Lobo was one of the first two players signed by the WNBA for its inaugural season. She played seven seasons in an injury-shortened career with the New York Liberty, Houston Comets, and Connecticut Sun. A two-time All-Star, Lobo was named to the All-WNBA team in 1997. She is currently an analyst and reporter for ESPN.

MICHELLE MARCINIAK

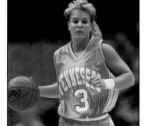

Courtesy of Nick Myers,
UT Photographic Center

Michelle Marciniak was a crowd favorite at the University of Tennessee. Affectionately known as "Spinderella" for her spinning, weaving style of play, she led the Lady Vols to their fourth national championship — and was named Final Four MVP. At Tennessee, she scored over 1,000 points and is still in the school's top ten all-time for assists and three-point scoring. Marciniak played for two and a half seasons in the short-lived ABL and earned First-Team All-Star honors. Her hard-nosed play made her a fan favorite in her three seasons with the WNBA Seattle Storm. She was an assistant coach for the University of South Carolina from 2002–2008 before co-founding SHEEX, Inc., makers of "athletic-performance sheets."

LEFT Jelleff Recreation Center, Washington, D.C.

Courtesy of Kim Mulkey

KIM MULKEY

Baylor coach Kim Mulkey has been a success at every level of the game. By winning Baylor's first national title in 2005, Mulkey became the first person, man or woman, to win a basketball national championship as a player, assistant coach, and head coach. In her 12 years at Baylor, the Lady Bears have made 11 NCAA Tournament appearances, including three Final Fours, and won two national championships. Her 2012 team was 40-0, a feat unprecedented in college basketball by men or women. As a player, Mulkey led Louisiana Tech to two national titles (1981,1982). During that time, the 5-foot-4 playmaker, known for her spectacular passes was also a part of the USA's gold medal-winning team at the 1984 Olympics.

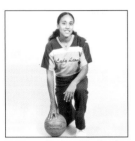
Courtesy of Southeastern
Louisiana University

ROBIN ROBERTS

Before she entered her first broadcast studio, Good Morning America's host, Robin Roberts, was a star basketball and tennis player for Southeastern Louisiana University. She finished her hoops career as the school's third all-time leading scorer (1,446 points) and rebounder (1,034). She is one of only three Lady Lions to score 1,000 career points and grab 1,000 career rebounds. After graduation, Roberts worked as a sports anchor and reporter, eventually landing regular duty on ESPN and Good Morning America. Since 2005, she has been the co-host of GMA. Her return to the air in February, 2012, following a six-month health leave of absence brought a flood of best wishes and a 1,800 percent spike in bone marrow donors.

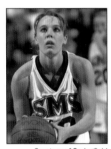
Courtesy of Doris Rogers

DORIS ROGERS

In an era before Title IX, when opportunities for women athletes were limited, Doris Rogers was an international star. She played on eight consecutive AAU National Championship teams (1962–1969) with Nashville Business College. A seven-time AAU All-American, Rogers helped the USA win gold medals at the 1963 and 1964 Pan American Games and was also a member of the USA's World Championship team that competed in Lima, Peru, in 1964. Rogers also represented the United States in international competitions throughout the 1960s in Europe, Mexico and the USSR. She scored 3,550 points in high school, including 74 points in one game. She is a member of the AAU Basketball Hall of Fame and the Women's Basketball Hall of Fame.

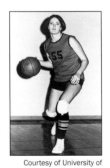
Courtesy of Springfield
News-Leader

JACKIE STILES

Jackie Stiles is the all-time leading scorer in NCAA Division 1 history with 3,393 points. An all-around athlete, she used her quickness and athleticism to defy defenses designed specifically to stop her and led Missouri State to an improbable Final Four appearance in 2001. In the Sweet 16 game, she scored 41 points in an 81-71 shocker over top-ranked Duke. Stiles remains the only woman to score more than 1,000 points in a single season. She was a consensus All-American in 2001, winning the major player-of-the-year awards. Stiles won WNBA Rookie of the Year honors in 2002, but injuries took their toll and she retired several years later. Through her camps and clinics, Stiles helps young athletes around the country achieve their dreams.

Courtesy of University of
Tennessee at Martin

PAT SUMMITT

Pat Summitt is the all-time winningest coach in NCAA history of either a men's or women's team in any division. In her 38 years of coaching — all at the University of Tennessee — she never had a losing season and guided the Lady Vols to eight national championships. Summitt was named the Naismith Basketball Coach of the Century in 2000 and was awarded the Presidential Medal of Freedom by President Obama. As a player, Summitt was a collegiate All-American and co-captained the USA's first Olympic national team to a silver medal. Eight years later, she coached the national team to its first Olympic gold medal. Diagnosed with early-onset Alzheimer's disease, she retired as Tennessee's coach in 2012.

DIANA TAURASI

Diana Taurasi is used to finishing on top. In high school, she was the National Player of the Year. At the University of Connecticut, she was a two-time College Player of the Year and led the Huskies to three straight NCAA titles. As a professional, she has been the league's MVP and a WNBA Finals MVP while leading the Phoenix Mercury to two WNBA Championships. A five-time scoring champion, Taurasi has been named to the All-WNBA team eight times. In the WNBA's off-seasons, she has teamed up with fellow WNBA All-Stars Lauren Jackson and Sue Bird to win four consecutive Euroleague championships for Spartak Moscow. Taurasi has also been a key member of three Olympic gold-medal-winning teams for the USA.

Courtesy of Diana Taurasi

RIGHT Jelleff Recreation Center, Washington, D.C.

BOYS

Courtesy of Rick Barry

RICK BARRY

During his 14-year career, Rick Barry was a 12-time All-Star. His jump shot was one of basketball's most feared weapons and enabled him to become the only player in history to lead the NCAA, ABA, and NBA in scoring. In 1975, Barry was named the NBA Championship Series MVP, leading the underdog Warriors to a four-game sweep of the Washington Bullets. In his pro career, Barry scored 25,279 points and received nine All-NBA/ABA First Team honors. He is enshrined in the Basketball Hall of Fame and was named to the NBA's 50th Anniversary All-Time Team. Barry's unusual underhand free throw style enabled him to finish his career with the second best accuracy in the history of the NBA, 90%.

Courtesy of Seattle University/
Elgin Baylor

ELGIN BAYLOR

Before Julius Erving and Michael Jordan, before the days of widespread television coverage, there was Elgin Baylor. One of the first flashy performers in basketball, many of Baylor's acrobatic plays were never captured on film. His graceful, midair exploits survive primarily in stories told by fellow players. Bill Sharman, who played against him and later coached him, called him "the greatest cornerman who ever played pro basketball." Baylor averaged 27.4 points and 13.5 rebounds over his 14-year career and led the Lakers to the NBA Finals eight times. An 11-time All-Star, he was named to the All-NBA First Team 10 times, to the NBA's 50th Anniversary All-Time Team, and to the Basketball Hall of Fame.

Photo by Curt Beamer

TOM BROWN

Tom Brown began his career with the Department of Veterans Affairs in 1975 in Richmond, Virginia. A world-class athlete himself, he was inducted into the National Wheelchair Basketball Hall of Fame in 1992 and the Wheelchair Sports USA Hall of Fame in 2000. In 1981, while working as a recreation therapist in Richmond, Brown co-founded the National Veterans Wheelchair Games. Under Brown's leadership, this unique therapy program has grown tremendously and has made significant differences in the lives of disabled veterans. Today, the Games are a premier event for the Veterans Administration and Wheelchair Sports. It has grown to be the largest wheelchair sporting event in the United States.

Courtesy of Archbishop
Carroll High School

AUSTIN CARR

Known to Cleveland fans as "Mr. Cavalier," Austin Carr first gained national notice in high school as a Parade All-American. During a three-year career at the University of Notre Dame, he averaged 34.5 points per game — fifth best in collegiate history at the time. Carr also became the second college player to score more than 2,000 points in a season, joining Pete Maravich. Carr still holds NCAA tournament records for most points in a game (61 vs. Ohio in 1970), most field goals in one game (25) and most field goals attempted in one game (44). He averaged an astounding 50 points per game in seven NCAA playoff games. As a professional, he led the Cavaliers to three playoff berths and had his jersey retired by the team.

Courtesy of Kevin Durant

KEVIN DURANT

In his one season at the University of Texas, Kevin Durant was the consensus national Player of the Year and just the third freshman ever to be named First Team All-American. Drafted second overall by the Seattle SuperSonics, Durant won the Rookie of the Year award and was just the third teenager in league history to average over 20 points per game. Two years later, he became the youngest player ever to lead the league in scoring (30.1 ppg). In 2011-12, Durant was named to the All-NBA First Team for a third consecutive season after becoming only the seventh player to lead the NBA in scoring for three consecutive seasons. Durant and the Oklahoma City Thunder have risen together, reaching the NBA Finals in 2011-12.

Courtesy of James family

LEBRON JAMES

Winner of four MVP awards, Lebron James is widely regarded as one of the best athletes of his generation and one of the greatest basketball players of all time. After seven record-setting seasons in Cleveland, James led the Miami Heat to two straight NBA Finals, capped by an NBA championship in 2011-2012. James also helped lead the United States to gold medals in the 2008 and 2012 Olympics. He won the Rookie of the Year award in his first year out of high school and has been named to nine All-Star teams. James currently ranks third on the NBA's all-time scoring average list behind only Michael Jordan and Wilt Chamberlain and is also a four-time NBA All-Defensive First Team selection.

Courtesy of Villa Angela-
St. Joseph High School

CLARK KELLOGG

Former first-round draft pick Clark Kellogg is the lead analyst for CBS's coverage of college basketball, partnering with Jim Nantz. He has served as a game and studio analyst for the past 18 years with CBS. Kellogg is only the second CBS Sports lead college game analyst since Billy Packer joined the Network in 1982. Kellogg was the Big Ten's MVP in 1982 for Ohio State University. Drafted eighth overall by the Pacers in 1982, he was a unanimous selection to the 1983 All-Rookie Team. After five seasons, chronic knee problems forced him to retire with career averages of 18.9 points and 9.6 rebounds per game. In July 2010, he was named Vice President of Player Relations for the Indiana Pacers.

Courtesy of U.S. Army

MIKE KRZYZEWSKI

In his 29 seasons at Duke University, Mike Krzyzewski has built one of the great dynasties in collegiate history — winning four national championships along the way. A 12-time National Coach of the Year, he already owns the record for most career wins in NCAA Division 1 history. Krzyzewski was a team captain and an All-NIT honoree at the United States Military Academy under coach Bobby Knight. After five years as an army officer, Krzyzewski spent a year assisting Knight at Indiana before returning to West Point as head coach. Five years later, he took the helm at Duke. Krzyzewski was enshrined in the Basketball Hall of Fame in 2001, and coached the United States' Olympic basketball teams to gold medals in 2008 and 2012.

Courtesy of Boys & Girls Club
of Newark

SHAQUILLE O'NEAL

At 7 ft. 1 in. and 325 pounds, Shaquille O'Neal was one of the most overpowering low post players in NBA history. At LSU, Shaq was the 1991 NCAA Player of the Year — once blocking 17 shots in a single game. As a pro, he won four NBA championships (three with the Lakers and one with the Heat). During his 19-year career, he was an MVP, a 15-time All-Star, a three-time NBA Finals MVP, a three-time scoring champ, and a 14-time All-NBA selection. Vocal and gregarious, O'Neal had a string of nicknames, including "the Diesel" and "the Big Aristotle." Off the court, he pursued careers as a rapper (1993 platinum album), actor (*Blue Chips* and *Kazam*), and law enforcement (reserve officer in L.A. and Miami Beach).

Courtesy of Bobby Plump

BOBBY PLUMP

Indiana's Mr. Basketball in 1954, Bobby Plump led tiny Milan High School to an improbable state championship that year — an achievement that inspired the film *Hoosiers*. Plump was named to the all-state team in 1953 and 1954 and went on to star for Butler University in Indianapolis. At Butler, he established single-season and career scoring records and still holds the Butler career record for most free throws made. An Honorable Mention All American his senior year, Plump also played on the United States' Pan American and Olympic playoff teams. A 2007 internet vote of fans named him the No. 1 Butler basketball player of all time. Plump was also a two-time all-conference baseball player for Butler.

DANNY MANNING

Danny Manning is the University of Kansas' all-time leading scorer and rebounder. The Jayhawk legend is the eighth leading scorer in NCAA history, a two-time All-American, and the College Player of the Year in 1988 — the year he led Kansas to the National Championship. Drafted first overall by the Clippers, Manning played for seven teams in an injury-shortened career. He was a two-time All-Star and won the league's Sixth Man award in 1998. After he retired, Manning returned to Kansas as an assistant coach — playing a part in one NCAA national title, two Final Fours, five NCAA Elite Eight appearances and eight Big 12 regular season titles. He is currently the head coach at the University of Tulsa.

Courtesy of Danny Manning/
Kansas Athletics Archives

GARY PAYTON

The only point guard ever to win the NBA Defensive Player of the Year award, Gary Payton, also known as "The Glove," is widely regarded as one of the best point guards of all time. He was selected to the NBA All-Defensive First Team a record nine consecutive times. He was also a nine-time All-Star and a nine-time All-NBA Team member. In his prime, he was often the NBA's highest-scoring point guard as well. Payton is best known for his 13-year tenure with the Seattle SuperSonics, whom he led to the NBA Finals in 1996. He holds Seattle franchise records for points, assists, and steals. He helped the USA Olympic team to gold medals in 1996 and 2000, and Miami to an NBA title in 2005-2006.

Courtesy of Gary Payton

OSCAR ROBERTSON

Widely considered the best all-around player in NBA history, Oscar Robertson retired with more points (26,710) and more assists (9,887) than any guard in history. Robertson was the NBA's first "big guard" and actually led his team in rebounds one year. In 1961-62, he averaged a triple-double for an entire season — something no other player has done. As a collegian at Cincinnati, he led the nation in scoring three times and set 14 NCAA records. "The Big O" made the All-NBA First Team nine consecutive times, played in 12 straight all-star games and won the MVP award in 1963-64. He helped the Bucks win the NBA title in 1971 and was elected to the Basketball Hall of Fame and the NBA's 50th Anniversary All-Time Team.

Courtesy of Crispus
Attucks Museum

BILL SHARMAN

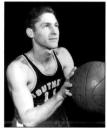

Bill Sharman was a seven-time All-NBA player and arguably the greatest shooter of his era. One of the first NBA guards to shoot above .400 for a season, Sharman also led the league in free-throw shooting for a record seven seasons. He and Bob Cousy formed one of the finest backcourts in league history and guided the Celtics to four championships together. Sharman also had great success as a coach. He is the only man to win championships in three professional leagues (NBA, ABA, and ABL). Sharman guided the 1971-72 Lakers to what was then the best regular season record (69-13) in NBA history. He is a member of the Basketball Hall of Fame and the NBA's 50th Anniversary All-Time Team.

Courtesy of USC

WES UNSELD

Hall of Famer Wes Unseld bulled his way to the top with relentless rebounding, brick-wall picks, and crisp passes. Despite regularly playing against taller centers, Unseld fought fiercely for the ball and retired as the NBA's seventh all-time rebounder. A consensus All-American at his hometown University of Louisville, Unseld averaged 20.6 points and 18.9 rebounds a game during his college career. Drafted by the Baltimore Bullets, who had never had a winning season, Unseld led them to 12 straight playoff appearances — and an NBA title in 1977-78. The MVP and Rookie of the Year in 1968-69, and a five-time All-Star, Unseld was named to the NBA's 50th Anniversary All-Time Team and was elected to the Basketball Hall of Fame.

Courtesy of Seneca
High School

JERRY WEST

Jerry West's accomplishments as both a player and front-office executive are unmatched in NBA history. They include seven NBA titles as a player, executive, or special consultant, two NBA Executive of the Year awards, 14 All-Star appearances, and 10 First Team All-NBA selections. Dubbed "Mr. Clutch" for his ability to produce with the game on the line, West is undeniably one of the greatest players in NBA history. Just the third player to score more than 25,000 points, he also scored 20-plus points in 25 consecutive NBA Finals games and still holds the season mark for free throws made. A member of the Basketball Hall of Fame and the NBA's 50th Anniversary All-Time Team, his silhouette is featured on the NBA's logo.

Courtesy of Jerry West

ROBIN LAYTON

Photojournalist/Artist/Filmmaker

During her 25 years as a photojournalist, Robin Layton has produced countless notable photographs and earned a place among the world's elite photographers. At 24, she was honored by *LIFE* magazine as one of the eight most talented photographers in America. Her documentary images have been featured by the Smithsonian and nominated for a Pulitzer Prize.

After an award-winning career in newspapers, Robin embarked on a freelance career that has taken her on assignments throughout the world — photographing everything from street people to presidents. In her personal work, she has expanded the boundaries of traditional photography, combining her images with vintage found objects to create critically-acclaimed art pieces.

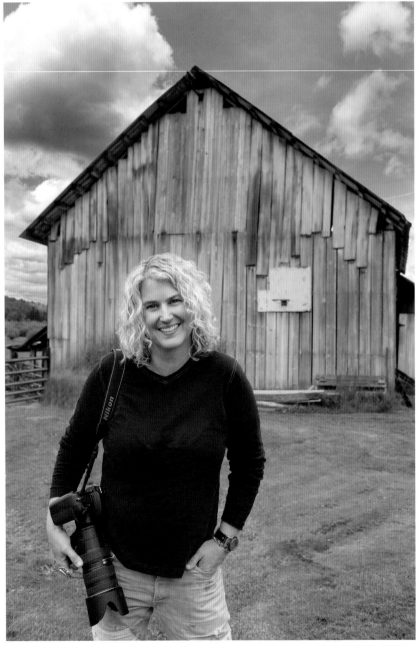

photo by E. Shakti Chen

ACKNOWLEDGEMENTS

Thanks to all the participants in this book who shared childhood memories and, when possible, the location of their childhood hoops. Your lives and your love for the game of basketball continue to be an inspiration to us all.

This book would not have been possible without the contributions of its Hall-of-Fame lineup: Rick Barry, Elgin Baylor, Sue Bird, Tom Brown, Austin Carr, Swin Cash, Tamika Catchings, Anne Donovan, Ann Meyers Drysdale, Kevin Durant, Chamique Holdsclaw, LeBron James, Clark Kellogg, Mike Krzyzewski, Lisa Leslie, Rebecca Lobo, Danny Manning, Michelle Marciniak, Kim Mulkey, Shaquille O'Neal, Gary Payton, Bobby Plump, Robin Roberts, Oscar Robertson, Doris Rogers, Bill Sharman, Jackie Stiles, Pat Summitt, Diana Taurasi, Wes Unseld, and Jerry West.

If there is one thing I've learned, it's that it takes a village to create a successful project. This book is the result of contributions from many old friends — and even more new ones. One connection led to another and through the generosity of fresh acquaintances, hoop was born.

Andy & Amy Fredericks: Andy, thanks for always being my constant inspiration. Thanks to you both for all your love and support and most importantly, thanks for being my true and beloved friends.

Lisa Montanaro: You are an angel that I know my parents sent to me. Your unselfishness and kindness compare to no other. Thank you from the bottom of my heart for helping make my dream come true.

Sean Halpert: One of the best days of my life was when I met you in Boston. Your support of my art and generosity of help were instrumental in getting hoop published.

Elizabeth Evans: Thanks for believing in this project from day one and for all your hard work in making this book happen. I knew I was in good hands, having "B & B" by my side.

Craig Cohen: Thanks for seeing and believing in this project as much as I do. I'm honored and thrilled powerHouse is the publisher of hoop!

Peggy Fitzsimmons: Thanks for always being so positive, for all your help, enthusiasm, ideas, and support.

Libby Moore: Thank you for your kindness and support of this project and for introducing me to Lisa and Nancy.

Michelle Marciniak: Thank you for always believing in me and this book and for all your support. We are family.

Susan Walvius: Thanks for always being there for me. We are family.

Debbie Jennings: You are one of the main reasons a lot of the players and coaches are in this book. Thanks for all your help and connections.

Lisa Lax and Nancy Stern Winters: Thank you both for your support from the very beginning of this project and for introducing me to Annie. It was the beginning of many wonderful things to come.

Kim Carney: Thanks for saying "YES" to my crazy idea when I asked you to drive across the country with me. This incredible journey would not have been the same without you and your amazing talents. Thank you for being a fellow artist, cheerleader, driver, therapist, and weightlifter.

David Miller: Thanks for being our "guiding light" along this journey. The content and ideas of this book would have never happened without your love,

passion, and knowledge of the game of basketball. Thanks for turning all my crazy jumbled thoughts into sheer poetry.

Karen West: Your infectious enthusiasm and generosity, allowed this seedling to grow and blossom into a book beyond my dreams. Thank you from the bottom of my heart for helping make this dream come true.

Tauja Catchings: From the second we first communicated, you were beyond helpful. Thank you for connecting me to Jamie for we would have never gotten into the White House without her.

Jamie Smith: The photo of the White House would have never happened without you. Thank you.

Corey James: Thanks for your enthusiasm and support for this book and for giving us a tour of the Cleveland Cavaliers' facilities.

Jakki Nance: You were so kind to me the second we connected. Thanks for pointing us in the right direction and putting us in touch with some of the key players in hoop.

Elaine and Elgin Baylor: Thanks for inviting us into your home and for all your help and support.

Karen Bryant, Seattle Storm CEO: Thanks for all your enthusiasm and support since the second I showed you this project.

Katie Wynn: Thanks for helping this project get off to a good start and for introducing Pat Summitt to this project.

Justin Bauman: Thanks for your valuable contacts and for consistently pointing me in the right direction. Your generosity and enthusiasm meant so much to me.

Chris Theisen: Thanks for all your time, knowledge and guidance at the University of Kansas.

Suzanne and David Booth: Thank you for inviting me into your beautiful home and for letting me photograph James Naismith's original rules of basketball.

Tasha Stenning: A special thanks to you for all your help with the basketball rules. You made it so easy for me and were so warm and approachable.

Bryan Newlin: Thanks for taking down and giving us the hoop off your barn!

A special thanks to the following people I met along this journey. Thanks for your hospitality, generosity, and enthusiasm for this project: Nancy Bennett, Ervin Boyd, Patty Burdon, Michelle Campbell, Lynn Claudon, Lyndsay Colas, Bob Dearmond, Mary Ford, Steffen Foster, Jon Jackson, Steve Jackson, Diane and Michael Kane, Ted Kwasnink, Dollie Lane, Karen Marlowe, Cindy Masters, Roselyn McKittrick, Kelly McMahon, Sonny Mullen, Emily Robinson, Stephanie Rosa, Steve Rushin, Nancy Slominski, Hannah Storm, George Vecsey, Kattie White, Specelle Williams, George Dohrmann, and Elana Winsberg.

Shakti Chen: Thanks for always believing in me and for supporting me in everything I do. You make me a better person and I am incredibly grateful that you are my partner. I love you.

... and a HUGE thank you and shout out to all the people who answered their doors and let me photograph their hoop! Without you, this book would have never been possible.

hoop
the american dream™

Photographs © 2013 Robin Layton
Foreword © 2013 Jerry West

Published in the United States by powerHouse Books,
a division of powerHouse Cultural Entertainment, Inc.

37 Main Street, Brooklyn, NY 11201-1021
T 212.604.9074 – F 212.366.5247
info@powerhousebooks.com – www.powerhousebooks.com

First edition, 2013

Library of Congress Control Number: 2013940407

ISBN: 978-1-57687-671-8

Book Design by Kim Carney and Robin Layton

Printed and bound in China through Asia Pacific Offset

10 9 8 7 6 5 4 3 2 1

To order original prints from this book or to see more of Robin's work, visit her website:
www.robinlayton.com

Back Cover: Waldorf, Maryland

and shall keep the time. He sha

made, and keep account of the goals

usually performed by a referee.

12. The time shall be two fi

minutes rest between.

13. The side making the most

declared the winners. In case o

ment of the captains, be continued

First draft of Basket
Hung in the gym tha
learn the rules — Dec